KT-495-317

Bruno Nardini

LEONARDO

Portrait of a Master

GIUNTI

Original title: *Vita di Leonardo*
Translation: Catherine Frost

ISBN 88-09-01350-6
© 1999 Giunti Gruppo Editoriale, Firenze

PART ONE

Truth and legend

SPRING HAD ARRIVED, in France as elsewhere. All around Clos-Lucé, in the territory of Amboise, the hills had suddenly blossomed after a last, unnatural frost in April. The banks of the Loire were dotted with lilies of the valley, hurrying to keep their appointment with May Day.

High above a kite sailed through the sky on open wings.

In a great bedroom under a gilded ceiling an old man, pale and still, lay slowly dying, watched over by a few family members.

Suddenly, from the stairway, a voice cried out:

«The King! The King!»

The old man, roused from his drowsy torpor, tried to lift his head from the cushion. A brocade dressing gown was thrown over his shoulders, someone helped him to sit up. The King entered the room, walking quickly to his bedside.

«...Then he was struck by a paroxysm, the harbinger of death... and expired in the arms of the King, at the age of seventy-five».

It was the second of May, 1519. A drawing by Ingres illustrates the crucial moment of this legend; for the death of Leonardo da Vinci in the arms of Francis I, King of France, as described by Vasari, is only legend.

For his contemporaries too, Leonard was cloaked in mystery. Little was known of him, for he conceded nothing to the curiosity of the world. He wrote incessantly, about everything, but gave only the rarest of glimpses into the enigma of his own life.

Leonardo was a man of the world, we would say today; elegant and extravagant, handsome and strong – «...he bent an iron horseshoe as if it were made of lead...» – refined in words and gestures, sophisticated in dress, «...and so pleasing in his conversation that he won the hearts of everyone...» And yet he was alone, without a friend, without love.

Faced with the tragic events of his day he remained as imperturbable as a Stoic philosopher. And in the midst of everyday problems he showed an Olympic calm, detached from disturbing reality while at the same time observing it impartially.

«He is a sorcerer», remarked many of his contemporaries, in admiration tinged with fear.

Leonardo was aware of this myth. Between himself and others he purposely erected a barrier of mystery based on occult learning, knowledge not gained from books but conquered, almost secretly, through experience. Behind the mask of the sorcerer he hid from everyone, himself included, the face of a man who felt the need of other human beings and the warmth of affeetion.

Leonardo was a living contradiction. In a century rich in innovatory trends, leaving behind it a vast heritage of art, he impersonated in himself the themes of Humanism and the Renaissance; but also turned his back on that century to gaze far into the future, anticipating an age still to come – our own, the twenty-first century.

Leonardo's essential nature lies beyond our grasp. Neither misanthropic like Michelangelo nor serene like Raphael, he concealed his true self by dispersing his energy in what Vasari called «whims and caprice». His secret tragedy was that he could not accept a sentiment – emotion or inspiration – without translating it into a rational concept, without «turning it into anatomy».

Leonardo was a seeker after the truth, at any price and at the cost of any renunciation.

«King Francis», wrote Cellini in his memoirs, «took so much pleasure in his conversation that he spent few days in the year without his company...»

Is this another legend? Or a reality so remarkable as to seem legendary? The love of Francis I for Leonardo is sufficient justification for Vasari's version of the last moments of the great solitary genius from Vinci.

If Leonardo did not die in the arms of the King it was only because the sovereign, unaware that the end had come, was celebrating the birth of his second child with the whole court at Saint Germain-en-Laye.

Otherwise he would have hurried like a son to Leonardo's bedside, and the legend would have been true.

Good blood will tell

IN THE FIFTEENTH century, as today, some deductions in income tax were allowed, and the taxpayers in each family listed the «mouths to be fed», that is the women, the elderly, young children and servants.

In 1457 the Notary Ser Antonio da Vinci declared to the tax bureau that in his home, among the mouths to be fed, were «Lionardo, son of Ser Piero, illegitimate, born of him and of Chaterina now the woman of Accattabriga di Piero del Vaccha da Vinci, five years old».

The men of that time were accustomed to note important events in the family book, and Ser Antonio was no exception to the rule:

«1452. My grandson was born, the son of Ser Piero my son, on April 15th, Saturday, at 3 in the night. He was named Lionardo and baptized by the priest Piero di Bartolomeo da Vinci...»

On Albis Sunday the baby was baptized in the little church of Santa Croce in the town of Vinci. Five men and five women, scrupulously listed by their full names, witnessed the legitimate entry into the family of Ser Piero da Vinci's illegitimate son.

And the child's mother? Who was this Caterina that the earliest and most reliable biographer of Leonard – the so-called Anonymous Gaddiano – describes as being of «good blood», who was later to become the wife of a certain Accattabriga da Vinci?

In Tuscany «good blood», does not mean, as some have thought, «good lineage», but indicates instead a certain physical, and above all moral, quality.

«Good» meaning healthy, sound not only in body but also in soul. Caterina must have been a girl from the surrounding countryside, healthy, honest and beautiful, to whom the eldest son of Ser Antonio, «ser» himself as well as young and handsome, may have made some rash promise of marriage.

In the little town of Vinci, in those few houses grouped around the Càssero – the name of the ancient castle tower – the title of «ser» conferred special dignity. «Ser» had been, in the fourteenth century, a certain Michele da Vinci, and «ser», or notary, were all of his direct descendants down to the bold, reckless son of Antonio.

Born in 1427, Ser Piero was twenty-five when Caterina gave birth to Leonardo. At once Antonio, to banish wild ideas from his son's head and remorse from his own conscience, married Piero off, in that same 1452, to a very young Florentine girl named Albiera, from the Amadori family. Then he forcefully convinced the turbulent son of Piero del Vacca, nicknamed Accattabriga, to take to wife the beautiful and disappointed Caterina.

Having thus settled his domestic affairs – with a daughter-in-law to help her mother-in-law and act as foster mother to the little love-child, and with his other son Francesco, «who sits at home and does nothing» – old Antonio could continue to write up contracts and play at «royal table» with the peasants of Anchiano. His son Ser Piero soon rented a house in Florence, having decided to pursue a career and make money with the support of the Medici and the Servi of Santissima Annunziata.

The kite

«IN THE EARLIEST memory of my infancy it seemed to me that, as I was lying in my cradle, a kite came down to me and opened my mouth with its tail, and struck me many times with its tail between my lips».

This extraordinary dream, rich in symbolic meaning, was deeply impressed not only in Leonardo's memory, but in his very soul – today we would say, more precisely, his unconscious – like an obscure foreboding of his destiny.

The kite was a bird often seen soaring above Vinci and the castles that dotted the countryside between the Arno and Mount Albano. Leonardo's uncle Francesco had often called to his nephew to look up at this bird, with its characteristic forked tail and wheeling flight.

«See him?», cried Francesco, throwing himself down on the grass to watch the bird of prey in flight. «When the wind blows high, like now, the kite stays up high. When the wind blows low the kite is not afraid to descend as far as the Càssero. It is one of those birds that beat their wings little and always search for currents in the air».

The child Leonardo listened and observed. His school was the fields and meadows around the country house at Anchiano, the woods that covered the mountain down to the outskirts of Vinci, and his teacher was his young uncle Francesco, only seventeen years his elder.

This uncle, a philosophic idler, conveyed to his nephew his own personal theory of nature, made up of observation, testing and verification, but primarily of love for all things created.

«Philosophizing about natural things», says Vasari, «he learned to understand the properties of herbs».

Each day Francesco revealed to his nephew the marvelous wisdom of nature. He took the boy down to the river and, gazing into the water, showed him an image of daily reality always in motion. As they strolled through the woods he described the metamorphosis of insects. He had the boy touch with his hands a clod of earth in which the grain was about to sprout, wondering aloud what mysterious force let that slender green thread

push its way through the frozen earth. When summer came they watched ants dragging grains of wheat bigger than their bodies. Occasionally the uncle told a fable, like that of the secret pact between an ant and a grain of wheat.

«What was the pact, Uncle Francesco?».

«Leave me here, the grain of wheat said to the ant. Let me go back to the earth which is my element and in a year's time I will give you not one, but a hundred grains like me».

«And the ant?».

«She was tired, and accepted. But she didn't really believe in that pact. The next year, instead...»

«An ear of wheat, Uncle Francesco! The grain had become an ear of wheat!».

It was a brief resplendent childhood, soon ended but never forgotten, spent at Anchiano and Vinci in the home of Leonardo's grandfather, waiting for Saturday when Ser Piero returned from Florence.

From behind a half-open door a woman watched the child walking through the village. A gentle, melancholy gaze followed him, lingering secretly.

«Father», said young Ser Piero one day, «I have rented a house from Michele Brandolini, in Via della Prestanza behind Palazzo della Signoria. With your permission I would like to take Albiera and Leonardo to Florence. The boy must begin his studies, he can't keep on roaming the fields from morning to night».

Ser Antonio looked at his grandson and silently nodded in agreement. Uncle Francesco tried to find the courage to smile. Albiera only asked:

«When?»

«Next month», answered Ser Piero. Approaching Leonardo he raised the boy's face, gazed into his eyes and exclaimed:

«You will see Florence, my boy: the world!».

It was that same night, perhaps, that the boy dreamed of the kite. He seemed to be in his cradle, small, defenseless, and the bird of prey, with its wheeling flight, dived suddenly onto him, beating its forked tail against his mouth.

Florence

MUSIC AND ARITHMETIC, the flute and the grammar book were the daily bread of little Leonardo upon arriving in the city. His last sight of Vinci, while the horse picked its way down the rocky winding road, had been Uncle Francesco, standing at the door to watch him leave.

After the silence of the countryside came the uproar of the city. The artisan's shops threw their doors open at dawn and the streets were filled till sundown with the noise of tools, axes and hammers, winches and bellows. It was like an immense collective breathing interrupted occasionally by the crash of a collapsing building, as the ancient tower-houses were demolished to make room for the new «residential» architecture.

Florence was small. Brunelleschi had just begun to build a mansion for Luca Pitti at the foot of the Boboli hill, on the other side of the Arno, and Michelozzo had just finished a fortified palace for Cosimo de' Medici in Via Larga, not far from the Baptistery.

The city was taking heart again after the economic collapse of its trading companies which had lost their centuries-old monopoly on the wool and silk markets. The new foreign production had put many companies out of business and caused a number of banks to fail.

The resulting mistrust in commercial initiatives was a stimulus to invest in something apparently more stable, real estate; and money was now being swapped incessantly for agricultural land and houses. If the houses were old, demolition and rebuilding represented a second and more daring initiative that was not only economical but also artistic and social.

The creators of the splendor of that great century all lived and worked in Florence: Donatello, Brunelleschi, Fra Filippo Lippi, Benozzo, Rossellino, Michelozzo, Paolo Uccello, the two Pollaiuolo, Luca della Robbia, Mino da Fiesole, and Luca Signorelli. Ghiberti and Andrea del Castagno had died only recently. And over all, vigilant and alert, the elderly Cosimo ruled without seeming to rule, destroying his enemies with «burdens», extremely high income taxes, and personally choos-

ing the «*accoppiatori*» who superintended tax collection and the selection by lot of candidates for public office.

Like a raging epidemic, the fever for study and research that was called Humanism had suddenly broken out. A Rumanian Greek, Giorgio Gemisto Pletone, had founded a Platonic Academy inspired by ancient school of Athens. Other learned men had come to Florence, invited by Cosimo, to teach Greek. Men were winning fame, men like Marsilio Ficino – who proposed to reconcile Christian doctrine with Plato's philosophy – Cristoforo Landino, Agnolo Poliziano, Giovanni Pico della Mirandola and Leon Battista Alberti who, for his great knowledge of classical architecture, was called the Florentine Vitruvius.

In this vigorous climate Leonardo lived the formative years of his boyhood, exposed to a culture and an environment that were to exert a determinant influence on his life.

«In elementary arithmetic», wrote Vasari, «in the few months that he studied it he made such progress that, continuously resolving the doubts and difficulties for the master who taught him, he very often threw him into a state of confusion».

But Leonardo's vocation was another. Ser Piero was determined to make him a notary, a «ser» like all of the first-born sons of his family. Having once reached this decision, he supervised the son's education very little or not at all.

Leonardo, however, had begun to discover and to recognize himself.

Almost always alone, he wandered through the workshops of artists and artisans, attracted alike by the beauty of a painting and the ingenuity of a tool, while his aversion to grammar and scholastic notions in general grew by leaps and bounds. He began to contradict his teachers, in the name of that natural knowledge learned from Uncle Francesco, opposing to the abstract information of books, based only on Aristotle's remote statements, the concrete, irrefutable data of experience.

Alone he continued to investigate the animal kingdom and the plant world. In the orchards and gardens of Florence, along the Arno and the Mugnone, he captured insects, fish and birds, collected plants and flowers. To keep them fresh in his memory, he began to draw.

This was his secret. The busy, distracted father knew that his son was studying arithmetic, grammar and music, but never suspected that Leonardo was secretly venturing along the path of art.

Although the boy may have admitted something to Albiera, she did not dare to tell her practical, hot-tempered husband.

In those years, moreover, painters were to be seen at work in any church, sculptors and architects everywhere. Leonardo had only to choose among a wealth of opportunities for observing art in the making.

At the initiative of Cosimo new books on non-religious subjects were being illuminated, in the workshops of Attavante and of Gherardo in particular. The Medici Library was acquiring precious documents, in competition with that of the powerful, erudite King of Hungary Mattia Corvino.

Then suddenly, in the Summer of 1464, news of the death of Cosimo in his villa at Careggi swept like a cold wind over the city. The notables of Poggio began to conspire against those of Piano. With fear and apprehension the Florentines saw the return of the factions.

And in 1465 Albiera degli Amadori, Leonardo's «mamma» and companion, also died.

In the following year a conspiracy led by Luca Pitti, Agnolo Acciaiuoli, Niccolò Soderini and Diotisalvi Neroni plotted to overthrow Cosimo's son, Piero il Gottoso. Gathering their armed partisans on the outskirts of Florence they awaited the aid of an army that had left Ferrara commanded by Duke Ercole d'Este.

Informed at the last minute, Piero, although ill, had himself carried in a stretcher from the villa of Careggi to Florence. But his enemies, foreseeing this move, had laid an ambush for him. His seventeen-year-old son Lorenzo, riding before him with a little band of armed men, realized in time. Without turning back, to avoid arousing the suspicion of the assassins lurking by the wayside, he managed to send word to his father, who reached the palace in Via Larga by another road. And immediately, supported by the people, the Piano faction moved to counterattack. The heads of the conspiracy were first con-

demned to death, then generously pardoned and exiled. The Florentines breathed a sign of relief.

In that same year Ser Piero married a girl of sixteen, Francesca Lanfredini, and brought her home to act as mother to his fourteen-year-old son.

In the workshop

THE «*BOTTEGA*» OF a Renaissance master had nothing in common with an artist's studio of today.

The *bottega* was first of all a workshop whose owner was usually a painter, a sculptor, an engineer, a blacksmith or a carpenter. The name of the artist appeared above the shop as the sign of a commercial enterprise, mid-way between craftsmanship and industry. The boys who worked there lived with the Master, eating and sleeping under his roof, forming a group, or school, with a strict hierarchy.

Donatello, for example, «was a very generous man», according to Vasari, «and did more for his friends than for himself. He gave no importance to money, keeping it in a bag tied with a rope to the scaffolding, from which each of his workers and friends could take as much as he needed, without his saying anything».

Things were probably much the same in the workshop of Andrea di Cione, known as Verrocchio. His pupils shared the tasks, from sweeping the floor and running errands to more demanding work such as applying plaster and grinding dyes, or painting a detail in a picture, precisely tracing the lines of the cartoon drawn by the Master.

Verrocchio's shop had several rooms: a big hall with a very high ceiling, with a forge and a bellows standing against one wall, and an anvil for hammering out iron and bronze. On the other side of the room, under an open skylight in the ceiling, stood enormous trestles and scaffolding, used to sculpt statues larger than life-size. Other rooms held furnaces for casting, carpenter's benches, a storage deposit for plaster and wax, one corner for mosaic work and another for inlaying.

Andrea was a goldsmith, «perspective painter», sculptor, inlayer, painter and musician. In his youth he had also studied science, geometry in particular, which in those days included geology and astronomy.

Among the group of young men working with him were two highly talented assistants: Pietro Vannucci da Perugia, known as Perugino, and Sandro Filipepi, known as Botticelli. Other boys in the shop were already winning names for themselves – Lorenzo di Credi, Francesco Bottini and Francesco di Simone.

Ser Piero da Vinci, Notary of the Signoria, had met Verrocchio more than once, on the business of drawing up and signing apprenticeship contracts. He must have been on good terms with the artist if one day he entered his shop on personal business.

«Master, please help me resolve a difficult case of conscience».

«Willingly, Ser Piero. What is the problem?»

«My son Leonardo. Look at these drawings, they are his and tell me frankly what you think of them. If he has talent, well and good. If not he will be a notary like me, if I have to force him to it».

Verrocchio took the drawings from Ser Piero's and looked at them for many minutes, in silence.

«Who would ever have thought that that boy was hiding such a passion?», continued the notary. «He is full of interests, it's true, he is distracted by a thousand trifles. Now he is studying animals, now plants. He fills the house with insects, while he neglects his Latin, argues with the teachers. And yesterday, in his room, what did I find? A bundle of drawings. I took a few of them at random».

«Ser Piero, bring me your son», said Verrocchio, gravely and solemnly. «He will come here to live, with these other boys. Bring him when you will, even right now. I'll make something good of him».

Ser Piero wasted no time. If he had to give up the idea of making the boy a notary, he might as well make him a painter at once.

Returning home, he told his young wife to send Leonardo to him in his study.

A few minutes later the boy entered the room, greeted his father and stood waiting.

«Leonardo», Ser Piero confronted him at once, «which would you rather be, a notary or a painter?»

«A painter».

«Are you sure? Are you sure you have enough talent? I mean enough talent to be the first, not the last?»

Ser Piero stared at his son with the eye of an inquisitor. In his heart he had to admit that the boy was not only very handsome, but was distinguished by a singular attraction that emanated not only from his gaze but from his whole person.

«Yes», replied Leonardo.

«Then pack up your things. After dinner I will take you to Master Andrea Verrocchio. You will be apprenticed to him, and you will go to live in his home».

It was 1469. A few months earlier, in Vinci, old Ser Antonio had died. In the big house Grandmother Lucia now remained with Uncle Francesco and his young wife Alessandra. The last time he had seen his nephew, just before his wedding, the philosopher uncle had urged him not to make hasty decisions, but to listen to an inner voice.

«And then», he had concluded, «don't do as you want, but as you feel».

Master and disciple

VERROCCHIO'S PUPILS SHOULD not be imagined as any other than they really were: a band of lively, fun-loving boys, always ready to play a joke on someone, swift of hand and of tongue, united by a common interest, or rather a common love of art.

Each intensely engaged in the task assigned him, they knew when to keep quiet so as not to disturb each other. They frankly criticized and corrected one another, in a kind of *esprit de corps* expressed in the work of art they had produced as a

team, signed not with the name of Andrea Verrocchio but with that of his *bottega*.

«...The dome of Santa Maria del Fiore having been finished, it was decided, after much discussion, to make a copper ball, which was to be placed at the top of that building», reports Vasari. This important work «was assigned to Master Andrea».

Leonardo too participated in making the ball. As the last to arrive he was given all the beginner's work, from sweeping the floor to grinding dyes, but he completed his course of apprenticeship very quickly.

His closest friend was Lorenzo di Credi, still very young.

They drew together, going to Santa Croce to study Giotto's frescos and to the Carmine for those of Masaccio. They experimented with constructing instruments to lift heavy weights, in preparation for hoisting the ball to the top of the lantern on the dome. When Master Andrea made plaster masks of the faces of the dead they willingly assisted him. Verrocchio had discovered the properties of a special plaster which, mixed with warm water, became malleable as wax and then dried as hard as a rock. He had begun to use it to mold the faces of the dead, for the so-called death-masks that kept alive the memory of the deceased. His shop was thronged with clients asking for these death-masks, and making them was always an urgent task that could not be postponed.

Leonardo and Lorenzo assisted Verrocchio with enthusiasm, attentive to every gesture, ready to help at every sign.

«And on the 27th of May 1471, the gilded copper ball was hoisted up to the top of the lantern on the dome of Santa Maria del Fiore».

The news is reported by Luca Landucci, a shopkeeper in Canto dei Tornaquinci, eye-witness to the event. The time had come for Verrocchio to show his fellow citizens his skill as engineer, hoisting up to the top of Brunelleschi's dome a metal ball large enough to hold a number of persons, «resting it», as Vasari specifies, «on a button, and chaining it so that a cross could be secured above it».

Ropes and chains, wheels, levers, hinges, scaffolding and winches, as well as other original and complicated mechanisms,

were employed to lift the ball. Leonardo, fascinated by the spectacle, pulled a notebook out of his pocket to draw those machines, take note of certain gear mechanisms, make calculations and check the measurements.

The other boys watched in amazement as he used his left hand to write backwards, from right to left. Even Lorenzo di Credi was a little frightened at those mysterious signs, jotted down swiftly and surely. Leonardo, offering no reply to questions and comments, was secretly pleased at that «magic» effect which suddenly, like a wall, separated him from the others. Mirror writing became a secret language, intelligible only to initiates.

In similar manner his drawing, with the cross-hatching of shadow running from left to right, took on an unmistakable individuality, more distinctive than a signature.

One day Leonardo was intent on painting the head of an angel on an altarpiece commissioned of Verrocchio by the monks of Vallombrosa, depicting Saint John baptizing Jesus. It was lunch time and Lorenzo di Credi, lost in admiration, his elbows propped on the table and his face in his hands, was watching his friend instead of eating.

Beside Leonardo's angel was another already painted by Verrocchio, and the comparison sprang spontaneous to Lorenzo's lips.

«Do you realize, Leonardo, that your angel is more beautiful than that of the Maestro?»

Leonardo pretended not to hear him.

«I'm telling you so, and he would tell you so himself if he were here».

The other pupils, seated around a table cluttered with tools, were eating and chattering, jumping up to lean out of the window and joke with the housewives rinsing their laundry at a nearby fountain.

Leonardo was unable to leave the angel's head. He tried to refinish what was already finished, to add perfection to what was already perfect.

«Leonardo, I'm telling you; your angel is more beautiful than Andrea's!» cried Lorenzo.

Leonardo turned quickly. Verrocchio, his hands on his hips, was gazing from the door at his young pupil's work. He had arrived just in time to hear Lorenzo's fervent cry, and now he could see with his own eyes how true it was.

Verrocchio approached the altarpiece – according to the biographers – gave Leonardo an affectionate pat on the shoulder, then picked up the paint-brush he had used last and broke it in half, as if to say that he had broken with that art.

Is this too a legend, or merely an allusive fantasy?

His manner, that was so gracious

IN VERROCCHIO'S SHOP, while the Baptism of Christ was being painted, a sudden visit from Lorenzo de' Medici was a common occurrence. Since December of 1469, at the death of Piero il Gottoso he had become, at the age of twenty, the head of his family and ruler of the city. Like his grandfather Cosimo he too was open to everyone, and to artists in particular, whose workshops he loved to visit. Certainly his interest in that gilded ball, which promised to bring a new and striking message to the world of Florentine art, was strongly felt and sincere. And so it is most likely that the *bottega* of Andrea del Verrocchio was the site of a first encounter between the young Lorenzo and the young Leonardo.

«Leonardo... who is your father?», would had asked the son of Piero de' Medici, gazing at him with benevolent attention.

«Ser Piero da Vinci», would have answered Leonardo, sure of pronouncing a well-known name.

Just at this time Lorenzo, to confute the secret enemies and false friends who thought his days were counted because of his «immaturity», was preparing to welcome the Duke of Milan Galeazzo Maria Sforza and his wife Bona di Savoia.

Florence, under his reign, had been suddenly transformed. In a single night the church of Santa Maria del Fiore was given a façade, made of inlaid and painted panels. The streets were adorned with elaborately decorated triumphal arches. Every window was draped in brocade, every door adorned with festoons.

And when the Duke of Milan made his solemn entry into the city «with a cortege that aroused amazement and wonder even among the Florentines», Lorenzo had him follow a fairy-tale itinerary, up to the palace on Via Larga, enchanted for the occasion by the fantasy of Botticelli.

The sly, subtle politics of Cosimo were now being superseded by Lorenzo's decided methods. The merchant was succeeded by the prince; occult financial power by political determination; a republic by a Signoria.

«The Medici made me and unmade me», Leonardo was to remark bitterly as an old man.

It was Lorenzo in particular who «made him». He observed Leonardo's work, had commissions assigned him, chose him as consultant and as friend, and hired him to collaborate on the sculpture gardens of San Marco where he had begun to collect masterpieces of classical and contemporary art. Lorenzo spoke to Leonardo of music, philosophy, poetry and painting; perhaps he listened to the artist explaining mechanics and anatomy.

But even for the man who was to become the «Magnificent», Leonardo remained as enigmatic as his mirror handwriting, a kind of «vessel without a handle», a man who wished to conceal himself and knew how to do so, to protect his inner freedom.

Who were Leonardo's friends, apart from the circle of companions in the workshop? Who did he visit, and what did he do, in his spare time?

Listed one beside the other in the *Codice Atlantico*, are names that give some idea of Leonardo's friendships, his search for exceptional company whose interests were far removed from painting.

«Quadrant of Carlo Marmocchi – Messer Francesco Araldo – Ser Benedetto da Cieperello – Benedetto dell'Abbaco – Master Pagolo physician – Domenico di Michelino – Calvo degli Alberti – Messer Giovanni Argiropulo».

They were all important personages, notables of the times, including the humanist and teacher of Greek Giovanni Argiropulos, who stayed in Florence up to 1472.

«Quadrant»: so the subject was astronomy and Carlo Marmocchi, learned in that science, had perhaps shown his instru-

ment to his friends, among them Benedetto and Màster Pagolo. But Benedetto Aritmetico, or dell'Abbaco, is known still today as one of the greatest Florentine mathematicians of the fifteenth century, and Pagolo is no other than the wise old Paolo Dal Pozzo Toscanelli – astronomer, geographer, mathematician and physician – «friend of all the learned men of his age».

Francesco Filarete was the Herald of the Signoria, Ser Benedetto da Cepperello was an aristocratic, erudite notary, Domenico di Michelino was a painter, Calvo degli Alberti was a relative of Leon Battista, Argiropulos was the translator of Aristotle's *Physics* and, according to Filelfo, the most erudite of all of the Greeks who had come to Italy. Leonardo, not yet twenty, was certainly the youngest, but already these scientists were welcoming him to their scholarly discussions. He knew how to listen in silence, and «with his manner, that was so gracious, he brought calm to every troubled soul».

It is a thing divine

LORENZO DI CREDI was a good Catholic. A deep, sincere religious feeling dominated his thoughts and emanated from his every act. Sandro Botticelli, instead, opposed the Church in the name of a primitive, long-forgotten Christianity. Now that his Humanist friends had taught him about Justin and Origen, he believed in the triple nature of man – body, soul and spirit – and openly affirmed that hell, as a place of distance from God, was only temporary and that redemption was universal.

Pietro Perugino proclaimed himself an atheist. Deriding the faith of these two friends, he openly denied the concept of an immortal soul, and even declared that most of the clergy thought as he did.

In Leonardo's opinion, both the two believers and the atheist were ignorant men, since their words reflected an obscure feeling rather than a clear concept. It was necessary to know first of all, to investigate not just the Earth but the whole universe, because true knowledge is the daughter of experience. Study first then, and believe later.

Of course these arguments were not confined to the walls of the workshop, but continued outside as well, so that Botticelli was soon held to be a false prophet, Perugino one of the damned, and Leonardo a heretic.

«But if we doubt the certainty of everything perceived through our senses», insisted Leonardo, with the gentle Lorenzo di Credi in particular, «even more must we doubt of the things rebellious to our senses, such as the essence of God and of the soul». Before believing it was necessary to know; before questioning the spirit, to study bodies. And if the architecture of bodies seemed marvelous, «think that these are nothing compared to the soul, that in this architecture lives, and truly, whatever it may be, it is a thing divine».

To learn more about bodies Leonardo went to the morgue of the Santa Maria Nuova Hospital to dissent cadavers. He spent whole nights in the dim wavering light of a candle examining an organ, understanding its function, discovering its intimate beauty. Then he drew it in his notebook, strikingly realistic, to fix its precise image in his memory.

The mouth of truth

IN THE FIFTEENTH century it was a common practice to denounce a neighbor in an anonymous letter. Inspired by the example of Venice many other cities, including Florence, had even installed letterboxes for this purpose in the courtyards of the Palace of Reason or of the Signoria, with a slot in the outside wall.

The slot was called «hole» or «drum». When for aesthetic reasons it was masked by a laughing or sneering mouth in a face sculpted in high relief, it was known as the «mouth of truth».

Jealousy, resentment and revenge all ended up in that mouth, and on the other side the «officials» were busy sorting out the accusations to subject them to regular trial.

The «officials of night and of the monasteries» in Florence were interested only in accusations concerning morals. For all of the other misdeeds – crimes, theft, the practice of magic, usury – other mouths gaped avidly in the walls of the Bargello.

On April 9, 1476, Leonardo, along with four other defendants, appeared before these «officials of night» to hear the following accusation read out:

«I hereby inform Your Official Lords that it is a true thing that Jacopo Saltarelli, blood brother of Giovanni Saltarelli... pursues many miseries and keeps company with persons who share in such evil practices... I will hereby list some of them:

Bartolomeo di Pasquino, goldsmith, lives at Vaccereccia,

Leonardo di Ser Piero da Vinci, stays with Andrea del Verrocchio,

Bacino the doublet-maker, lives at Orto San Michele...

Leonardo Tornabuoni, known as Teri, dresses in black».

If newspapers had existed in those days a great scandal would have broken out in Florence. Apart from the goldsmith's apprentice and the doublet-maker, there was the son of the respectable notary and procurator of Santissima Annunziata. Even more important, there was the favorite grandson of the pious Lucrezia Tornabuoni, the widow of Piero il Gottoso and mother of Lorenzo de' Medici.

The news, however, never reached the streets and public squares. It spread secretly, whispered though corridors, in a frantic to-and-fro of messengers between Via Larga, the Bargello and the Signoria. Ser Piero suddenly had urgent business with his lawyer friends, and the magistrate of the «night officials» had problems to resolve. The accused were heard and then absolved *cum conditione ut retamburentur*, that is, subject to being re-examined. Two months later the sentence of not guilty become definitive.

«When I made God a cherub», Leonardo was to write many years later, mentally addressing his fellow citizens, «you put me in prison. Now, if I make him a grown man, you will do me even worse».

Although this heartfelt cry does not refer to the episode of Saltarelli – who was not a cherub, but a seventeen-year-old boy – it is still significant testimony to Leonardo's resentment at being misunderstood.

Perhaps he had witnessed, with irritated irony and eloquent silence, the contorted maneuvers carried out to soften, conceal

and suffocate the news of the anonymous denunciation. Perhaps he was declaring aloud, and under trial, that he had used Saltarelli and the other friends as models for his drawings. Perhaps he even showed the officials of the night his notebooks, the proofs of his innocence. Certainly, after having been declared not guilty, he felt no gladness, only desolation.

The need to get away from the city and from certain persons probably led him to Vinci, where Ser Piero had bought a farm some years before and where Uncle Francesco would always understand him without asking a lot of questions.

Probably he sought and found again the friend of his childhood, Nature; galloped for hours through the peaceful countryside; followed again with his eyes the flight of birds, with his ears the sound of water running over stones in a brook. He fervently resumed his study of landscapes, making each time a detailed analysis, breaking down reality into the tiniest particulars in the search for an absolute reason, for an ultimate answer.

«A painter must be solitary, and consider what he sees, and speak with himself...»

At the time of the anonymous denunciation Leonardo was almost twenty-four. By now he was a man. After his acquittal he returned no more to Verrocchio's workshop, leaving behind him the companionship of the other apprentices.

He rented a house – where we do not know – to find solitude and freedom. The study of nature he had declared essential for a good painter was now becoming more important than painting itself. Leonardo's curiosity about natural life became a need to observe the phenomena of nature. Science, no longer at the service of art, was becoming an end in itself, science for the sake of science.

Oh miserable mortals, open your eyes

«AND IF YOU are alone you belong only to yourself». Alone, in the bustling city where there was work for everyone since Lorenzo had exonerated from «every burden», that is, from all taxes, those who constructed new buildings, Leonardo fre-

quented first one group, then another. Among his friends were the Herald of the Signoria Francesco Filarete, Manuale Crisolora, Teodoro Gaza and John Tiptoft the Count of Worcester, who had come to Florence to attend the lessons of Argiropulo. From them Leonardo learned his first words of Greek, tasted the first fruits of the classics.

He was present at gatherings held by Lorenzo and Giuliano de' Medici, with Neri and Donato Acciaiuoli who transcribed and commented Argiropulo's lessons, with Alamanno Rinuccini who gave speeches in Greek, with Bartolommeo Sacchi, known as Plàtina, who had left the Gonzaga court to come to Florence and learn Greek, and with the Canon Marsilio Ficino, head of the Platonic Academy, who was now rediscovering the enlightening revelations of Plotinus's *Enneads*.

Leonardo also frequented a circle of erudite Jews who initiated him into the secrets of ancient mysteries, from the cabal to alchemy. Another of his interests was music, and he met often with Master Antonio Squarcialupi, the Cathedral organist, with Alexander Agricola – a German musician with a Florentine wife – with Gerolamo Amazzi, physician and musician, and with Bastiano Foresi, a famous maker of wind instruments.

At the same time Leonardo continued to visit hospital wards and morgues, to study anatomy; resumed his studies in geometry and mathematics; and conducted detailed research in mechanics and hydraulics.

Everything interested him and everything aroused his enthusiasm. No science nor any discipline was extraneous or indifferent to him – astronomy and geology, as well as mineralogy, zoology and botany. He was an argonaut sailing to conquer the golden fleece of knowledge, leaving the subtle abstractions of the Middle Ages forever behind him.

«Nature is filled with infinite reasons which never were in experience». This was to be his battlefield and his commitment as modern man: to discover those infinite reasons and to experience them.

At this time of his life Leonardo belonged to everyone and to no one; and was thus alone with himself. No longer a painter in search of images but a philosopher seeking in the marvelous,

mysterious architecture of the universe for the features of its great Maker. And when science, through the contemplation of reality, aroused in him a profound emotion, the cause of those «infinite reasons» was revealed to him a flash of inspiration, and he called it the «Prime Mover». Then he cried out to others to «experience it» within themselves, exclaiming: «Oh miserable mortals, open your eyes!»

The round shield

IN THE VINCI home there was another woman now: Margherita, the daughter of Francesco di Jacopo di Guglielmo, the third wife of Ser Piero after the early death of Francesca Lanfredini. Margherita was prolific. She had already brought into the world a *«putto»* baptized with the name of Antonio, after his grandfather, quickly followed by Giuliano in 1479, Lorenzo in 1484, Violante in 1485 and Domenico in 1486.

Leonardo visited his father's house frequently and often stayed for dinner, so that he could draw at his ease «the little children with actions ready and distorted when they sit, and timid and fearful in standing erect...»

There is a whole series of drawings of a child playing with a cat. Probably it is little Antonio, or Giuliano, one of Ser Piero's «legitimate» children, who many years later were to band together to protest the right of their famous brother, a «bastard», to his inheritance.

Ser Piero, in the meantime, continued to invest his earnings in the territory of Vinci, buying houses and land and returning to the village increasingly often to hunt or fish.

One day when Ser Piero was at his country villa, as Vasari writes, «he was sought out by one of his peasants, who had with his own hand made a round shield of a fig tree which he had cut down on his farm». The peasant, who was one of Ser Piero's hunting companions, asked his master to have that shield painted by some Florentine painter.

Ser Piero agreed to do so, and back in Florence he sent the object to his son, asking him to decorate it.

As soon as he picked up the shield Leonardo saw that it was irregular and distorted, «crooked and badly worked». He gave it to a woodworker who remodeled it, planing the faces and making it «smooth and even». Leonardo then applied plaster to the surface to be painted and began to think about what to paint on it – something sensational, impressive, attracting and terrifying like the head of the Medusa.

«He carried for this purpose to a room», continues Vasari, «where no one but he himself entered, lizards, crickets, serpents, butterflies, locusts, bats and other strange species. By adapting various parts of these he created a horrible, frightful animal with poisoned breath that set the air on fire. And he had it come out of [that is, he prepared and painted it so that it seemed to issue forth from] a dark, broken rock, spewing poison from its open mouth, fire from its eyes, and smoke from its nostrils so strangely that it seemed a monstrous and horrible thing».

Leonardo worked on the shield for months, so long that his father and even the peasant had forgotten all about it. Ser Piero was surprised when, meeting his son one day, he was told that the shield was ready and he could send for it whenever he wanted.

«I will come», replied Ser Piero, filled with curiosity.

The next day the notary knocked at his son's door. Leonardo asked his father to wait a moment in the entrance hall. He ran to his room, closed the window to dim the light, lit a lamp beside the shield; and then called to his father to come. Ser Piero entered the room, then on seeing that painted figure that seemed real, leaped backward in fright.

Leonardo laughed, exclaiming: «Father, this work has served the purpose for which it was made. You can take it and carry it away, for this was the intended effect».

Ser Piero felt he was dreaming. Never had he seen such an extraordinary thing, such an incredibly unusual masterpiece.

Lavishly praising his son and thanking him on behalf of the peasant, Ser Piero carried the shield away. But instead of sending it to Vinci he kept it himself. Then he bought from a merchant another shield bearing a heart transfixed by an arrow and

gave it to the peasant, who remained grateful to him for life. «Afterward», reports Vasari, «Ser Piero secretly sold the shield painted by Leonardo to some merchants in Florence, who paid one hundred ducats».

This emblematic episode provides a perfect description of the father and son, Ser Piero and Leonardo.

Ser Piero is the shrewd, practical man who knows how to take advantage of every occasion for gain and who secretly congratulates himself on his ability. He takes the shield from his son, praising him, estimates immediately what it is worth and realizes that it would only be wasted on the peasant in Vinci. And so he buys another one for a few coins, makes the peasant happy, sells the one his son has painted to merchants, and the operation is concluded to the satisfaction of all.

Leonardo is the ingenuous dreamer. His reward is the fright shown by his father on seeing the shield. While painting it he had imagined just this reaction from anyone seeing it for the first time. Ser Piero's terrified leap backward is enough to make up for all his laborious work. Leonardo had painted for the joy of creating, and no price is high enough to pay to the artist who loses himself in his work. For this reason he had said, take it, carry it away: «this was the purpose for which this work was made». Not financial reward, but the chance to transmit an emotion and a message, had been his aim. Ser Piero, with his leap backwards, had paid the right price, in Leonardo's opinion.

The tan cap

«LEONARDO WHAT ARE you doing?» Leonardo turned with a smile. Lorenzo di Credi, standing behind him, was staring at the notebook where his friend was drawing a picture of a hanged man.

Around the two painters was a crowd of curious onlookers, staring upward with their noses in the air. From a window of the law court palace hung a rope, at the end of which swayed the body of Bernardo Bandini de' Baroncelli, the assassin of Giuliano de' Medici.

«Cap of tan color,
doublet of <u>black</u> satin,
<u>black</u> lined gown,
<u>turquoise</u> jacket lined with <u>fox</u>
and the collar of the jacket lined with
<u>black and red</u> velvet,
Bernardo Bandini Baroncigli. <u>Black</u> stockings».

The drawing was not enough. Leonardo was also taking note of the hanged man's clothing, underlining the colors in his notebook. Lorenzo di Credi signed himself with the cross; but whether that sign was asking mercy for Bandini or for Leonardo he could not say. The friend who had painted the angel's head in Verrocchio's altarpiece with such loving care was now observing a cadaver with cold, inhuman detachment, and taking notes as if that hanged man were not a Christian like himself.

Realizing how disturbed his friend was, Leonardo placed a hand on his shoulder.

«Is this not also an act of men? The painter is an observer of nature. There is external nature, which is the world with its stones, plants and animals, and there is a more secret nature, that of man. A few days ago I saw an Annunciation where the angel, in his announcing, seemed about to drive the Madonna out of the room, with an insulting gesture, that of an enemy. And it seemed that the Madonna, desperately frightened, wanted to throw herself out of the window. No, Lorenzo», continued Leonardo, «in the same way that God made man in his own image the painter makes his figures, which always bear the imprint of their maker. That hanged man is Bandini, but this drawing is not Bandini alone, it is myself as well, and you too, all of us who are here to look. And it is also the Magnificent who has brought him back from Constantinople to vindicate his brother, betrayed and killed, and the hangman who executed him, everyone».

«I don't know how to explain it», continued Leonardo gazing intently into his friend's eyes, «it's difficult. The painter who paints by practice and judgement of the eye, without reasoning, is like a mirror, which imitates all things placed before it but has knowledge of none. But we instead, we search for knowledge,

because only from that can we have the certainty of things». The two friends, intent on their conversation, were walking toward Verrocchio's house. Although he no longer lived there Leonardo continued to visit the shop and even accepted commissions for some minor works.

In the shop they found a group of representatives of the Republic of Venice engaged in conversation with Master Andrea. They had just told him that Bartolommeo Colleoni, in dying, had left a hundred thousand *scudi* to the Republic for an equestrian monument to be erected to him. The messengers did not say that Colleoni wanted it in Piazza San Marco, since the diplomatic skill of the Venetians had already found a way to get around that obstacle. The monument was in fact to be erected in Campo Giovanni e Paolo, and the sculptor was to be a Florentine master, just as Donatello, in Padova, had sculpted the statue of the Gattamelata.

A monumental equestrian statue was the great dream and the highest ambition of every sculptor. Verrocchio's studio was intensely aroused by this news. Leonardo too, although now enrolled in the Compagnia di San Luca, the brotherhood of painters, wanted to participate in this great work of sculpture, putting his mathematical knowledge at the service of his friends to create new methods of hoisting and transporting. When, finally completed, the great model of the monument was sawed into pieces and shipped to Venice in enormous wooden crates, Leonardo found himself with a wealth of drawings that, taken as a whole, could have formed a treatise on the anatomy of the horse. Muzzles, withers, manes and tails; horses rearing, shying, falling, galloping, both free and saddled, with and without riders. Horses on a pedestal, like a grandiose monument, awaiting a client and a destination.

Subtle «difficulties»

HAVING ABANDONED VERROCCHIO'S shop and refused his father's hospitality Leonardo was faced with the problem of earning his daily bread. His perpetual refusal to be satisfied, which

made him seem unstable and inconstant, was harmful to his reputation, arousing suspicion and distrust. And since most of the work he did in those years has now been lost we can only listen to the testimony of those who saw it.

The question of Leonardo's works is a puzzling one. From the years of his youth only a few remain that are undoubtedly his, some of them unfinished such as the Adoration of the Kings and the St. Jerome. Those of his maturity are instead too many to be all his; and it is impossible to say where the hand of Leonardo ends and that of a pupil begins.

The first news of a commission refers to a «door-piece» to be made in Flanders, of interwoven gold and silk, for the King of Portugal. This is obviously a tapestry, and Leonardo's cartoon depicted «Adam and Eve, when in the earthly paradise they sinned».

The cartoon, which hung for years in the home of Ottaviano de' Medici, has disappeared. The «Medusa's Head» with its mass of serpents coiling above a dying face, which up to the nineteenth century was thought to be in the Uffizi, has also disappeared, after having been listed among the «excellent things» conserved in the apartments of the Grand Duke Cosimo I.

And where is the Madonna of the Carafe, in which «Leonardo painted a carafe filled with water, with flowers in it, reproducing the effect of the dewy condensation on its surface so well that it seemed more alive than life itself»?

Remaining from this period are the great Annunciation in the Uffizi, and the small Annunciation in the Louvre, which Leonardo may have been begun even before leaving Verrocchio's shop and which he kept at home, perhaps as a sample of his skill to show to potential clients.

We may add, although the date is uncertain, the Madonna del Fiore, or Benois Madonna, now in the Hermitage Museum at St. Petersburg, where the child is reminiscent of the *«putti»* drawn in the home of Ser Piero. Of completed works, nothing else remains. The St. Jerome in the desert and the Adoration of the Kings are both unfinished. Another painting, commissioned of the artist by Lorenzo the Magnificent for the chapel of Saint Bernard in Palazzo Vecchio, remained in the form of a sketch

and was later finished, or rather painted, by Filippino Lippi, who was also to paint an Adoration of the Kings for the monks of San Donato a Scopeto in replacement of the one begun and never finished by Leonardo.

But an artist who leaves a work half-finished, after having accepted a commission, not only loses the stipulated payment but also risks having to return any money accepted on account.

«...As I told you in the days past you know that I am without any of my friends...» This is the draft version of a letter addressed to Simone d'Antonio da Pistoia, husband of his aunt Violante, the daughter of his grandfather Antonio.

The artist did not turn to Uncle Francesco yet, knowing that he would be ready to go into debt for him despite his own poverty. Nor did he turn to Ser Piero, since his father had other «mouths to feed» at home, or perhaps because, while drawing one of those children, he may have overheard Margherita scolding her husband not to be so generous with his son, now an adult.

The monks of San Donato a Scopeto had set him a date: thirty months in which to consign, finished, the painting for the high altar depicting the Adoration of the Kings. Leonardo must have been in need of money if a month later, in August of 1481, he also agreed to paint an *oriuolo* – that is, a clock – for that monastery, his payment to consist of a load of heavy firewood for the winter.

But after seven months of studies, drawings, trials, sketches in perspective and calculations, Leonardo was to give up the idea of finishing that great painting.

Fifty-seven figures in motion, arranged along lines winding around the fulcrum of the Virgin, were to prove too much for the artist, who «was formulating in his mind some difficulties so exceptional that with his hands, although they were most excellent, he would never have been able to express them».

And yet, although it has not come down to us, some other painting from this period was contributing to spread the fame of Leonardo.

Florence is not an easy city, and to distinguish oneself among so many great artists Leonardo must have done some-

34

thing truly exceptional, better than anything that might come out of the shops of Verrocchio or Ghirlandaio.

Unfortunately, this can never be affirmed or denied with certainty. Leonardo, the only one who could have left some mention of it, is as usual silent, at least in his writings.

But there was Lorenzo de' Medici and there were Leonardo's scholarly friends in Via Larga, who could appreciate artists for what they were worth. And if all of them agreed in recognizing extraordinary qualities in the young Leonardo da Vinci, it means that they had seen the proof.

Zoroastro

LORENZO THE MAGNIFICENT had had two pavilions built in the garden of San Marco to hold not only *«anticaglie»*, works of classical art, but also drawings, cartoons, sketches and models of the finest works produced in those years by the shops of the Florentine Masters.

Bertoldo, Donatello's favorite pupil, presided over that extraordinary «academy» where each pupil received a «salary» sufficient to meet his own personal needs or those of his family.

Verrocchio, who sometimes visited the garden, was considered an occasional teacher, called upon in particular to explain to those exceptional pupils his methods of making plaster casts and of casting with several furnaces.

Lorenzo di Credi was among those who visited the garden, along with a group of promising young men such as Francesco Granacci, Ghirlandaio's pupil, Giuliano Bugiardini, Pietro Torrigiani and Giacomo della Porta. They were often joined by a young inlayer of semi-precious stones called Giovanni dalle Corniole and a worker in wrought iron named Nicolò Grosso.

Leonardo came and went, as whim or curiosity brought him to visit Bertoldo or Marsilio Ficino. He also visited the poet and Latinist Naldo Naldi, the philologist Niccolò Michelozzo and the scholarly Bartolommeo Fonzio, who has been the teacher of Lorenzo de' Medici.

He dropped into the workshops, where he always found some patient artisan ready to waste time on one of his extravagant projects, happy to share in his dream of a miraculous machine for dragging or hoisting enormous weights, or an ingenious device for drilling tunnels through mountains or a mechanical spindle for twisting cords to make thick, sturdy ropes. Leonardo even found time to give music lessons to a talented boy named Attavante Migliorotti, an illegitimate child like the painter himself. Often they played together, and so well that the news spread though the city, arriving at the ears of the Magnificent.

But in those years Leonardo's attention was chiefly focused, without doubt, on the workshop of Zoroastro, whose real name was Tommaso Masini da Peretola, master foundryman, mechanic, hydraulic engineer, engraver, pattern-maker and, in his spare time, sculptor, painter, inventor and sorcerer.

More than a workshop his reign seemed a magic cave, entered by descending a long flight of steps, where reality mingled with fantasy in a forge laden with symbolic meaning.

With Master Tommaso, Leonardo attempted to translate into concrete reality the multitude of intuitions that sprang to his mind each day.

Together they had already built lightweight bridges to be thrown from one river bank to another in the wink of an eye. They had designed and built a water-scooping machine, readapting Archimedes' famous screw to draw water from below and discharge it higher up. After many attempts they had managed to cast a special mortar that shot a burst of fire like a machine gun. They had built a semi-mobile fortress consisting of a cone placed on a large base resting on wheels, equipping it with a mortar and other tools of war.

Maso Masini, nicknamed Zoroastro, was the faithful interpreter and happy executor of Leonardo's drawings. For him all metals were docile, all shapes were easy. Together they had also designed a system of canals in miniature, applying the principal, discovered only much later, of communicating vessels. By artificially flooding an area they had managed to put it in communication with a network of water courses, con-

trolling the flow through metal ports like those used today in dams.

«Zoroastro» this man was called, because it was rumored of him that he had been in the Middle East, in the land of the legendary prophet Zoroaster, and had learned there the cult of the sun, or Ahura Mâzdao, as well as the art of transforming lead, the symbol of Saturn, into gold, the symbol of the sun.

In his melting pot not only iron but sulfur was often burning. Magic practices, the evoking of the occult forces of nature, were aspects of a research that, while not yet scientific, was not irrational. Leonardo and Tommaso, like two fearless pioneers, challenged the Inquisition which had it been able to discover them in the act, would have dragged them to trial as heretics.

Now even Ser Piero had become suspicious. That son of his that everyone praised so highly seemed to consider painting a secondary activity, like a trade to fall back on, preferring to dedicate himself to mysterious and perhaps prohibited practices, beyond any control.

«Father», Leonardo replied one day to the concerned parent who was questioning him, «don't worry about me. I want to be a painter different from all others, and for this I have to study what the others ignore or neglect. I must know the causes and not the effects, which are eternal, so that I can paint them».

Ser Piero could not understand, but had to accept, his son's explanation. Occasionally he sent him a little money, in secret now, so to give him enough to live on, while concentrating on promoting his own prospects with the Signoria, which was about to appoint a new Procurator.

Leonardo continued to frequent various circles, academies, schools, workshops and friends without neglecting either painting or music. With his young pupil Migliorotti he had begun to study the lyre, and had designed one of these instruments in the form of a horse's head, to get a new effect of extraordinary resonance from the chords. This news too, apparently of no importance, soon reached the ears of the Magnificent.

Lorenzo's messengers

SINCE THE TIME of that spectacular visit from Galeazzo Maria
there had been talk between Milan and Florence – or rather,
between the Sforza and the Medici families – of erecting an eques-
trian monument in memory of Duke Francesco, Galeazzo's father,
to be sculpted by a Florentine master.

Ludovico Sforza, in assuming the regency of the Govern-
ment of Milan, had found this project, dating from 1473, among
the papers of his brother Galeazzo, stabbed to death in church
by conspirators, and had written to Lorenzo de' Medici to ask
his advice.

In the meantime Verrocchio had left for Venice, with the
faithful Lorenzo di Credi, to cast the great equestrian statue of
Colleoni. Perugino and Botticelli had gone to Rome to fresco
Pope Sixtus' new chapel. Rossellino, Mino da Fiesole and
Bertoldo had grown old. The only artist available was Leonar-
do, and Lorenzo sent to call for him.

Now the artist stood before the Magnificent in the palace on
Via Larga and heard the question:

«What would you say, Leonardo, to a great statue on horse-
back of the late Duke of Milan Francesco Sforza?»

Leonardo suddenly saw again the feverish activity of Ver-
rocchio's shop, all of his studies on the anatomy of the horse, all
of those drawings put aside. Gazing straight into the eyes of the
Magnificent, he answered:

«I would say yes».

«Do you feel you can do it?»

«I feel I can do it».

«That you can finish it?»

«This I do not know. It remains to be seen».

«Take this», continued Lorenzo, «it is a portrait of Duke
Francesco. Think about it for now, and then we will speak
again».

Some time later Ludovico Sforza wrote Lorenzo asking
more advice. He needed a lyre player and would be grateful to
the Magnificent if he could send him a good musician from
Florence.

«Leonardo, at this point you should prepare to leave», Lorenzo told the artist. «The Duke of Milan is looking for a lyre player, and I know that you have an extraordinary silver lyre, which you will bring me so that I can give it to him. In sending you to Milan, I will render him a dual service. I will show him your talent as musician, and you will make the statue of the Duke his father on horseback».

This was one of the inimitably skillful maneuvers of Lorenzo. They were the expression of his political genius, and no one knew better than he how to choose the most suitable tools. Along with the products of art he exported artists too, sending them to the courts of Italy and all over Europe as the messengers of a culture that was called Humanism in Florence, and that was soon to be called the Renaissance the world over.

From the San Gallo Gate

IT WAS SPRING again in Florence, the spring of 1482. With the heavy firewood of the monks of San Donato a Scopeto, the thirty-year-old Leonardo had spent a warm winter. Now, with the return of good weather, he was preparing to leave.

Precise and methodical, he made a list of the paintings, sculptures and projects he would take with him. They could be used as documents of presentation in that unfamiliar city that had begun to attract the attention of the Florentines.

It was said that Duke Ludovico was looking for capable men everywhere, ready to pay their weight in gold: commanders and engineers for his wars, advisers for his political ambitions, artisans and scholars for his court.

Leonardo's list is a precise inventory, not of his entire production, but of the works still in his possession on the eve of his departure from Florence.

For example, «an Our Lady, finished», is a Madonna of which we know nothing. Among the «certain St. Jeromes» is the one now in the Vatican, which was found by chance, at different times and in different places, by a French cardinal named Fesh. Half of the panel was being used as the cover for a box

and the other half as a bench in a shoemaker's shop. A «story of the passion made of shapes» is without doubt a series, perhaps complete, of bass-reliefs depicting Christ's passion, commissioned by a church. A «gypsy's head» reminds us once again of Leonardo's insatiable curiosity. He had gone to see a caravan of gypsies, descendants of Attila belonging to tribes coming from distant Hungary, passing through Florence and had painted the portrait of one of their beautiful women.

The young Attavante Migliorotti, flute and lyre player, Leonardo's pupil, followed his master to exhibit his own work to Ludovico il Moro.

Master Tommaso Masini, the faithful Zoroastro, was a member of the group, certainly at the request of Leonardo who needed the precious hands of the wizard from Peretola.

Leaving the city behind them at the San Gallo Gate, riding up the road to Lastra, toward the ridge of Montorsoli, the group headed for the road that led over the Apennines.

At the first stop Leonardo dismounted from his horse to look back at Florence, where the waters of the Arno glittered in the sun and the city seemed clothed in a thin veil of bluish air. The copper ball on Brunelleschi's dome shot out gilded darts of light and the Palazzo della Signoria glowed in the ocre tones of its ancient stone.

From the tower of Fiesole, to the West, the pealing of a bell drifted on the wind. Solitary and majestic, a kite wheeled through the sky overhead, between the Castle of Vincigliata and the Rock of Montesenario.

Leonardo lingered over this vision, storing it deep within in himself, marking it in his blood. Then, remounting his horse, he turned his back on his city.

PART TWO

«Whoever he may be»

IN A ROOM in the castle of Porta Giovia, a secretary had begun reading a long letter to Ludovico il Moro:
«Having, my most illustrious Lord, seen and sufficiently considered the proofs of all those who call themselves masters of the tools of war, and seen that the inventions of said instruments are in no way different from those in common use, I will try to explain to Your Excellency, revealing to him my secrets and then offering them for any use he may wish to make of them in good time, how to make all those things that for the sake of brevity will be listed in part below...»

«What does he mean by this? That all of the tools of war are the same, and that the inventors have invented nothing new?»

«Probably so, Your Excellency», replied the secretary, and continued:

«1. I have ways to make bridges that are extremely lightweight and strong, easy to carry, and with them to follow, and sometimes to flee the enemy... And I have ways to burn and destroy the bridges of the enemy».

Ludovico listened, interested; nodded in agreement several times, then gestured to the secretary to continue.

«2. I know, in laying siege to a land, how to remove the water from ditches, and make infinite bridges, catways, ladders and other instruments pertinent to said expedition.

«3. Item, if for the height of the bank, it should be impossi-

ble in besieging a land to employ a mortar, I have ways to mine any rock or other fortress.

«4. Furthermore, I have modes of bombarding that are very easy to carry, and can be used to scatter gunshot; and with the smoke of it to throw the enemy into panic, to his great harm and confusion».

The secretary broke off reading, raising his eyes from the letter, but the Duke, leaning against the back of the chair, his chin in his hand, ordered him with an imperious gesture to continue.

«5. When at sea, I have many instruments most suitable for attacking and defending ships.

«6. Item, I have methods, by secret and distorted ways, and without making any noise, of coming to a certain designated place, even should it be necessary to pass under ditches or a river.

«7. Item, I will make carts that are covered, secure and inoffensive, which when they enter amidst the enemy's artillery, there is no multitude of armed men so great that it can resist. And behind these will follow numerous infantrymen, without any impediment...»

«Impossible!», exclaimed Ludovico. «This man is a visionary – or a sorcerer. Go on! Keep reading!»

«8. Item, as they are needed, I will make cannons, mortars and weapons of most beautiful and useful shapes, unlike any commonly used.

«9. Where the operation of the mortars might fail, I will make catapults, mangonels, trabuches and other instruments of admirable effectiveness, and out of the ordinary».

«But not even Vulcan, not even Mars would dare to say all this with such certainty! Who is this man? A new god of war?»

The Duke squirmed in his chair, then sat still to listen, gesturing to the secretary to go on reading.

«10. In peacetime I believe myself to be the equal of any one in architecture, in the construction of buildings, both public and private, and in bringing water from one place to another.

«Item, I can accomplish in sculpture, in marble, bronze or earth, as well as in painting, whatever anyone else can do, whoever he may be.

«Furthermore, the bronze horse could be sculpted, to the

immortal glory and eternal honor of the happy memory of the Lord your father and the magnificent house of Sforza».

«And if any of these things mentioned above», continued the secretary, raising his voice, «should appear to some impossible or unfeasible, I offer myself ready to experiment them in your park, or in any other place Your Excellency may desire, which I humbly recommend most urgently».

When the secretary had finished reading, Ludovico il Moro sat silent, reflecting on what he had heard, smiling at that «humbly», an insincere formula of conclusion to a letter that might be entirely true.

«And what exactly does he say», asked the Duke, «when he speaks of the things of art? That he can make architecture, sculpture and painting as well as our best masters?»

«As well as any other can», read the secretary again, «whoever he may be!»

Ludovico rose from the chair and started for the door, but before leaving turned back to his secretary:

«Call for this Leonardo», he said, «have him come here, I want to speak to him».

The annuity

LEONARDO HAD ALREADY been to see Ludovico, more than once. Soon after his arrival in Milan he had gone to bring him a gift from Lorenzo the Magnificent, along with a letter of recommendation. Then, almost certainly, he had returned to speak of the equestrian statue, perhaps showing the Duke some of the drawings made while he was working in Verrocchio's shop. Probably Leonardo and the young Attavante had also played for the Duke and his court on the famous silver lyre designed to amplify harmony «with greater resonance and more sonorous voice».

In the meanwhile Leonardo continued «to look around him» in a systematic exploration of the city and its surroundings. Milan with its pale skies, its abundant water courses, its tree-shaded plains suddenly hidden by thick veils of fog, must

have seemed to him a city that was the opposite of Florence, yet strangely attuned to his spirit, for the veil of magic that could descend on nature from one moment to the next.

He began to draw, to take notes; and finally entered fully into the life of the city, meeting its most prominent citizens and making a name for himself.

«But aren't you the Leonardo musician and sculptor sent me by Lorenzo de' Medici for that project of the horse? You promise many things... too many! How can I believe you?»

«Your Excellency, I'm not asking you to believe me, but to see for yourself».

«Cecilia, what do you think?»

Cecilia Gallerani had already heard much of Leonardo. She had heard of him from visiting Humanists and had seen some of his works, including the painted shield. Her sweet, intelligent face expressed the dreamy grace and gentility of the Lombard women, so different from their «practical» husbands, coarse and rude.

The girl's smile cut short, on Ludovico's lips, a curt reply. Gazing at Leonardo the Duke's sixteen-year-old mistress said:

«We will put him to the test, of course, but not for the machines of war. We wish of him something beautiful, like the fame that has preceded him».

Leonardo, back home again, opened his notebook to write:

«When you wish to see if your painting is like the thing depicted, take a mirror and let the living thing be reflected in it...».

In the castle of Porta Giovia, in a mirror hanging on the wall, he had observed Cecilia's reflection at length and had seen in it the ideal «portrait». Now he had only to await the chance to transpose it faithfully into painting.

The annuity of five hundred ducats a year assigned to Leonardo by Il Moro in return for his services was enough to let him face the future with confidence. With this amount, he could support the whole family, consisting of a groom and a housekeeper in addition to Zoroastro and Attavante.

Leonardo's letter – written and rewritten before arriving at the final version – had had its desired effect.

Leonardo was not even aware of the risk he had run. He had dared to speak on equal terms to a prince, he had listed his own qualities without a shadow of modesty, and he had declared himself second to none, in any field, challenging Ludovico to put him to the test.

It could only be the raving of a madman or the self-confidence of a genius; who, being such, could face his illustrious counterpart with bold assurance.

Content with the results of his letter, Leonardo went to see «the Predas», who had become good friends.

Evangelista De Predis and his brother Ambrogio were considered masters of Lombard painting, along with Foppa and Bergognone. They often worked together, sharing the tasks. Evangelista painted mainly walls and panels for altarpieces while his brother Ambrogio preferred portraits and miniatures.

As good Lombards, practical and hardworking, they never refused a commission, even when it was beyond their field of competence. To avoid losing a customer they commissioned work to others, subcontracting it to some needy painter, who then became one of the «company's» faithful collaborators.

The De Predis brothers had received an interesting proposal from the Brotherhood of the Holy Conception of the Virgin for the Church of San Francesco. They were to study the project for a great altarpiece with a central panel representing the Virgin and her Son with the infant John the Baptist between two side panels depicting prophets.

With humility and realistic good sense they decided to assign the most important panel to a master, Leonardo.

His financial problems resolved by the Duke's annuity, Leonardo had gone to his friends the De Predis to discuss that panel in greater detail. He had in mind a Virgin, not enthroned like those painted up to now by all artists from Cimabue on, but seated within a fantastic world of rocks where rays of light illuminated distant landscapes, her feet resting on a carpet of humble but glorious herbs and flowers, like that of his Annunciation.

The Virgin of the Rocks

THE RESULT SURPASSED all expectations. Nothing of the kind had ever been seen before in Milan.

Traditional Lombard painting, linked to the static, somewhat archaic style of Foppa, Bergognone and the De Predis, was abruptly swept backward in time. From having been the recent past it suddenly became, in comparison with the painting of Leonardo, the remote past.

Dressed in a flowing blue mantle the Virgin, at the center of the scene, rests her right hand, like a tender embrace, on the shoulder of the infant Saint John the Baptist who kneels, his hands joined, before the child Jesus seated on the ground. His right hand raised, the middle and index fingers pointing, Jesus gazes at John, while his Mother holds her left hand above his head in a propitiating gesture. An angel gazes out of the picture, providing an ideal link with the spectators.

The Virgin instead, with lowered eyelids, seems to encompass the two children in a single gaze. This emotional fusion is heightened still further by the positions of the woman and the two children, while all of the personages, including the angel, are contained within an ideal circumference.

In the background is an unreal, fantastic vision of rocks; above, an interwoven pattern of branches; far away, in the rocky landscape, flows a stream.

In the foreground is a carpet of herbs, like those covering the banks of rivers, sprinkled with flowers. The moment is solemn and serene, the Madonna both familiar and majestic. A sense of mysterious foreknowledge is expressed in the devotion of John the Baptist and in the gesture of the child Jesus, confirmed by the knowing look of the angel.

With this painting Leonardo, less than a year from his arrival in Milan, won the unconditional admiration not only of the court, but of everyone who saw it.

Following in the steps of Ambrogio De Predis, converted from «master» to student of Leonardo, all of the young painters – Bernardino Luini, Fra Antonio da Monza, Giampietrino, Giovanni Antonio Bazzi, Bernardino de' Conti, Giovanni da

Montorfano, Andrea Solari – were enthralled by Leonardo's words and his example. Abandoning the old models , «crude and very dry», they began to study and even to copy the works of the «Florentine Maestro», to nourish their new language with those «universal principles».

«My beloved Diva»

WHEN LEONARDO ARRIVED in Milan, Ludovico Sforza was engaged to a little girl of seven, a member of the d'Este family. While waiting for his future wife to grow up he had taken as mistress a sixteen-year-old girl, Cecilia, from the noble family of the Gallerani, who was not only beautiful but highly educated. She was in fact so erudite that years later Bandello referred to her in his «novelle» as the modern Sappho, revealing that the beautiful lady wrote excellent poetry not only in Italian but also in Latin.

She was a lady then, because Il Moro, after having loved her and had by her a son named Cesare, recognized and legitimized just as Ser Piero had done with the little Leonardo, married her off to Count Ludovico Bergamini, just as shrewd Ser Antonio had done with Caterina. It is true that Caterina, although of «good blood», was only a peasant woman from Vinci and not an aristocratic Lombard girl. And Count Bergamini, both the vassal and the friend of the Duke of Milan, was certainly not an Accattabriga. But the fruit of Ludovico's noble love was an insignificant courtier named Cesare, while that of Ser Piero's peasant ardour was an artist named Leonard.

Cecilia was beautiful and, moreover, sensitive, since culture is always an enrichment of the inner self. Leonardo was extremely handsome. He is described as tall, elegant, with long wavy blond hair, a well-trimmed beard, blue eyes, a piercing gaze, and a good conversationalist, his words accompanied by refined gestures. Ludovico il Moro was, on the contrary, vulgar, brutal and firmly convinced that money could buy everything and everyone – alliances, friendships and love.

A mediocre Tuscan poet, supported by Il Moro and even appointed official poet of the court, confirmed in bad verse the

news that Leonardo was painting Cecilia's portrait, simulating a dialogue between the poet and nature. The poet asks nature whom she is angry with, and nature answers that she is angry with Vinci who has painted the portrait of one of her stars, Cecilia. But the portrait is silent, while the real woman speaks.

The Marchesa of Mantua, who prided herself on discovering contemporary talent and collecting its works – on condition that they cost little or nothing – wrote in 1498 to Cecilia Gallerani, who had now become Countess Bergamini, sending a horseman from Mantua to Milan expressly to deliver the letter, asking Cecilia to lend her for the portrait painted by Leonardo so that she could compare it with one by Giovanni Bellini.

«Happening today to see certain beautiful portraits by Zoanne Bellino, we remembered the works of Leonardo with the desire to see them and compare them with these, and recalling that he painted you from nature, we beg you to send us your portrait by this horseman that we send purposely for this, because in addition to wishing to make the comparison we also wish to see your face. Immediately, as soon as we have made the comparison, we will send it back to you...»

Cecilia replied by sending the portrait and specifying that, if it did not resemble her, the fault was not that of the Maestro. «...and truly I believe that he has no equal to be found; it is only that this portrait was painted at such an imperfect age; and my appearance has entirely changed...».

The imperfect age was that, marvelous and timeless, of love.

Leonardo looked at the girl's delicate face, seeing it again as it had appeared to him the first time in a mirror, while his hand skillfully evoked the inner self of that image.

The hall of the castle, magnificent and festive, gave Leonardo a feeling of elated security.

Every day he arrived punctually, behaving as a perfect courtier. Elegantly dressed, the artist was accompanied by pupils, young, fashionable and handsome, who swarmed around him grinding and mixing the paints, diluting them in oil, handing him the brushes.

Surrounded by the ladies of the court Cecilia sat gazing at the painter. Perhaps there was an ermine in the room, escaping

from its cage occasionally to terrorize the girls. The unpredictable, inexhaustible Leonardo had a fable or a legend to tell for everyone, for Cecilia in particular.

«A little ermine was running over the snow, on the crest of a hill, and the hunters were after it. It ran fast to get back to its den further down the mountain. But the sun had melted the snow around the den, making it a swamp. The ermine stopped...»

Leonardo too stopped, interrupting his story to concentrate in that silence on a detail in the painting, creating a moment of collective suspense, then after a last touch of the brush, continued with a smile:

«No, the ermine could not dirty its white coat, it refused to wallow in the mud like a common fox. It remained there, standing on the last finger of snow; saw the hunters pursuing it, until an arrow pierced its heart...»

Cecilia, she alone, understood the hidden meaning of the story. Better to die than to foul oneself in the mud of every day. Purity of thought and of heart, like the ermine's white coat, is more sacred than life itself.

Now she too began to look into Leonardo's soul, to seek and find in him something of herself, just as the artist sought in her something of his own.

The girl of the «imperfect» age discovered and recognized herself not in the painting but in the words of the painter; while for him the sittings were gradually becoming transfusions of thought.

At times Cecilia felt like clay into which the voice of Leonardo was breathing form and life. She realized that she was being modeled by his words, was becoming one of his creations.

«Why do you not sculpt statues? Do you consider painting greater? You are also a sculptor».

«It's true», answered the artist with a smile, «and as I work no less in sculpture than in painting, I believe I can express a judgement as to which is greater... The difference is that the sculptor creates his works with greater bodily fatigue and the painter with greater mental fatigue...». Leonardo ironically

described to Cecilia the sculptor, sweaty and dirty, armed with a heavy chisel or a great hammer, while the painter «sits at his ease before his work, well dressed, and moves the light brush with its soft colors, accompanied by music, without the strident blow of hammers...»

Cecilia smiled incredulous. She had seen Leonardo's laboratory, knew of his forge, could imagine his face reflecting the dancing flames, had seen his sculpture and the first immense metal framework of the horse. She had seen his anatomical drawings, had understood his solitude, his distress at the sight of the cadavers overcome only by the desperate will to know. She knew the drama of that man alone, guessed what he did not tell, listened to what his words concealed, aware at last that she loved him.

While it is not sure that Cecilia was the author of the words written in one of Leonardo's notebooks and then diligently erased by him, the phrase beginning «My Lionardo», it is certain that Leonardo and Cecilia used the familiar form of address, at a time when the formal *voi* was used even between husband and wife, relatives and friends. And it is very certain that Leonardo wrote these words in the draft of a letter:

«Magnificent Lady Cecilia, my most beloved Diva. Having read your gentle letter...»

«Cruel and despotic monster»

B UT BEFORE PAINTING the portrait of Cecilia Gallerani, say the biographers, backed up by a letter from Ludovico il Moro to the King of Hungary, Leonardo painted a panel – a Madonna – for that Humanist Hungarian king «born to the benefit of the world» whose name was Mattia Corvino.

This monarch was not unknown to Leonardo. The artist had heard of him in Florence from his friends the miniaturists Gherardo and Attavante; and now, after Ludovico's commission of a Madonna, Ambrogio De Predis was asking him for more news every day, since he was making a miniature for that king.

«I am not very well informed on these matters», Leonardo

told Ambrogio. «I know that in faraway Pannonia there was a king named Sigismondo who bore on his head, it was said, five crowns, being king of five nations. But he was not a good general and was defeated by the Turks who almost entered his house. It was the father of this Mattia, the Condottiere Giovanni Hunyadi, who stopped the Moslems, and the people proclaimed his son king in thanks».

Ambrogio De Predis listened attentively, winking once in a while to show that he not only understood, but knew something else.

«King Mattia Corvino, son of that Giovanni, married the daughter of the King of Naples, Beatrice d'Aragon», continued Leonardo, «who filled the court with Humanists and scientists such as Antonio Bonfini, Brandolino Lippo, my friend Naldo Naldi, the physician Giovanni Marliani, and Alessandro Cortese, and who had a passion for books. There lived for many years in Florence a certain Giano Pannonio, a friend of the king and pupil of Guarino Veronese, who was always searching for codexes through the book dealer Vespasiano da Bisticci. He and Cosimo de' Medici were always competing to see who got there first, and it was said that the library of King Mattia already held 500 works, and that of Cosimo only 200, while the Pope and the Duke of Burgandy had, at the time, about 800 books each».

«And now I will tell you something extraordinary», whispered Ambrogio. «Il Moro has asked me to illuminate a parchment containing a nuptial ode for the marriage of Giovanni, son of King Mattia, and Princess Bianca Maria, daughter of Duke Galeazzo. This marriage is a state secret, because Il Moro's niece has been promised since the age of two to Duke Filiberto of Savoia. And this», proudly continued De Predis showing Leonardo a portrait of expressive force, «is King Mattia, whom I have depicted on the parchment».

«Then my Madonna will be in good hands», Leonardo smiled.

As was his habit, however, he continued to alternate painting and calculation, art and science. At that time he was studying a project for renovating the castle, proposing to raise a very

high tower with a dome on top which would have formed an ideal background for the equestrian statue of Francesco Sforza. He also drew up a detailed report on a system for artificially flooding the castle moat by digging a canal from the Redefossi waterway. And while he was painting the portrait of Cecilia Gallerani, he designed a series of reinforcements in brickwork to consolidate the circle of defense. Lastly, he planned the itinerary of a secret road, based on Vitruvius' principle of oblique entrances.

But now the plague had broken out in Milan. Between 1484 and 1485 the city lost over fifty thousand persons. Less well-known but no less deadly than the plague described by Manzoni, this one depopulated homes and spread like wildfire through the countryside.

Leonardo did not flee the city. He avoided any contact not strictly necessary, going out as little as possible, absorbing himself in reading and meditation. He had realized that science, unlike poetry, demanded rigorous precision of language, not an evocation of images. Feeling that he lacked such precision, he began a systematic study of the use of words, reviewing the Latin and grammar of Donato. He set himself to copy a «Latin-Vulgar» vocabulary by Giovanni Bernardo, studying nouns and pronouns, verbs and adverbs.

It was in this constrained but fertile idleness that the urge arose in him to write, following the example of Leon Battista Alberti, a scientific treatise of encyclopedic nature. Immediately he began to seek inspiration and information in the works of antiquity and of the Middle Ages in particular.

In his notebooks he began to write his thoughts more fully, no longer merely jotting down reminders. During that time of Biblical calamity his notebooks took on the tone of prophecy.

«There will come animals on the earth – that is, men – which will always fight among themselves to the very great harm and often death of each of the parties. There will be no end to their malice... and for their overweening pride they will want to fly up toward heaven...

«Nothing will remain on the earth, or under the earth and the water, that is not pursued, removed or damaged...

«Oh world, why do you not open up? And precipitate such a cruel despotic monster into the deep gullies of your great chasms and caves and not show him to heaven...».

But this «monster», right there in the hard-working city of Milan, was already showing heaven a shining forest of spires and pinnacles, working incessantly on the Fabric of the Duomo.

«Give me power»

«...AND WITHOUT ANY expense to you it will be accomplished that all of the lands obey their leaders».

With this invocation, apparently rhetorical but in reality desperate, Leonardo began another letter to the Duke of Milan, perhaps never delivered, in which his concept of urban planning is so far in advance of the times as to seem the fantasy of a disordered mind.

Even in our own twentieth century, an architecture capable of creating a «rational» city like that of Leonardo does not yet exist. The courageous initiatives of Wright, Le Corbusier, Niemeyer, Nervi, and Branschi mark the first timid steps toward a conception of that organic «new city» which Leonardo not only conceived but described and drew as a historical reality and a social necessity.

All that is needed now is a wealthy, courageous entrepreneur willing to build the city of the Twenty-First Century. He would find the project – described in every detail – concealed, actually camouflaged, among Leonardo's manuscripts.

The city will be built near a river, whose waters are kept clean and always at the same level. There will be streets as wide as the «universal» height of the houses, great public squares, green spaces in which to insert the vast buildings – churches, palaces and schools – within a network of water continuously circulating through canals and fountains, not just for cleanliness but also to provide a harmonic link between nature and the city.

Leonardo's organic city was made to resemble man, according to an anthropomorphic concept in which the areas of the

head, or thought, are separated but not detached from those of the body, or metabolism. The houses were to have two streets, an upper one covering them instead of roofs and a lower one. The whole city could be traversed through the upper tree-lined streets or through the lower ones. «In the upper streets no carts or other similar conveyances shall be allowed. They shall be reserved for gentlemen. In the lower streets shall go the carts and other wagons for the use and convenience of the people».

The people were referred to as either «populace» or «gentlemen». Leonardo's distinction is clear and unmistakable. It is not a question of rich and poor, but of a multitude that works honestly with its hands and an *élite* that works with the mind, to direct and organize manual work on a rational basis.

«One house must turn its back on the next, leaving the lower street between them, and from the doors will enter supplies, such as firewood, wine and similar things. To the subterranean streets will be relegated stables, stalls and such fetid things. From one arch to another there will be three hundred *bracci*, that is, each street receives light from the space between the streets above; and each arch shall be a rounded stairway...»

A city on two levels. How could it fail to be described as futuristic, when even today it seems a utopia? And yet it is neither absurd nor impossible, but the very city urgently needed by our polluted earth to survive, a city made to the measure of man, to be respected like a human being, with overhead streets for walking, ground-level streets for traffic and business and underground streets for waste disposal; tall, airy houses with vast inner courtyards, public squares and gardens, navigable canals from which even fish that muddy the water, such as the tench and the eel, are banished; majestic buildings, fountains and monuments.

The ecological solution to the problems, or the crimes, of our century is to be found in these striking intuitions, where the microcosmos of man is conceived according to the laws and harmony that govern the macrocosmos of the universe.

«Give me authority... and I will build you five thousand houses with thirty thousand dwellings, and so you will disperse that great congregation of people who live like goats, one atop

the other, spreading their stench everywhere... And the city will confer honor on your name, and on you profit from its taxes and eternal fame with its growth...».

But Ludovico, rather than giving him «authority», did not even give him his stipulated pay, and Leonardo disconsolately turned the pages of his notebook, where the city of man died before being born, returning to dreamland like a painting conceived but never painted.

The Duke is in a hurry

IT WAS ALMOST morning when Leonardo turned the key in his door. He was tired, but instead of going to bed he walked over to the table and opened his anatomical notebook. With pen in hand, gaze fixed in the void, he saw again the hospital ward and that old man as bleached and pale as if he had no blood left in his veins, alone on the threshold of death.

«...And this old man», wrote Leonardo, «a few hours before his death, told me he was over a hundred years old...» The artist had stayed at his bedside, encouraging him to talk. The old man told him he felt «nothing wrong with him, except weakness». At last «gently, with no other movement or any sign of accident, he passed out of this life».

Then in the same tone, without a hint of involuntary contrast, Leonardo continued to write:

«...And I practiced anatomy on him, to see what was the cause of such a gentle death...»

Even centuries later we can still imagine the affectionate, tender gaze of the artist suddenly transformed into the cold inexorable stare of the examiner. This is yet another confirmation of Leonardo's complex, contradictory personality. The need to know and to understand had driven him to plunge a knife into the still warm body of a poor old man whose eyes, only a few minutes before, he had piteously closed, to discover not the occult forces of illness but the cause «of such a gentle death»

Information, research: he questioned death and life, the mystery of birth and prenatal existence. He saw again in his imagi-

nation the long, interminable nights spent beside cadavers, that absurd, impossible dialogue with their dissected bodies, «...and if you are attracted to such a thing you will perhaps be prevented by the stomach, and if this does not prevent you, it will be the fear of spending the hours of the night in the company of such bodies, quartered and skinned and unpleasant to see...»

A few days earlier he had found an ingenious way of studying «the marvel of the eye, the window of the soul». He immersed an eyeball in the white of an egg and dropped it into boiling water. The albumin cooked and the eye could be sliced in thin sections like a hard-boiled egg.

Daylight surprised him still seated at his desk. He got up, looked out at a snowy landscape and saw a messenger approaching on horseback.

«The Duke will make the horse», he read in a familiar handwriting, «but he is in a hurry». No signature.

That same day Ludovico il Moro sent for him.

«Leonardo, I am not pleased with you. In seven years you haven't even managed to make the model of the equestrian statue to Duke Francesco. If you wait any longer I will ask the Magnificent Lorenzo to send me another sculptor».

«I very much regret», answered Leonardo, «that the problem of earning enough to live on has forced me to interrupt the work that Your Lordship commissioned of me. But if Your Lordship thought I was so rich he was mistaken, because I have had six mouths to feed for fifty-six months now, and I have had from Your Lordship only fifty ducats».

«Or is it that you don't know how to make this monument?»

Il Moro's brutality could be provocative at times.

«I have already said, and I am repeating now to Your Lordship, that in sculpture, as in the other arts, I fear comparison with no one».

«Then hurry up and give me the horse».

Il Moro did not tell the artist that he had already complained of this delay to Pietro Alamanni, the Florentine ambassador, and asked for another sculptor; but Alamanni, as was his duty, had immediately informed the Magnificent in Florence.

Wounded in his pride, Leonardo resumed work again «because the Duke is in a hurry». Again he took up the studies made in Florence for the Adoration of the Kings, in Verrocchio's shop in preparation for the equestrian monument to Colleoni, and in the first years of his stay in Milan.

Giuliano da Sangallo, who had recently come from Florence to build a palace for Ludovico, was near him in those frenetic days, giving him precious advice on the technique of casting.

Only a few months had passed and already the artist was asking the orator and poet Platino Plato to compose an epigraph to be engraved on the base of the monument.

It was to be an immense horse, rearing in the air, bearing on its back the glorious Duke Francesco, majestic and haughty.

But suddenly, when the clay model was almost finished, Leonardo changed his mind. A new version of the horse had flashed into his mind, a horse no longer rearing but prancing, its eager muscles trembling under the sure hand that held the reins.

Leonardo opened a new notebook and wrote on the first page: «On the day of April 23, 1490, I began this book, and began the horse again».

Paradise

WHO WAS LUDOVICO il Moro and what had he done up to now? After having been exiled to Pisa by his sister-in-law Bona di Savoia he had returned to Milan in 1479, to the incredulous stares of the people and the dismay of the true ruler of the duchy, Cicco Simonetta, who had been Duke Galeazzo's secretary.

«Your Excellency», said Simonetta to the duchess, «I will lose my head, and you the State».

And in fact, having made his peace with Bona, Il Moro did not wait long for revenge. «...In the Castle lunette, on the side of the park, on a black cloth, Cicco Simonetta was decapitated at the age of seventy and painfully ill of gout». In that same 1480 Ludovico threatened with death Bona di Savoia's lover, a young man from Ferrara called Antonio Tassino, making him

flee for his life from Milan. Then he had his nephew Gian Galeazzo, whose mother was acting as regent, kidnapped and imprisoned in the Castle dungeon.

But it was expressly in this kidnapping that the great political skill of Il Moro was to emerge. He convinced his nephew, now eleven years old, to refuse his mother's regency, forcing his sister-in-law to retire to the Castle of Abbiategrasso. The young duke now offered himself as ward to «the illustrious Signor Ludovico, my uncle», who accepted for the good of the family and of the State. Since the age of three Gian Galeazzo had been engaged to the infant daughter of the King of Naples Alfonso d'Aragon. The children had even exchanged naive letters. Little Isabella had given Giangi a pony, begging him to «accept it and ride it for love of her».

On the first of February 1487 the daughter of the King of Naples, now become a woman, entered Milan «with amazing splendour» as the legitimate consort of Duke Giovanni Galeazzo Sforza. The next day the new duchess and her husband, dressed in white according to the custom of the court, went to visit the altar of the Virgin Mary in the Duomo. They were escorted «at the stirrup» by the Milanese nobility, among whom Ludovico il Moro, the Duke of Calabria, was most striking «for his stature and majestic appearance».

After the wedding banquet a great allegorical spectacle written by Bellincioni and directed by Leonardo was held.

The performance took place in the castle of Milan. In the introduction to the poem «Paradise» Leonardo is mentioned for the first time as set designer and theatrical engineer.

«The following operetta composed by Messer Bernardo Belinzon at a festival or true representation called Paradise was given by Signor Ludovico in honor of the Duchess of Milan. It was called paradise but it was fabricated with the great skill and art of Maestro Leonardo Vinci Florentine, paradise with all seven planets that turned and the planets were represented by men in the form and dress described by the poets, and all of these planets spoke in praise of the aforesaid Duchess Isabella as you will see in reading it».

What happened in Leonardo's paradise?

Something similar to what Brunelleschi had done in Florence seventy years earlier for the Feast of the Annunziata, an event so memorable it was still being spoken of.

A hemisphere perforated with lighted holes representing the firmament was raised against the ceiling, to give the effect of the heavenly vault. A solid structure made of iron, with jointed arms, was rotated by special devices, bearing «a group of eight angels», children about ten years old standing on spoon-shaped or almond-shaped supports. On a larger support a youth in the costume of the Archangel Gabriel rose toward the sky and descended again.

«Leonardo's Paradise», wrote an eyewitness, «was made like half an egg, all opened to show the inside, with a great number of lights for stars, with certain grooves holding the seven planets, placed high or low according to their degree. Around the upper edge of this half sphere was written XIJ, with certain lights inside which made a gallant sight to see; and in this Paradise were many songs and most sweet and haunting sounds...»

It was a marvelous spectacle of automation, welcomed with fervent enthusiasm. The ambassadors, from Venice, Florence, Naples, Ferrara, Paris and the Papal Court all wrote back to their governments to describe it.

But meanwhile the young Gian Galeazzo, due to the excesses committed in these festive days, had to take to his bed without being able to consummate the marriage. Ten months after the wedding the bride, still a virgin, was threatening her indolent husband to leave him and return home.

Once again the regent stepped in. Backed up by a theologian Ludovico informed his nephew that he was risking the fires of hell if he continued to disdain a sacrament such as marriage. Then with the aid of the court treasurer he told him he would have to return to the King of Naples, along with his wife, the large dowry that had accompanied her.

In 1491, at last, Duchess Isabella gave birth a son. Her indolent husband, to save the honor of the duchy and to comply with his uncle's wishes, had finally done his duty.

A wedding under the sign of Mars

AND NOW IT was Ludovico's turn. The child born to the d'Este family had grown. She was now fifteen years old, and the political reasons for which this marriage had been arranged long ago were still valid.

The exuberant Ludovico had already provided for the future of his illegitimate children. Leone, born in 1476 to an unknown mother, was recognized by permission of the young Duke Gian Galeazzo; Bianca, born in 1482 of a brief interval of love for the aristocratic girl Bernardina de Corradis, was also legitimized through the Duke's intercession and immediately «married» at the age of eight to Galeazzo Sanseverino, a commander in the Sforza army. Lastly Cesare, whose date of birth is unknown, the fruit of Ludovico's long relationship with Cecilia Gallerani, as mentioned in sonnets by Bellincioni and del Fiesco, was legitimized by Gian Galeazzo in a special ceremony.

With his conscience at rest – at least as regards his complicated love life – Ludovico sent Beatrice d'Este a pearl necklace «bound with golden flowers and with pendants of rubies and emeralds», and a sculptor, Gian Cristoforo Romano, to sculpt a portrait bust of her.

While a deputation guided by the poet Gaspare Visconti set out for Ferrara to bring back the bride, Ludovico called together, from Treviglio, Novara, Lodi and Monza, the most famous artists in Lombardy and asked for the immediate return of «magistro Leonardo» from Pavia.

Last but not least, he urgently sent for Master Ambrogio da Rosate, the court astrologer, to question him on the stars and to choose «by astrological point» the day and the hour most propitious for his wedding.

Accompanied by her mother Eleonora d'Aragon, by an uncle who was a cardinal, by her elder sister Isabella, wife of Francesco Gonzaga and Marchesa of Mantua, and by a swarm of ladies and gentlemen, Beatrice embarked at Ferrara to sail down the Po River to Pavia where her future husband awaited her.

With Beatrice was her elder brother Alfonso, he too on his

honeymoon, traveling to rejoin the young Anna Sforza, the daughter of Bona di Savoia and the late Galeazzo, to whom he had been married thirteen years ago when she was still a baby.

The wedding date was finally set, January 17, 1491, because that day, «selected through great study» by Master Ambrogio, was under the direct influence of Mars and thus auspicious for a prince who must have a male heir.

In the chapel of the Ducal Palace at Pavia the bride, adorned with magnificent jewels and wearing a sumptuous white gown sprinkled with pearls, was accompanied to the altar by her mother, her brother, her sister and her uncle. Ludovico, Regent of the Duchy of Milan and himself Duke of Calabria, honored by the presence of his nephews Gian Galeazzo and Isabella Dukes of Milan, by his sister-in-low Bona di Savoia and by the ladies and gentlemen of his court, married his bride, placing a ring on her finger. The wedding was followed by a magnificent banquet.

The next morning at dawn a herald proclaimed that the marriage had been happily consummated.

Ludovico, after having verified that Leonardo was no longer at Pavia, left the same evening for Milan.

Salaì

THE CITIZENS OF Pavia were building their cathedral when the work was suddenly interrupted by a technical problem. A consultation was proposed, as if at the bedside of a sick man. The famous architect Francesco di Giorgio Martini had just arrived in Milan, at the request of Duke Gian Galeazzo, to resolve the old problem of the dome. And Pavia, having heard the news, had sent a deputation to ask him to express an opinion. But along with the judgement of the great architect they wanted to have that of an equally famous artist – Leonardo.

In early June 1490 Leonardo and Francesco di Giorgio had left for Pavia.

Leonardo was thirty-eight years old, Master Francesco almost thirty years his elder. Both were passionate students of

mathematics, logic and dialectics. Leonardo was more theoretical, Master Francesco more practical.

They were accompanied by a numerous entourage of assistants and servants. Leonardo brought with him for the first time, in addition to Zoroastro, his young pupils Marco d'Oggiono and Antonio Boltraffio.

They were lodged at the Hosteria del Moro at the expense of «Fabric of the Duomo». Francesco di Giorgio, who had to return soon to Milan, immediately began the checks, verifications and measurements necessary for continuing the work. Leonardo, free from problems of time or architectural technology, dedicated himself to the study of geometry, assisting his friend Francesco, but only as regards theoretical matters, by searching for information on perspective and mathematics in the well-stocked library of the castle of Pavia.

It was probably at this time that the artist met Salaì.

«Jacomo came to stay with me on St. Mary Magdalene's day in 1490; aged ten years.

Thief	«The second day I had two shirts cut out for
liar	him, a pair of stockings and a jacket, and
obstinate	when I put aside some money to pay for
glutton	these things, he stole that money from the
	purse, and it was never possible to make him
	confess, although I was certain of it».

Who this Jacomo was we do not know: a boy living in the streets, more savage than wild, a boy with a beautiful face to whom Leonardo – on St. Mary Magdalene's day, the 22nd of July – felt suddenly attracted as by an unknown force.

«In the Orient», pronounced Zoroastro, «they call *karma* that mysterious law which at times makes us meet a demon with the face of an angel, like this boy. You have a debt, Leonardo, a very old debt, that you contracted with him in some previous incarnation, and now has come the time to pay it».

Leonardo listened to the words of his friend the sorcerer and smiled without answering.

«You don't believe me? It doesn't matter», continued Zoroastro. «Destiny has no need of our approval».

«The next day I went to dine with Giacomo Andrea [an architect from Ferrara], and the said Jacomo ate enough for two and did mischief enough for four, breaking three cruets and spilling the wine, and after this he came to sup at my house».

Leonardo, after having had the boy washed, combed and dressed, studied him like a phenomenon of nature, trying to remain a detached spectator. But his thirty-eight years, his long solitude, the boy's wild nature and his beauty laid a trap for his feelings. Without wishing to, and perhaps without even realizing it, he felt as responsible for that creature as a father for a rebellious son.

«I raised you with milk like my own son», Leonardo was to write him years later. But now, while he was practically nursing the boy, Leonardo had to continue, almost monotonously, to note his thefts.

«Item on the day of September 7 he robbed a pin worth 12 *soldi* from Marco [probably Marco d'Oggiono], who was here with me, which was of silver, and he took it from his studio, and then after Marco had looked for it everywhere, he found it in the box of said Jacomo».

In December then, Leonardo had returned to Milan, along with a certain Agostino Vaprio, obeying Ludovico's order. Other painters, such as Bernardo di Gennaro and Bernardino de' Rossi – also staying in Pavia – had even been threatened with a fine of 25 florins if they failed to appear in time.

But Ludovico could not ask Leonardo to organize a spectacle like that of the Paradise, since it would have seemed an imitation. He commissioned him instead to choreograph the tournament that Galeazzo Sanseverino had been ordered to announce officially to the nobility of all Italy.

On January 22nd Duchess Isabella, the wife of Gian Galeazzo, left the Castle with an imposing retinue to go the Church of St. Eustorgio and await Beatrice.

Duke Gian Galeazzo and his uncle Ludovico il Moro went instead to meet the bride at Porta Ticinese. Then the procession, led by 100 trumpet players, crossed the city adorned for a festi-

val on their way to the church where the wedding was to be celebrated.

Awaiting the bride and groom at the Castle gate was Duchess Bona di Savoia with her daughters Bianca Maria and Anna. The next day the marriage of Alfonso d'Este and Anna Sforza was also privately consecrated in a solemn religious ceremony.

A memorable Tournament

IN ORGANIZING THE Tournament Leonardo exceeded himself, producing an even more magnificent spectacle than the Paradise. This time the actors had first names, last names and titles, as the cream of the Italian nobility entered the lists escorted by picturesque processions of squires and pages.

Leonard had established residence in the sumptuous home of Galeazzo Sanseverino, with an army of painters, technicians, mechanics, tailors and servants. From there, like a wizard, he moved the wires of a gigantic carousel.

Alfonso Gonzaga, preceded by twelve gilded lances, accompanied by nineteen knights dressed in green velvet and followed by fifteen infantrymen wearing silver breast-plates, led the parade. After him came Annibale Bentivoglio of Bologna, with a «moor's head» helmet and a procession of equerries dressed in green satin; then Gaspare Sanseverino, called Fracassa, with twelve footmen wearing moorish costume borne on a triumphal cart carrying a globe surmounted by a moor, drawn by three horses, two of them disguised as a unicorn and a deer.

But where Leonardo's fantasy exploded was in the procession of Galeazzo Sanseverino, the nominal husband of little Bianca, Ludovico's daughter. Galeazzo mounted a monstrous horse, covered all over with gilded fish-scales painted so that they changed color at each step. On his head he wore a helmet that looked like a ram's head in front while in the back it became a serpent. He was escorted by footmen costumed as savages and trumpet players riding wild horses.

At the end of the parade a knight dressed in moorish cos-

tume climbed onto a platform to read an ode in praise of Beatrice. Then the tournament began.

«This I believe can be stated without fear of contradiction, that in the tournament there were broken as many lances as have ever been broken in any tournament in Italy for a very great number of years. The size of the lances was not only beyond the usual, but such as not to be believed by anyone who had not seen them», wrote the Duke of Milan Gian Galeazzo to his orator at the papal court.

All were brave, courageous, and applauded, but the gold banner, the prize contended by the knights, was awarded Galeazzo Sanseverino, the commander of the Milanese army.

Ludovico il Moro then took the ambassadors and ladies to visit the treasure kept in the Maestra tower. The young Isabella, Marchesa of Mantua and sister of Beatrice, was, it seems, highly impressed. The Ambassador of Ferrara described in glowing terms this second spectacle made up of golden ducats spilling out in a cascade over precious carpets, which made «a most worthy and happy sight and which were estimated by many to be no less than six hundred fifty thousand ducats, and it was even rumored that they amounted to eight hundred thousand. Then there were long tables on which were spread out the jewels, chains and golden necklaces of these most illustrious Lords and Ladies, which was a beautiful and precious sight to be seen».

There were also sixty-six silver life-size statues of saints standing along the walls, four great crosses studded with gems and on the floor, in the corners of the rooms, mountains of silver coins so high that «a mountain goat could not have leaped over them». Above the door was carved a hundred-eyed Argus, and the words «Adulterinae abijte claves» – false keys, keep your distance.

A few days later, in the silence of his room, Leonardo wrote in his notebook:

«Item, on the day of January 26th, I being in the home of Messer Galeazzo da Sanseverino to organize the festival of his tournament, and certain footmen undressing to try on some costumes of savage men, Jacomo approached the purse of one

of them, which was on the bed with other garments, and took the money that he found inside – Lire 2, s. of L. 4».

No word, then of the great success, no mention of Beatrice who had asked to meet him on that occasion. He noted instead, in *lire* and in *soldi*, the amount of the theft, which he paid back immediately.

Leonardo continued to observe that «phenomenon of nature» with the cold detachment of a scientist.

«Item, Master Agostino da Pavia having given me in that home some Turkish leather to make a pair of boots, Jacomo, within a month, stole it from me and sold it to a shoemaker for 20 *soldi*, with which money, as he himself confessed to me, he bought candies and sweetmeats».

From his first stubborn refusal to admit the evidence the boy had now arrived at confessing his misdeeds, but not at giving them up.

«He was filled with grace and beauty», wrote Vasari, «having beautiful wavy hair with ringlets which delighted Leonardo, and he taught him many things about art».

But in the field of art the boy learned little, as Leonardo soon realized. He continued to teach him painting however, exerting infinite patience.

«Item, on the 2nd day of April, Gian Antonio [Boltraffio] having left a silver pin lying on a drawing, Jacomo stole it from him. Its value was 24 *soldi* = L. 1, s. of L. 4».

Perhaps it was at this time that Leonardo nicknamed that dangerous adopted son of his Salaì, in the memory of the character in Morgante.

Salaì, in fact, was the devil in Pulci's Morgante, and all the assistants and pupils who frequented the house, from the eldest Zoroastro to the youngest Marco d'Oggiono, compared him to this personage.

Seven years later, scrupulously noting the expenditure for a rich wardrobe for the boy, who had now become a vain, demanding adolescent, Leonardo added at the bottom of the list, with laconic bitterness: «Salaì steals money».

«Oh mathematicians, shed light»

L EONARDO'S WHOLE LIFE is based on «it seems» and «they say», and the sudden emergence of some new piece of information has frequently exploded a whole edifice of scholarly assumptions.

It is thus impossible to jump from one fact to another – from the portrait of Cecilia Gallerani to that of Beatrice d'Este, for example – without the doubt, or rather the certainty, that between these two episodes of which we have proof are many others of which we know nothing, but which form part of the connective tissue of this mysterious man's everyday life.

Milan, for Leonardo, represented the transition from youth to maturity; and while this period is fundamentally important for everyone, it was vitally so in his case.

With the studies and projects for the domes of the Milan cathedral and that of Pavia Leonardo revealed his genius as architect, with a scientific background consisting not only of the classical source of Vitruvius but also the modern one of Leon Battista Alberti and Francesco di Giorgio Martini. With the Virgin of the Rocks and the other Madonnas lost to posterity, and then with the portrait of Cecilia, he not only gave Lombard painting a new style but actually revolutionized it, to the immediate acclamation of the young. He could rightfully claim to head a school which for the vastness of the «human» interests it investigated could be called an «Academy», like that of Florence.

With the bas-reliefs and portrait busts sculpted in Florence, and even more with the immense horse in progress, he was confirmed again as the true heir of Verrocchio.

In his writings, those of a man who has educated himself, aware of the force of his own modes of expression, he found a language of his own and was content to describe himself, in arguing with the literary figures of his time, a «man without letters».

But this was not enough. In dissecting cadavers and proposing to write a treatise on anatomy, he anticipated Vesalius. In the experimental method applied to scientific research, consisting of «proofs» and «counterproofs», he was a forerunner of

Galileo. In hydraulic engineering he prepared the way for the great engineers of the next century, and in mechanics he was at least four centuries in advance of the discoveries of our own, so-called «technological» civilization.

But all this is stated in monosyllables, in hints, as in an incomprehensible language, one that could be translated only through a kind of splitting – the reflection of an image and a sign in a mirror – like an «ego» projected outside of itself in order to overcome and recognize itself again.

To hearsay and to history, no concession was granted.

Meanwhile Andrea del Verrocchio had died in Venice in 1488, and the faithful Lorenzo di Credi had brought his body back to Florence. In 1492 Lorenzo the Magnificent died at Careggi. All over Italy the talk was now of a reformer friar who, from the pulpit of the Florence cathedral, was denouncing the Curia in Rome. Pope Innocent VIII had died and an anti-Christ named Alessandro VI had been elected to the throne of Saint Peter. In Milan Ludovico il Moro was plotting a great attack on the territorial freedom of Italy, inviting the young, ambitious King of France Charles VIII to cross the Alps and conquer the Reign of Naples. In Milan a cold war was being fought between the two first ladies of the Duchy, Isabella d'Aragon and Beatrice d'Este.

Leonardo, extraneous to all this, was dedicating himself to the study of sorcery, with all of its phenomena of spiritism and metamorphosis. He participated in mediumistic sessions, searched for the reasons behind those powers, saw here too the presence of obscure, indistinct phenomena. Then abandoning the search through that land devoid of any real consistency, he returned to «solar» science and with a sense of liberation wrote: «Sorcery, a standard or flying banner, blowing in the wind, is the guiding spirit of the foolish multitude... affirming that men transform themselves into cats, wolves and other beasts, while instead those who state such things are the first to become beasts. Oh mathematicians», exclaimed Leonardo at the end, «shed light on this coarse error!»

These mathematicians, in the broad sense, were his real friends, which whom he met frequently to investigate the visi-

ble and invisible nature of things. They were called Luca Paci-
oli, Fazio Cardano, Pietro Monti, Giacomo Andrea da Ferrara,
and the two Marliani physicians.

Their fellowship, in the noisy, frivolous Milan of the time,
has something symbolic about it. Each of these friends con-
cealed his own scientific knowledge behind a mask of igno-
rance. They spoke of man and his future, of physics and alche-
my, of medicine and mathematics, of astrology and mechanics.
In the name of science and reason they banded together against
all forms of superstition.

Beatrice's court

«REJOICE, MILAN, THAT within your walls
 Of excellent men you have today the honor of Del Vinci,
Of his drawings and his colors
That both modern and ancient artists fear...»

These verses are by Bellincioni, who felt himself to be a kind
of assistant to Leonardo, entertaining with his improvisations
the beautiful young Duchess of Calabria, Il Moro's wife, while
the artist was painting her portrait.

Of «excellent men», many had come to Milan at the invita-
tion of Duke Ludovico, especially since new university chairs
had been established. Students from Italy and abroad flocked to
the lessons of the jurist Giasone del Maino, and to the Hebrew
and Greek lessons taught by Benedetto Ispano, Demetrio Cal-
condila and Giorgio Mèrula. A Franciscan monk from Borgo
San Sepolcro, Luca Pacioli, even managed to make mathematics
popular.

In contradiction to this liberality, but as a logical conse-
quence of the extravagant expenditure for the recent weddings,
Ludovico had cut costs to the bone in the Castle, rationing not
only foodstuffs but firewood and torches.

Only when a torch or candle had burned «to the green»,
that is down to the green-colored end, could a courtier receive
another one, consigning the burnt end of the old one to the
accountants.

Leonardo, accompanied by his selected court of pupils which now included the handsome Salaì, painted the lovely, willful Beatrice in profile.

Il Moro must have been present at the sittings often, if it is true that, as reported by a chronicler of the times, «the Duke hearing the most admirable reasoning of Leonardo, became enamored of his talent to an incredible degree».

Leonardo, like a true director, controlled himself above all. «The words which do not satisfy the ear of the listener will always provoke in him tedium or resentment; in sign of which you will see, many times, such listeners overcome with yawns. Thus you, who speak before men of whom you seek benevolence, when you see such signs of resentment, cut short your speech, or change the subject...»

Beatrice loved music and Leonardo, as we know, played the flute and the lyre. It is logical to suppose that the Duchess' salon was often transformed into an auditorium, if not actually into a theatre, during the sittings.

«Conspicuous in Leonardo», states Giovio, «were gifts of great skill, very friendly and generous manners accompanied by a most gracious aspect; and soon he was the rare and masterful inventor of all elegance and in particular of delightful theatrical spectacles, and possessing also music, played on the lyre in sweetest song, he become supremely dear to all the princes who knew him».

Through the castle halls, from mouth to mouth, ran the charades, riddles, fables, witticisms and prophecies of Maestro Leonardo.

«Who are those who flay their own mother, throwing her skin back over her?»

«Who is he who lies upon the mortal remains of the dead, as if he himself were dead?».

The allusion was to the peasants who plow the earth, and to a man who sleeps on a bed of feathers. The ladies and gentlemen of the court amused themselves by resolving Leonardo's riddles, repeating his anecdotes and fables, which soon spread beyond the castle walls through the whole city.

«Have you heard what Maestro Leonardo told His Excel-

lency yesterday? A simple story, but it made him think, and loosen his purse-strings a little».

«What did he say?»

«While Leonardo was painting the Duchess' portrait Il Moro asked him to tell some of his fabulous stories. Leonardo, without laying down his brush, told the one about the royal eagle.

«An eaglet stuck its head out of the nest and saw a great flock of birds flying around the rocks.

«"Who are they?", it asked its mother.

«"Have no fear, they are our friends. The royal eagle lives a solitary life, but she must have a court. If not, how could she be a queen? These birds of the many-colored feathers are her courtiers".

«The eaglet, satisfied by its mother's explanation, settled into a more comfortable position from which to admire the court. But suddenly it cried out:

«"Mamma, they have stolen my dinner!"

«"No", replied its mother, "they have not stolen it, I gave it to them. And remember now what I tell you. A royal eagle will never be so hungry that it cannot leave some of its prey to the birds around it. At this height, in fact, they would find nothing to nourish them and would have to descend below to keep from dying of hunger. He who wishes to keep a court must always be generous, and must nourish his faithful courtiers every day in exchange for their love and devotion"».

«And Il Moro?»

«He got up, went over to Leonardo, and gave him an affectionate pat on the shoulder...»

Leonardo lived not far from the castle. One evening, returning home, he found an unsigned note under the door. It was a farewell. The next day, at court, through the usual fast-spread rumors, he heard that the Duchess Beatrice had given her husband an ultimatum:

«Either she goes, or I go! There is no room for two wives in this house!»

Reasons of state, but not those alone, had triumphed. Cecilia was the past, Beatrice, still so young, the present. And the gen-

tle Cecilia Gallerani left the Castle as she had entered, on tiptoe, departing from the life of Il Moro to become the wife of Ludovico Bergamini, one of his friends.

The horse

THE MARRIAGE OF Bianca Maria to the son of Mattia Corvino was not to take place. Il Moro had decided that a marriage to Maximilian I, King of the Rumanians and Emperor of Austria would be more advantageous, not for her but for himself.

Leonardo had rashly accepted a commitment to exhibit a clay model of the equestrian monument at the wedding festivities. This time he could not leave the work half-done, since the personal prestige of Il Moro was at stake.

So here he was, still in search of models. His room was strewn with drawings and notes: heads, necks, manes, muscles, nerves and hocks. His students helped him as well as they could, that is little or nothing. Maso Masino, the faithful Zoroastro, prepared the bearing structures for the big model, while the artist gave the finishing touches to the small-scale one.

In late November 1493 the Emperor's ambassadors – among them the stern Bishop-Count of Bressanone – arrived in Milan to fetch the bride. The city was on holiday. The great Piazza del Castello was adorned with «admirable and beautiful buildings» and in the middle, marvelous and majestic, stood the equestrian monument to Duke Francesco Sforza. It was only the clay model but the skillful Zoroastro had given it a special patina that made it seem sculpted in gold, not bronze. In Latin and in the vulgar tongue the court poets, Lazzaroni, Tacconi, Curzio and Bellincioni, voiced the general acclaim.

Tacconi wrote:
«...See how in the court he has had made of metal
in memory of his Father a great colossus.
I firmly and without contradiction believe
that neither Greece nor Rome ever saw one larger.
And look how beautiful is that horse!
Leonardo da Vinci to make it alone has worked.

Sculptor, good painter, good geometer,
such rare genius from the heavens descends...»

A secret admirer of Brunelleschi and Donatello, and disciple of Andrea del Verrocchio, Leonardo had now exhibited the proof of his genius in the public square. Now he had created a new precedent in sculpture too, inconceivable up to that day: a horse 7.13 meters high from head to base, requiring for its casting – according to the complicated calculations of Luca Pacioli – 200,000 *libbre* of bronze, about 653 hundred-weights.

«He worked for Ludovico il Moro», wrote Giovio, «in clay a colossal horse that was to be cast in bronze, and above it was to figure Ludovico's father Francesco, a famous warrior, made of the same material».

Once again in the Castle square pageants, tournaments, parades and triumphant processions were organized to honor the guests from beyond the Alps. Ludovico's purse opened again and seemed to be replenished by magic. On November 30 the Archbishop of Milan Arcimboldi celebrated a marriage by proxy in the Duomo, and in early December the daughter of Galeazzo Sforza and Bona di Savoia started out on «the road that leads to her desired husband in Germany».

As far as Como she was accompanied by a magnificent entourage, including her mother, her brother Duke Gian Galeazzo – called «the little Duke» – and his wife Isabella d'Aragon. From Como the procession sailed in a fleet of boats along the canals to Bellagio, from where they traveled on muleback up the Valtellina and through the Alps.

Bartolommeo Calco, secretary to Il Moro and eye-witness, described the most interesting towns in the Lario: Pliniana, Bellagio, Fiumelatte; and by a strange coincidence we find these same names diligently transcribed in Leonardo's notebooks.

«At the head of the Voltolina is the mountain of Borme always covered with snow. Here ermine are born».

Then there is a note on Pliniana and another on Fiumelatte, called Fiumelaccio in dialect. Leonardo wrote the names as he heard them pronounced: Borme for Bormio and Voltolino for Valtellina, just as the Italian emigrants of the nineteenth century called Brooklyn «Broccolino».

Probably Leonardo was a member of the court of honor that accompanied Maximilian's young bride to Germany. Traveling with them was a caravan of mules bearing the bride's fabulous dowry of 400,000 gold florins.

It was the price of ambition and power. The Emperor, in fact, secretly conferred on Ludovico the title of Duke of Milan.

Two sumptuous courts now reigned in the same city, with two duchesses who began to cast ferocious glances at each other. But Isabella d'Aragon had a weak, sickly husband, and was forced by her rival to retire in defeat to the castle of Pavia.

Less than a year later Gian Galeazzo, suffering from fever, thought he could recover, or was led to think so, by eating a great number of pears washed down by a flask of wine. The next day he was dead.

Machiavelli and Guicciardini, giving voice to general opinion, spoke of poison. It is now believed instead that an intestinal infection proved fatal to an already weakened organism.

Ludovico hurried to Pavia, had the body of his nephew transported to the Duomo of Milan, watched over the sarcophagus, and ordered a solemn funeral.

Then, having convened the Secret Council in the Castle, he proposed that Gian Galeazzo's son, the little Francesco, be recognized as legitimate duke and heir.

The Secret Council, composed of men faithful to Ludovico, unanimously refused to ratify the proposal. Instead they named Il Moro Duke of Milan.

Ludovico tried to dissuade them, then, obedient to the general consensus, accepted.

Immediately afterward, dressed in gold brocade, he crossed the city at the head of a procession to receive the Ducal sword and scepter in the church of Sant'Ambrogio.

«Catelina»

«ON THE DAY of July 16. Catelina came on the day 16th of July 1493». It is a dry, detached note. But some, with good justification, have found a crack in the façade, the emotion betrayed by the repetition of the date. This is not due to distraction, as it might seem, but to its opposite. It is the sign of a total concentration which appears as confusion.

«Came»: the verb stands alone, with no complement. For his pupils and workers, instead, Leonardo always wrote «came to stay with me», «came with me», «came for 4 ducats a month».

In that lonely verb, much may be implied: «came» from the village of Vinci, from afar, to this city. And on the back of the same sheet is a list of family names, like a memory evoked by her presence:
Antonio
Bartolomeo
Lucia
Piero
Lionardo.

No, that Catelina to whom Leonardo, on January 29, 1494, gave 10 *soldi*, writing this fact in his notebook, is not a housekeeper, a servant who cooks and does the shopping. She is a presence wrapped in eloquent silence. A subsequent note, written a little later, was to dissolve the mystery that enshrouded her.

Leonardo must have been five or six years old when he first became aware, in the village of Vinci, of that woman secretly watching him.

Whenever he passed the house of Accattabriga in the company of Uncle Francesco or Albiera, that woman hurried to the door as if in response to a call.

«Who is she, Uncle Francesco?»

«It's Caterina», answered his uncle.

And Caterina she remained, even when Leonardo, in Florence, discovered that the wife of Accattabriga was his mother.

Now, suddenly, she had come to Milan. And a little later, without a word of comment, Leonardo noted:

Expenses for the *socteratura* (burial) of Catelina:

3 pounds of wax	s.	27
for the coffin	s.	8
banner on the coffin	s.	12
bearing and placing the cross	s.	4
for bearing the dead	s.	8
for 4 priests and 4 choirboys	s.	20
bell, book, sponge	s.	2
for the burying	s.	16
to the old man	s.	8
for the license and the officials	s.	1
	s.	106
medicine	s.	5
sugar and candles	s.	12
	s.	123

Here is the shield that hides his soul. This brief note, terrible in its purely economic list of items, is like a mask defending Leonardo's heart from any casual curiosity.

Perhaps she was already sick when she came to Milan , or she may have fallen ill suddenly, as seems to be indicated by the modest expenditure for medicine, at the bottom of the list.

But the brutal word «socteratura» (burial under the ground) is shocking. Not «funeral», not «passed away», the gentler words used for the death of family members. The word brings to mind a desolate funeral procession with the body – «the dead» – lying uncovered on the coffin, a black banner borne before it, four priests and four choirboys and the gravediggers with lighted torches, because such «transports» took place by evening, as is still the case in Tuscany today. Behind the coffin walks a man alone, his face an impenetrable mask – Leonardo.

Perhaps in listing the expenses there flashed through his mind Caterina's last moments, the candles burning through the last long night, the sugar to sweeten the last drop of water.

But after having buried «Catelina» Leonardo, in his secret soul, could finally find room for a mother who had always been absent before.

«If you are alone, you belong only to yourself»

«LEONARDO, HOW IS the horse progressing?»
«Your Excellency», answered Leonardo, caught unprepared by Il Moro's question, «I am perfecting a system of multiple crucibles to let the smelted metal flow into all of its parts».

«And then?»

Il Moro was brisk and sharp, a man with no time to waste.

«And then I have developed some alloys, one of bronze and copper and another of bronze mixed with arsenic, which promise excellent results».

«How much bronze do you need?»

«Two hundred thousand pounds».

«And how many cannons could be made from all that bronze?»

Leonardo, taken by surprise at this question, looked at Il Moro without answering.

«Leonardo, you had better take a look at the Monastery of Santa Maria delle Grazie where Bramante has already finished his work. Those Dominican fathers have a refectory to be decorated, and they want a Last Supper painted by you. Then, when we have dealt with the Venetians, we will provide the bronze for the horse and if your crucibles are ready you can cast it».

Leonardo found himself in the Castle courtyard without realizing how he got there. As long as it was others to urge him on and rebuke him for delays everything seemed normal. Now instead, after fourteen years of waiting, Il Moro was telling him to wait still longer, and he felt almost cheated. He had a vague premonition that the horse would never be finished, never be cast in bronze. It was as if he were suddenly been ousted from an invisible throne. The stills, the crucibles, the furnaces, all of his research on alloys, suddenly seemed useless. He realized he had wasted precious time, too many years, and had tried the patience of everyone.

Leonardo began to realize that he had no one to tell this to, had no true friend. He had only his desperate need to know, the obsessive procession of «whys» to be answered, the inexorable

79

need to walk into the night with a torch in his hand, to cast light on the shadows.

Even the pupils who lived under his roof were egoistic, attentive only to his hand as it painted, to his words that instructed them. Far away, at the boundary-line between man and beast, was that beautiful thief Salaì. Caterina was only a faint memory.

Suddenly he felt alone in the midst of a crowd. Perhaps the fault was his. He had dispersed himself in a thousand streams, had run after too many visions, had become fired with enthusiasm for too many things, and now he found himself living in a rarefied world where no one had followed him.

«And if all of my life were a mistake because I refused to content myself with painting alone?»

Leonardo had arrived home, opened the door, entered the laboratory. Under the window was his desk. He dropped down in a chair, opened one of his notebooks at random and read: «If you are alone, you will belong only to yourself...» Taking up a sheet of paper he began to draw a Christ, he too alone, in the midst of his Apostles, with his unutterable inner tragedy.

The Last Supper

ON THE WALL of the Refectory of Santa Maria delle Grazie the center of feeling, convergent and radiant, had now become a reality.

Under the impetus of his first inspiration Leonardo had begun the great painting – nine meters long and four meters high – by roughing out, within a strict geometrical scheme, the figures of the personages.

Contrary to all of his predecessors – from Giotto to Lorenzetti, from Andrea del Castagno to Ghirlandaio – who had represented the «communion» in the melancholy tenderness of the supper, Leonardo chose the dramatic moment of an announcement that was to destroy forever the unity of the Apostles. «One of you will betray me». Leonardo was to fix in those expressions their stupor, wonder, incredulity, indignation

and horror. The whole scene hinges around Jesus. It is broken down into four groups, each of which reveals a precise sentiment in the expression of the faces, the gestures of the hands, the motion of the persons and even the position of the feet protruding from beneath the table.

«That figure is most praiseworthy», had written the artist, «which through its action best expresses the passion of its soul».

And Christ, in the midst of that vortex of passions, calm and sad after the fatal announcement, is no longer merely a man but also a divine being, wrapped in unbreakable solitude. Leonardo painted and drew; arranged and rearranged his groups in a series of studies, filled the pages of his notebook jotting down sudden ideas even in the street.

«One who was drinking has left his glass where it is and turned his head toward the speaker.

«Another twists the fingers of his hands together and turns with a frown to his companion. Another, his hands spread open, shows his palms [to his companion] and gapes his mouth in astonishment.

«Another whispers into his neighbor's ear, and the listener turns toward him and lends him his ear, holding a knife in one hand and in the other a loaf of bread, cut half through by the knife...»

Already in 1497, as can be read in a letter from Ludovico il Moro, the work had reached a good state of progress: «...item, to urge Leonardo Fiorentino to finish the work in the Refectory of the Grazie...»

But Leonardo, after the first burst of creativity, had halted, became distracted, wanted to experiment with new painting techniques. He prepared a mixture of three different kinds of plaster to be superimposed which would allow him – or so he thought – to paint in oil in the manner he called «sfumato», with that richness of detail and the continuous re-elaboration so necessary to him.

The classic technique of frescoing, where the colors had to be applied to the fresh plaster swiftly and definitively, was not congenial to Leonardo. Michelangelo, a few years later, was to

fresco the entire ceiling of the Sistine Chapel with brush strokes as decisive as blows of the hammer. Leonardo was instead undecided, subjecting every line, every color – like every thought – to strict verification. He had to be able to correct without having to repaint; but a fresco can only be destroyed and begun again.

A novice in the Monastery of Santa Maria delle Grazie called Matteo Bandello was never to forget an image «from life» fixed in his memory – that of Leonardo painting the Last Supper:

«He often used », the novelist was to write much later, «and I have seen and remarked it several times, to go early in the morning up on the platform, because the Last Supper is quite high above the floor. He would stay there, I say, from sunrise to twilight, never laying down the brush but continuing to paint without eating or drinking. Then there would be two, three or four days when he would not touch the painting, and yet each day he would spend one or two hours examining it and criticizing the figures to himself».

«I have also seen him», Bandelli continued, «according to the whim and caprice that took him, leave the Corte Vecchia where he was working on that stupendous horse of clay at midday, when the sun is in Leo, and go straight to the Grazie, and climbing onto the scaffolding take a brush and give a few touches to one of those figures, and immediately leave and go elsewhere».

Leonardo, although he said nothing of this, had realized that the wall had been poorly prepared. The three layers, each of a different substance, reacted differently to air and heat. It was as if a cancer were secretly eating at the wall. With terror the artist discovered a network of tiny cracks still almost invisible but which time was to accentuate like wrinkles on a face. He tried to find a remedy by painting over the surface again, but he felt that this masterpiece of his was as fragile as the horse that still remained to be cast. So he suspended work again to search for a solution, a medicine that did not exist. It was in one of those moments of discouragement, perhaps, that Bandello, and many other friars as well, came upon the artist standing motionless before those figures.

«They say that the Prior of the Grazie», wrote Vasari, embroidering on an anecdote told by Giambattista Giraldi, «urged Leonardo with tiresome persistence to finish the work, it seeming strange to him to see Leonardo standing half a day at a time lost in thought. He would have preferred that the artist, like the workers hoeing in the garden, never lay down his brush.

«As if this were not enough the Prior complained to the Duke so much that he was obliged to send for Leonardo and question him skillfully about his work, showing with great civility that he was doing so because of the Prior's persistence. Leonardo, who know that the Duke was sharp and discerning, decided to speak openly to him, as he had never done with the Prior. He talked to him at length about art, explaining that the greatest geniuses, while apparently idle, are searching for inventions in their minds, and forming those perfect ideas which their hands will then express. And he added that he still had two heads to be painted: that of Christ, for which he was unwilling to seek a model on earth and unable to think that his imagination could conceive of the beauty and heavenly grace required of divinity incarnate. The head of Judas was also still missing, and this too was a weighty problem, as he could not imagine how to depict the face of he who, after having received so much good, could have had a soul so wicked that he had resolved to betray his Lord and the Creator of the world. He was still searching for a model for this face but if in the end he found nothing better, he would use that of the Prior, who was so demanding and indiscreet.

«At this the Duke laughed heartily, telling Leonardo he was quite right. And so the poor confused Prior went back to harrying his gardeners and left Leonardo in peace, so that he soon completed the head of Judas, who seemed the very image of betrayal and inhumanity».

This detailed description confirms the familiarity that had arisen between Ludovico il Moro and Leonardo. During this same period the artist decorated for the Duke the Saletta Negra and the Sala delle Asse in the Castle, as can be seen from a letter by Gualtiero di Bescapè addressed to Ludovico:

«...in the Saletta Negra no time is being lost and on Monday the great Sala delle Asse, that is, of the Tower, will be cleared out. Maestro Leonardo promises to finish by September...». At about the same time – perhaps upon his return from Genoa where he had gone with Leonardo to study the fortifications – the Duke finally responded to an old request of the artist, giving him a vineyard of 16 *pertiche* outside of Porta Vercellina, near today's San Vittore.

It was not a princely gift since a *pertica* is only 600 square meters, and the whole vineyard was less than a hectare.

But Leonardo was content. Now he too owned a piece of land, like his grandfather Antonio, and could write the news to old Ser Piero in Florence. At once he drew up a great plan and devised projects for transformation that were never to be carried out. Then he looked for a peasant to rent the land so that it would be cultivated. It was taken by Giovanni Caprotti da Oreno, the father of Salaì.

The fruits of ignorance

A SAINT AND A murderer were the models Leonardo was searching for in the streets of Milan. Up to a few years ago, certain confessors used to admonish boys to be good by narrating that Leonardo, having finally found the model for Judas – a man with a face as dark as his soul – asked him, one day, who he was. Pointing to the serenely luminous figure of Jesus, the man replied:

«I am he. I was the model for that face, before becoming what I am now».

Of course there is not a word of truth in this anecdote. Leonardo searched for his Judas in taverns, barracks and worksites, and he searched for his Jesus among young people of both sexes.

«Giovannina, a fantastic face, lives in Santa Caterina, at the Hospital», «Cristofano da Castiglione lives at the Pietà, has a good head», «Cristo-Giovan Conte, the one of Cardinal del Mortaro».

And finally, after discoveries and abandonment, illusion and disillusion, even Jesus and his treacherous disciple had a face and a soul. The work was almost finished, and it was gigantic, without precedent. It was a compendium of painting and perspective, a luminous, grandiose image of «divine proportions»; and the school of the world.

Leonardo was aware of this, and knew that only time, not man, was conspiring against that wall on which the North wind blew.

Now that he was applying the last touches, visitors abounded. After Ludovico il Moro and the gentlemen of his court even the diffident priests, who had still seen nothing but the despairing gestures of the Prior, descended to the Refectory to look.

One day, reports Bandello, Raimondo Térault, the titular Bishop of Gurk, passing through Milan on his way back to Germany, «wanted to go down to the Refectory to see this work everyone was talking about».

Leonardo courteously went to meet him and showed him and his gentlemen «what he had accomplished up to now of his Last Supper». But that «modern painting» brought to the visitor's mind, by reaction, the recollection of ancient paintings. Turning to his companions the Cardinal «lamented that time and events had destroyed the masterpieces of the primitive painters, and made it impossible to compare the art of today with that of the past». Then he brusquely demanded of Leonardo how much the Duke of Milan was paying him for his services. The artist replied that his usual recompense was five hundred ducats a year, without counting the bonuses and extra amounts that Il Moro generously gave him from time to time.

The cardinal, scandalized, got up and left without even turning to say good-bye.

«Do you see?», said Leonardo to his pupils. «This is the fruit of ignorance. I say ignorance of the good classic authors because, if he had read them, His Eminence the Cardinal would have known that in the time of Gerone of Syracuse painting was held in great account».

«And he told», continued Bandello, «a story about Apelles

and another about Lippo Lippi among the Turks, who abhorred ignorant men like that Gurcense».

A short time later the Prior of Santa Maria delle Grazie announced that the work was finished. Giovio, who saw it still intact, wrote that all Milan flocked to admire it. But already Lomazzo, fifty years later, was writing that the painting «is all ruined today, and nothing can be seen of it but bright blotches».

Master Luca

LUCA PACIOLI WAS a bit mad, like all mathematicians. Born in Borgo San Sepolcro about the middle of the fifteenth century – like Leonardo – he had studied in Venice and in Rome. With his first teaching position in Perugia he had won early fame for a treatise on algebra. He was called to teach at Zara, then returned to Rome after have elaborated the theory of the «regular and dependent polyhedrons». The first follower, or the first victim, of this theory was Melozzo da Forlì, who tried to apply it in decorating the capitals on the palace built for the young Cardinal Girolamo Riario.

In 1483 Pacioli became a Franciscan monk, not as a vocation but for practical reasons, and went to Naples to comment Euclid's theories. There he met the condottiere Gian Giacomo Trivulzio, with whom he studied the application of mathematics to the art of war. Returning to Rome he frequented the home of the physician Pier Leoni, who introduced him to the works of Cusano. Then in 1493 his *Summa de aritmetica, geometria, proportioni et proportionalità* was printed in Urbino. Leonardo, from Milan, immediately ordered a copy, along with a Bible and a Chronicle of Sant'Isodoro of Seville.

We can only imagine the meeting between the illustrious author and his illustrious reader when Ludovico il Moro called the Franciscan monk to Milan to teach mathematics.

Their friendship was sudden and intense. From a first coolly detached note: «Have the monk from Brera show you *De ponderibus*», the tone quickly became more confidential. «Learn the multitude of square roots from Master Luca».

Leonardo brought his friend to the Grazie to show him the unfinished Last Supper; took him to the Corte Vecchia to show him the horse; invited him to his home, to the laboratory crammed with papers and instruments, and showed him – the highest sign of admiration and friendship – his notes for the «Treatise on light and shadow», those for the volume on «Proportions and anatomy of the human body» and those, much more numerous, for the «Treatise on local motion and on percussion and weights and all forces, i.e., accidental weights».

The monk's admiration soon turned to boundless enthusiasm. The Last Supper, the Horse, the «inimitable works» on Anatomy, Perspective and Mechanics, convinced him that he had met the greatest genius of all times and places. And while Leonardo acknowledged Luca as his master, describing to him his problems of proportion and calculation, the monk in turn revealed to Leonardo his plan for a book to be called *De divina proportione*, containing not only the highest concepts of regular polyhedrons but also an analytical review of the liberal arts based on Leonardo's thought.

It was the artist's friend Luca who calculated the exact volume of the horse, the precise amount of bronze required to cast it, and the weight of the monument.

It was the mathematician's friend Leonardo who illustrated, with his «ineffable left hand», as Pacioli was to write, «to all the mathematical disciplines most congenial», the treatise *De divina proportione*, or «the regular and dependent Platonic and mathematical bodies, which in perspective drawing cannot be done better the world over».

The Gascon archers

BEFORE LEONARDO PAINTED her portrait, the beautiful and strong-willed Beatrice had already given an heir to her impatient husband, first called Ercole after his grandfather the Duke of Ferrara and then Massimiliano when the doddering Emperor of Austria had agreed to become his godfather.

Beatrice, like her husband, was superstitious, and never took

a step without first consulting Master Ambrogio da Rosate who, as we know, was particularly fond of the number 17. After having questioned the stars the sorcerer authorized Beatrice to leave for Venice at the time of 17 hours on the 17th of May 1494, with the aim of consolidating relations with that Republic in view of the impending invasion of Italy by Charles VIII.

«Believe me», said the disconsolate Ambrogio De Predis to Leonardo, gazing at the useless effigy of Mattia Corvino on the marriage ode, «the wife of the "little Duke" has the pride of the Neapolitans and the wife of Il Moro is shrewd and scheming like everyone from the Po valley. One will complain with her grandfather Ferdinando, who is King of Naples, and the other will do the same with her father who is Duke of Ferrara – and it will end up badly for everyone concerned».

Invited by Il Moro, in fact, Charles VIII had already crossed the Alps, allegedly to conquer the Reign of Naples but in reality to set foot in Italy where the internal disorder following the death of Lorenzo the Magnificent now offered unexpected chances.

On January 2, 1497, after a period of mourning for the untimely death of Bianca, the daughter of Il Moro and wife of Sanseverino, a great festival was held in the castle of Pavia. Beatrice, who was expecting her third child, suddenly fell ill.

«It's only a slight disturbance», Il Moro reassured the guests, «let the dancing continue».

Three hours later the twenty-two-year-old Beatrice gave birth to a stillborn child. An hour later she herself was dead of a fatal hemorrhage.

The body was brought back to Milan and buried at a solemn but magnificent funeral ceremony.

Il Moro, grief-stricken, was the shadow of his former self. Desperation gave way to melancholy; tears to silence. For days he locked himself in his room refusing to see anyone, neither family members nor ambassadors. When he left his chamber it was only to go to Santa Maria delle Grazie to pray before the tomb of his young bride.

Il Moro had been a brutal husband – «from here there is no other news fit to be written, except that the Duke of Milan has

beaten his wife», in the words of an ambassador – but, in his own way, affectionate as well.

Although he openly betrayed Beatrice with a girl from the Crivelli family named Lucrezia, a friend of his late daughter Bianca, he said and thought that he loved her more than all the others, not only because she was the mother of his children, the six-year-old Massimiliano and the four-year-old Francesco, but also because with her he felt protected and defended.

When told that Beatrice, the day before her death, had knelt in prayer for hours on the recent tomb of Bianca, Il Moro burst into tears «with words that would have caused stones to break». A few months later Il Moro asked Leonardo for a portrait of Lucrezia Crivelli, to whom he had already given lands and towers on Lake Como and Lake Verbano, with the right to transfer them to the fruit of their clandestine love, the little Giovan Paolo Count of Caravaggio.

Soon afterward Charles VIII died in France, at Amboise.

Ludovico, thinking himself free at last from the threat of France and from remorse at having provoked it, resumed his usual hostile attitude toward the neighboring city of Venice.

Louis XII, successor to Charles VIII, appointed Trivulzio his viceroy in Italy. It was a bad sign. Filiberto di Savoia allied himself with Venice, Pope Alexander VI joined the League against the Sforza and the Marchese of Mantua abandoned Milan, and his brother-in-law, to return to the service of the Venetians.

Il Moro was surrounded.

Sanseverino, the great champion of tournaments, abandoned his post even before being attacked. Ludovico, feeling the Duchy crumble under his feet, donated his possessions to the Monastery of Santa Maria delle Grazie and entrusted his children to the care of his brother the Cardinal. Then while the cities all around were falling like castles made of cards, he fled over the Alps.

It was Autumn of 1499.

Leonardo, after having deposited 600 gold ducats in the bank of Giovan Battista Goro to be accredited to him at the Hospital of Santa Maria Nuova in Florence, left for Venice accompanied by Salaì, Zoroastro and Luca Pacioli.

When they departed from the city at dawn Trivulzio's troops had already sacked the Castle, and in the Corte Vecchia a group of Gascon archers were shooting at a target propped up against a great plaster horse.

PART THREE

From Mantua to Venice

THE FIRST STOP was Mantua. In that city lived a Marchesa who was intelligent, erudite, a lover of the arts and an admirer of Leonardo. It would have been absurd not to ask hospitality of her, at least until the French manhunt was over.

Leonardo, accompanied by Luca and the others, stopped at Mantua to request her hospitality.

Isabella Gonzaga had only recently, and very reluctantly, returned a splendid portrait by Leonardo to its legitimate owner, Countess Bergamini, the former Cecilia Gallerani, who had been the rival of her deceased sister.

Leonardo's arrival must have made her cry with joy if it is true, as they say, that this woman was always on the hunt for great artists and masterpieces. Princes and sovereigns entered her territory purposely so that the blond Marchesa could personally show them the collection that was her pride and joy and that included rare examples of ancient art along with many works by contemporary artists.

This time, however, the Marchesa greeted Leonardo with a forced smile. She granted him hospitably but openly showed her concern, saying that these were difficult times for her too. She invited him to the castle, but hinted that his presence could become dangerous.

Then of course she asked him to paint her portrait, at once,

ready to sit for it even by night; a beautiful portrait like that of Lady Cecilia, although her age was not as «imperfect».

Leonardo, as formal as a gentlemen of the court, agreed in part to the request. He drew not one, but two portraits in charcoal. He finished them in only a few days and took his departure, leaving one drawing to the Marchesa and taking the other with him, to paint her portrait from, so he said, perhaps already sure that he would never do so.

Isabella, fearing that the French in Milan could accuse her of giving refuge to exiles who were friends of Il Moro, let him leave; and repented doing so, but too late. Through that act she had revealed her true nature, cowardly as well as avid and petulant, since she had no real reason to fear. Her husband the Marchese had, in fact, betrayed Il Moro at the last moment to join the forces of Venice, an ally of the French.

But from that day on Leonardo was the victim of real persecution. The Marchesa gave him no peace, bombarding him – as will be seen – with letters and ambassadors, even having him constantly pursued by a monk, Pietro da Novellara, her ambassador to Florence, to get from him, if not her own portrait, at least a Madonna. And Leonardo, of course, continued to make vague promises.

In the end she left Mantua herself, on the excuse of a state visit. She begged him for a painting, any painting, even a tiny one; and Leonardo, always courteous, continued to make unfulfilled promises.

Now the group had arrived in Venice. Luca Pacioli knew the city well. He clearly recalled the hunger of those years when, to support himself as a student, he had become a tutor in the home of an aristocrat «under whose paternal and fraternal shadow», he told Leonardo, «into their own home they took me». The mathematician enthusiastically resumed his lessons in St. Bartolommeo and introduced Leonardo to his old friends and new pupils. We know in fact from the notebooks that the Milanese exiles were warmly welcomed in the city.

Leonardo made the acquaintance of the erudite Sienese Paolo Vannozzo, who attended Pacioli's lessons, of a certain Salamon – perhaps Alvise, a ship's captain –, of Pier Pagolo da Como, of

the Veronese Fra Giocondo, and of the Canon Stefano Ghisi of the Santissimi Apostoli parish. He made a sketch of a horseman among allegorical figures, with the caption «Messer Antonio Grimani Venetian companion of Anton Maria» (the famous Doge killed at Lepanto in 1499). Meanwhile, as was his custom, he had begun a systematic reconnaissance of the city and its lagoon and had gone to see and admire, high on its pedestal, the equestrian monument to Bartolommeo Colleoni, the last great statue of his master Andrea del Verrocchio.

His curiosity led him to study the phenomenon of the tides – «the flow at Venice is two *braccia*». Then, observing sea shells among the stones on the mainland, he realized that the beach advanced, pushing back the water – «as the River Po in brief time dries the Adriatic sea, in the same way that it dries a great part of Lombardy». With Luca Pacioli he concluded his investigation by affirming that where there was now land, in the past had been the sea, and where there was sea there had once been land.

«My illustrious lords, having seen how the Turks cannot enter Italy over land in any way without crossing the river Isonzio... I have considered that no fortress could be made at any other site that would be so universally valid as what could be made above the aforesaid river...»

This note probably refers to a commission assigned Leonardo by the Serenissima Republic to conduct a reconnaissance in the valley of the Isonzo after the Turks, arriving under the very walls of Vicenza, had demonstrated by the facts that the weak point in the Venetian defense lay to the north, in the Isonzo plain.

One thing was certain by now. Venice could not be defended from the sea alone, since the enemy could easily attack it by land.

Returning from his mission of exploration Leonardo spent most his time at the docks, observing «the ships and the motion of the waves», the ebb and flow of the sea, the flight of gulls, the sudden glint of a fish breaking the surface of the water.

He plunged into the world of nature, immersed himself in the force of the elements with all his senses on the alert, ready

to grasp a secret, to find answers to impossible questions. An idea, terrible and ingenious, suddenly struck his mind. In a flash he guessed the solution to all of the troubles that had distressed the Senate of the Republic since Ludovico il Moro had called the Turks to his aid.

His notes state: «Do not teach and you alone will be excellent», «Have the robe sewn at home», «Everything under water, that is, all the locks...»; and then in more technical notes, «...A panther's costume», «...A mask with solid glass eyes...»

In other words, Leonardo had discovered the possibility of remaining under water for an indeterminate time, using a «wetsuit» and skin diver's equipment. Anyone, furnished with a snorkel and a source of air, would be able to swim under water and attach «time bombs» to the keels of the Turkish ships, if they were anchored just outside the port.

Locked in his room, Leonardo analyzed his discovery. No instrument and no artifice, among the many that he had already designed and built, could compare with this. Heedless of hunger and the need for sleep he tested in a tank of water the seal of the mask with the goggles, the capacity of the leather bag to hold air, the functionality of the dispensing valve and the rational design of the underwater suit.

«I will become rich», he told himself. «This Republic is ready to pay any amount, since the Turks may arrive from one day to the next, and my invention will represent not merely defense, but salvation itself».

«I will have the money deposited with Manetto» (perhaps Alvise Manetti, a Florentine banker in Venice), Leonardo continued to dream, «and then I will have it sent to the Hospital of Santa Maria Nuova in Florence, and it will be enough for my whole life. I will even have some to give to those who have none, because this Government will pay me a certain percentage for each equipment and I will have them made myself to be sure of their efficiency. The Turks will experiment my invention at their own expense, and will never again dare to approach the lagoon...»

Leonardo's soliloquy lasted hours, all night long, till the break of day. But as the time passed, enthusiasm gave way to

doubt, content to dread. The artist considered all of the possible applications and consequences of his discovery. With certainty and dismay he realized that men would use it indiscriminately, not just for legitimate defense against the Turkish fleet but for the evil purposes of a new, more dangerous form of piracy.

As dawn was breaking he dismantled his discovery and put the pieces away in a box. He destroyed the wetsuit and the mask and tore up the drawings. Then, with the sun already brightly lighting up the room, he took out his notebook and wrote:

«How and why I do not describe my method of staying underwater... This I do not publish and divulge due to the evil nature of men, who would use it to murder at the bottom of the sea, breaking ships at the bottom and sinking them along with the men who are on them...»

The diving bell, forerunner of the skindiver's wetsuit, was to be reinvented only four centuries later.

The Duke lost the State...

P ASSING ONE DAY through a narrow, deserted street, Leonardo met an old friend, Lorenzo Gusnasco from Pavia, an engraver and maker of musical instruments at the Sforza court.

«Maestro Leonardo, have you heard the news from Milan?»

«No, what has happened?»

«Il Moro has returned. He was greeted with a great triumphal celebration».

«Really?»

«Yes. Betrayed by his Italian allies he returned to Milan with 16,000 Swiss and 1000 horsemen from Burgundy. First he occupied Vigevano, then – preceded by his brother Cardinal Ascanio – he entered Milan».

«And you, how do you know this?»

«I was there», replied Master Lorenzo. «With my own eyes I saw the people acclaiming the Duke. After three months of occupation by the French they were sick of it. Those soldiers

had only one thing in mind, to run after the women, and Trivulzio, to extort all the money he could. Every day a new tax was proclaimed».

Returning home Leonardo reported the news to his friends.

«It's bad news, very bad», said Luca Pacioli. «Francesco Sforza made his way by the sword. His son is making his way by money. And when he has run out of gold the Swiss will turn their backs on him».

A little later, in fact, the news reached Venice that a certain Tuzmann di Uri, commander of the Swiss mercenaries, had abandoned Il Moro and sold himself to Louis XII. Il Moro had begged the commander not to leave him, promising him everything he owned. He obtained only the cynical permission to disguise himself as a Swiss soldier and hide among the infantry that was retreating beyond the borders of the Duchy. Ludovico's days were numbered. For a few coins the Swiss infantrymen pointed him out to the French «while, concealed among the squadron, he walked on foot, dressed and armed like one of them». He was captured, taken to Lyon and imprisoned in a fortress. When he tried to escape he was put in irons. His last words were written on the walls of his cell.

The King of France, Lord of the Duchy of Milan, had a «Te Deum» sung in all the churches of the reign. Pope Alessandro VI did the same, and Venice and Florence joined in the choir.

Leonardo participated in these tragic events with impotent emotion. He collected news here and there, from the discussions of his powerful Venetian friends and the stories told by those who had fled the Duchy.

«The chatelaine taken prisoner» was perhaps that of Vigevano or Pavia. «Visconti dragged down, and then the death of his son», is his friend Gaspare, the official poet of the court. «Gian della Rosa, his money taken from him» was the astrologer of the Sforza family, the one who loved the number 17.

Goods were sequestered, persons were persecuted. The vineyard beyond the Vercellina gate was confiscated.

«What will happen to Giacomo Andrea, to Ambrogio De Predis, to the Marlianis?»

Leonardo had painfully returned from the universal to the «particular», had descended to earth again with his heart and mind absorbed in the tragedy of Milan, which was in reality the tragedy of Italy.

«Il Moro has been captured while fleeing disguised as a Swiss», Luca Pacioli told him. «They are taking him to France, a prisoner».

Il Moro was the man rashly responsible for the invasion of Charles VIII, the one who had lured the Sultan to Italy, the ambiguous troublemaker of the League.

«The Duke lost the State and his property and his freedom...», Leonardo wrote in his notebook. And in the embittered memory of the horse, of the lantern for the Duomo, of the Naviglio canal system remained unfinished, Leonardo continued: «...and no work was completed for him».

From Venice to Florence

THERE WAS FLORENCE, down in the valley. Suddenly there appeared, like a new but familiar apparition, the bell towers and tall castles, the swollen Arno emerging among the thick trees of the Cascine woods. Leonard did not pause in contemplation, did not look to see whether the kites were still wheeling through the sky. His eighteen years of absence from the city had been left on the other side of the mountain. As he recognized again the light, the colors and the air of home, it seemed he had departed only the day before.

At the head of the group he rode down the way flanked by cypresses, beyond which hills bright with olive grooves descended in a gentle slope.

It was spring, like that day when, accompanied by Zoroastro and the young Attavante, he had taken the Apennine trail. Then he had felt himself a dreamer driven out of his city. Now he was returning as a man of success, preceded by his fame, aware of his genius and determined to show it.

«We've arrived, Salaì», Leonardo smiled, looking over his shoulder.

Salaì was now twenty years old; and very handsome. In a city like Florence he would not go unnoticed.

Leonardo was given a warm welcome by his fellow citizens. From the workshop of Ghirlandaio to that of Piero di Cosimo, from the Servi dell'Annunziata to the Cloister of Santa Maria Novella, the news that Leonardo was back spread like wildfire. The young Dominican Bartolommeo di San Marco asked to become his disciple. Giuliano da Sangallo – who was demolishing the houses in Via della Prestanza to build a palace for Piero Gondi – went to welcome him as he had in Milan. So did Filippino Lippi, who had repainted the panel for the monks of San Donato a Scopeto, and the old friends from the *bottega*, Lorenzo di Credi and Sandro Botticelli; and those passing through, like Perugino and Luca Signorelli.

Leonardo found again his friends the illuminators Attavante and Gherardo; met the young and the very young, from Francesco Granacci to Andrea Contucci dal Monte a San Savino, Jacopo del Pollaiuolo, Giuliano Bugiardini, Baccio d'Agnolo and Lorenzetto.

But all of these artists, to their surprise and disappointment, soon realized that Leonardo kept them at a distance, barricading himself behind his encyclopedic knowledge.

«This is not a painter, but a mathematician», the younger ones murmured resentfully. «So what is he looking for in Florence, what did he come back for anyway?»

Even then, at the height of the Renaissance, the ignorance of artists was proverbial. We can imagine the striking effect made by Leonardo, with his refined elegance and astonishing knowledge. His conversation left his listeners open-mouthed. No one could contradict him, not even the learned Humanists, when he proclaimed the blindness of a culture, like that of the times, that slavishly swore allegiance to the arbitrary statements of Greek philosophers or Medieval theologians.

On April 24th Leonardo went to the Hospital of Santa Maria Nuova to withdraw 50 of the 600 ducats he had deposited in Milan.

Already the problem of supporting himself without depleting his savings had become urgent. But as it turned out this

problem was quickly solved.

«The Servite Friars », writes Vasari, but it should not be forgotten that old Ser Piero was the procurator of the monastery, «had commissioned Filippino Lippi to paint a panel for the high altar of the Annunziata. Leonardo mentioned that he would have gladly undertaken such a work himself. Then Filippino, hearing this, like the gentle-hearted person that he was, withdrew, and the friars, to let Leonardo paint it, took him into the house, paying the expenses for him and all of his family».

Alessandro the Priest

A T FIESOLE, IN the house of the Canon Alessandro Amadori, the brother of Albiera, Leonardo soon heard the news of Florence and of his family.

One of the first Florentine entries in his notebook was a memorandum to himself: find out «whether the Priest Alessandro Amadori is alive or not».

He was alive, living in Fiesole, and Leonardo soon went to see him.

«Florence has not changed», the Canon told him, «and it never will. When you left we were at war. You come back almost twenty years later to find us at war again. The Florentines drove out the Medici because they wanted their liberty. Now that they have liberty they want the Medici back again. They call themselves Palleschi and Piagnoni, Bigi and Arrabbiati, but the persons involved are always the same: Bigi when they are afraid, Arrabbiati when they set the piazza on fire and hold the power in their hands».

Leonardo listened with a smile. History was always the same everywhere, and Milan was no better than Florence. The «popolaglia», the populace that had joyfully welcomed the French was the same which had then reopened the door to Ludovico il Moro.

Priest Alessandro related the vicissitudes of the city following the death of the Magnificent. His son Piero had immediately shown himself incompetent and Savonarola, with his preach-

ing, had split the citizens into two great factions.

«He was a holy man, believe me, but his great mistake was that he failed to understand Florence. The accusations made at the trial were all false, but the Pope wanted him dead and so he had to be killed. His real fault was another. He wanted to stop the course of history, to take us all back to the Middle Ages. But at the trial, I must admit, he behaved magnificently. He died like a martyr, forgiving everyone and asking pardon of them, even those who crowded into Piazza della Signoria to watch the spectacle of his death, and who were the very same persons who had thronged the Duomo to hear him preach.

«And even today, you know, the city is still governed by a General Council and a Minor Council of the "Eighty", instituted by Savonarola. It was he who had the Great Hall reconstructed for the Council and who did not fear to confront Charles VIII when he came to Florence. And when the Medici left it was he who stopped the Florentine mobs crying for vengeance.

«You should have heard him preach. He was not a good orator, and he spoke with a foreign accent. But over fifteen thousand people thronged to hear him every day, early in the morning, before going to work».

«Collective delirium», remarked Leonardo.

«Perhaps, but the things he said had a striking effect on people's souls. Everyone repented of his sins and ardently resolved to be better».

«So much better than then they watched him die without moving a finger».

«This too is true», sighed the Priest Alessandro. Then, changing the subject, he asked Leonardo for news of his father.

«I have seen him, he is well. With all those mouths to feed he has his problems. But he told me that Uncle Francesco, as he ages, is subject to fixations, like that of wanting to fly, and spends all his time watching the birds».

Leonardo had not yet gone to Vinci. On his return to Florence he had immediately sought out Ser Piero, to whom he had continued to write regularly, although at long intervals. Margherita had died and his father had married again for the

fourth time a certain Lucrezia Cortigiani, 35 years younger, who had produced, with coarse regularity, another five children: Margherita in 1491, Benedetto in 1492, Pandolfo in 1494, Guglielmo in 1496 and Bartolommeo in 1497. In 1504 the twelfth and last son of Ser Piero, Giovanni, was born.

The first question Leonardo's father asked was a financial one:

«And now, what are you planning to do?»

«I don't know, I will try to get some commission for a painting».

«Have you got anything in mind?»

«Nothing precise. I would like to paint a panel that the Servi dell'Annunziata have commissioned of Filippino Lippi. He still hasn't decided what to paint, and he might give the job to me».

«I understand. I will speak with the Prior».

Always practical, always the same, was the Notary Ser Piero. And all those children running around the house, especially those of Lucrezia, had given him a boldly youthful air. By now he had become an authority in Florence, as Procurator of the Signoria since 1484 and Notary to the most prominent Florentine families.

«Your father», remarked the Priest Alessandro, «is strong as an oak. Four wives, eleven children including yourself, and there may be more coming».

Leonardo smiled, thinking of that father so different from himself and so content with everything – his profession, his houses and lands at Vinci, his clients, his fortune amassed by high-handed methods. Leonardo, instead, was still in search of a basic answer. He was like a pilgrim of his own self who had returned, now adult, to search for himself in the city where he had grown up and been formed.

But could Florence, with the sly skeptical curiosity of its artists, the suspicious nature of its merchants and the indifference of its magistrates, offer him anything new?

And now as then, one faction struggled against another. The followers of Monte and Piano had been superseded by those nostalgic for Savonarola and the Medici, the «Bigi» and the «Arrabbiati».

Returning to the city Leonardo found the Prior of the Servi waiting to speak to him about that panel for the high alter. He wanted to get some idea of the composition so he could report to the monks.

Leonardo, imprudently, promised to show him the cartoon soon.

«He can't stand the sight of a brush»

«LISTEN TO ME, I know him well, don't fool yourselves», said the elderly Botticelli to the Servi di Maria. «Leonardo will never paint that panel for the high altar. Admitted, he will make beautiful drawings, but then some wild idea will spring into his head and he will abandon the panel half painted. Isn't that what he did with the Magnificent? And with the monks of San Donato a Scopeto? And both times it was Filippino Lippi who saved the situation. Listen to me, stay in the good graces of Filippino».

The monks were worried. By now Leonardo had been living with them for almost a year, with Luca Pacioli, Zoroastro, Salaì and two more new and very young assistants, but he had not yet begun the painting.

He was always very busy, leaving the house in the morning and returning long after nightfall. He was a member of a commission appointed by the Console of the Merchants' Guild to express an opinion on the landslide that was threatening Monte di San Salvatore all'Osservanza – today known as San Francesco, with the church of the same name that Michelangelo called «*la bella villanella*». Unlike the other experts, among them Simone da Carino, Giuliano da Sangallo, Jacopo del Pollaiuolo and Filippo Legnaiuolo, he had conducted a detailed reconnaissance of all of the surrounding land, taking samples of earth and rock, making topographic surveys, sketches and maps, to summarize all of his observations in a report accompanied by many drawings, since lost.

The real cause of the earth-slide was the one described by Leonardo: a natural shifting of the geological layers due to the infiltration of water and the damage wreaked by man on the

underlying water tables. At the foot of the hill, in the San Niccolò quarter, there was in fact a brick factory which dug clay from the site.

«...If Leonardo Fiorentino, painter, is now there in Florence», wrote Isabella Gonzaga to her priest in the meantime, «we urgently request you to inform us of what life he is leading». In other words, the Marchesa hoped that Leonardo was short of work and of money; «...questioning him then, as you know how to do, as to where he will undertake to paint a picture in our studio...»

Leonardo, in the meanwhile, at the insistence of all of the monks of the Annunziata, had to lock himself in his studio to go on with the painting. After less than a month the cartoon was finished. The composition was so new and beautiful that the Prior exhibited it to the public in a room next to the Cloister.

«In the room», states Vasari, «for two days men and women, old and young, swarmed to see it, as if going to a solemn celebration, to see the marvels of Leonardo, that amazed all of those people».

It was April of 1501. Among that anonymous crowd was a young man just returned from Rome where he had sculpted in marble a Pietà that «had aroused the wonder of the world» and had been admired by all of the pilgrims arriving for the Holy Year. His name was Michelangelo Buonarroti.

«Since he has been in Florence he has done nothing», the priest answered Marchesa Isabella, «except a sketch in a cartoon. It shows the Christ Child, about one year old, who almost leaving his mother's arms has grasped a lamb and seems to hold it tightly. The mother, almost leaning out of St. Anne's lap, is pulling the child away from the lamb, an animal of sacrifice that signifies the Passion. St. Anne, almost rising, seems to try to restrain her daughter... And these are life-size figures...»

The cartoon confirmed to the artists of Florence, who were the greatest masters of the century, the innovatory greatness of Leonardo who, while retaining respect for tradition, broke with the customary schemes, revolutionizing the art of painting.

The group of figures could be enclosed within a triangle – an arrangement which was to suggest many solutions to Michelan-

gelo and to become dear to Raphael – while «in the whole scene», as a German critic wrote, «he manifests that powerful force of his, capable of making us forget his prodigious science of painter, to let us see the poetry alone...»

But while his fellow citizens, in a collective demonstration of civic maturity and love of art, were filing past his cartoon, Leonardo was trying to convince the supreme magistrates of the city to assign him the task of lifting and moving the Baptistery.

«And among these models and drawings», writes Vasari, «there was one with which he many times showed a number of ingenious citizens, who then governed Florence, how to raise the temple of St. John and put steps under it without ruining it...» and the reasoning of Leonardo was so logical, so well-founded on strictly scientific principles, that it could not be seriously contradicted. But when it was a question of passing from theory to action the Government paused in fear, and each of its members, alone in his own home, convinced himself that the initiative was impossible.

That it was not impossible had already been proven by Aristotile Fioravanti, in Bologna, who had succeeded in lifting a tower and moving it several meters.

But not content with the Baptistery Leonardo wanted to move the Arno river too, to create a lovely waterfall in Florence and then to channel the water through smaller canals, all to meet again at the Cascine.

«Here is the project», said the architect showing his drawings. «By channeling the river you can bring the water wherever you want, even inside houses for domestic use, without wasting a drop».

«...His mathematical experiments have so far distracted him from painting that he can no longer stand to see a brush», wrote the priest to Isabella Gonzaga, but also added that had seen him draw «a little picture, for a certain Robertet, favorite of the King of France... which is a Madonna, seated, as if about to wind yarn, and the child, having placed his foot on the yarn chest, has taken the yarn winder...»

Robertet, Minister to Louis XII, after having accompanied his sovereign to see the painting of the Last Supper in the

Refectory of Santa Maria delle Grazie and the clay model of the horse, had sent the Ambassador of France to Florence to look for Leonardo, and now the artist was working on a «highly urgent» commission for a «small religious painting».

But the painting of St. Anne and the promises made to Isabella remained one in the potential state of drawing, the other in that of words, since mathematical experiments were absorbing the artist to the point where he could not «stand to see a brush».

Leonardo spent many hours a day in the libraries of San Marco and Santo Spirito, seeking information on the high and low tides in the Caspian Sea. «Write to Bartolommeo the Turk of the ebb and flow of the Sea of Ponto». He was interested in Flemish customs. «Ask Benedetto Portinari how they run on the ice in Flanders». He asked Luca Pacioli about the squaring of the circle; «have the Master of the abacus show you how to square a circle».

«He's mad, I'm telling you!», cried Francesco Granacci to his friends leaving the garden of San Marco. «I have heard him say that the secret of painting lies in geometry, and that before painting he always has to make a series of mathematical calculations».

Among these artists were Giuliano Bugiardini, Indaco, Lorenzo di Credi, Jacopo di Donnino, Sandro Botticelli and Michelangelo.

«He is mad», repeated Granacci. «Yesterday I heard him speaking with the Prior of the Servi, and telling him that any good painter must divide a head into degrees, points, minutes, minimums and semi-minimums, and each measure is the twelfth part of the previous one. So that a head, to be well painted, has to be divided into 20,736 semi-minimums!».

Granacci's conclusion was met with laughter.

«What a pity!», sighed Lorenzo di Credi. «And such a good a painter! »

The Ducal patent

«MAESTRO LEONARDO», SAID Pier Soderini, «I am happy to welcome you to the Palace and honored to give you a message from His Majesty the King of France».

Florence too, following the example of Venice where the Councils were more stable and the Doge was elected for life, had decided to make the position of Gonfaloniere a permanent one and had elected Piero Soderini, who was then on a mission to the field of Arezzo.

For the first time in the history of the city the Gonfaloniere's wife went to live in Palazzo della Signoria, so as not to leave her husband alone for the rest of his life.

Soderini had received a letter from Minister Robertet, on behalf of Louis XII, asking news of Leonardo and whether he was planning to return to Milan.

«His Majesty the King of France would like to see you in Milan again, where everyone is talking about your Last Supper».

«Thank you», answered Leonardo. «Please send His Majesty my respectful greetings; but I do not intend to leave Florence at present, since I am engaged in work here».

«I know, Maestro Leonardo. I too have seen your marvelous cartoon at the Servi dell'Annunziata. But I would be happier if you would undertake some work for the Signoria».

«Perhaps», answered Leonardo.

«Perhaps what?», asked the Gonfaloniere.

«For the moment», replied Leonardo, «I could not paint. I would rather do some work of sculpture. I have seen a block of marble, abandoned by Agostino di Duccio, behind the Opera del Duomo. A magnificent statue could be made of it».

«Of course!», exclaimed the Gonfaloniere. «It would be an honor for the Signoria and for the whole city».

«I have to think about it», concluded Leonardo, «but I will make some drawings for you».

Leonardo did not know that other artists had already noticed that block of marble and were dreaming of it themselves. One was Sansovino, the other Michelangelo. When the

young Michelangelo was informed by Granacci of Leonardo's intentions, he hurried to Soderini to beg him again for that great block of stone. Michelangelo was so insistent, so certain of being able to sculpt a «colossus» that Soderini, persuaded also by the young sculptor's recent triumphant success in Rome, assigned the marble to him.

Leonardo was of course disappointed by Soderini's decision. Moreover, the Servi dell'Annunziata, tired of having only a cartoon to look at, had informed him that they needed him no longer. And Florence was beginning to bore him. So he offered his services as engineer and military expert to the young Condottiere Cesare Borgia, Duke of Valentino.

Some historians believe that Leonardo met Borgia at Milan, before leaving for Mantua, and offered his services verbally. Others think instead that Leonardo wrote him from Florence, as he had written Ludovico il Moro twenty years ago, listing and documenting his extraordinary capabilities.

But the truth of the matter may be even simpler.

This too is only a hypothesis, but certainly not an improbable one. The Duke of Valentino's troops were marauding between Florence and Pisa, as the diary diligently kept by Luca Landucci makes clear:

«...And on the 19th day of May 1501, Valentino departed from Signa and went between Montelupo and Empoli, pillaging everywhere... And on the 22nd day of May 1501, they were lodged near Empoli and they devastated the whole Valdelsa, robbing and plundering...»

In Vinci too, then; and the Duke of Valentino was there in person, along with his notorious Deputy Vitellozzo.

Leonardo probably met the Duke at Vinci and shortly afterward, in the spring of 1502, accepting a specific offer, left for Piombino, which had been captured by Vitellozzo in September of the previous year.

Like Machiavelli, Leonardo too had been dazzled and duped. The Duke of Valentino was neither the savior of Italy nor the great military genius he pretended to be.

While Leonardo was packing to leave a letter from the Marchesa Isabella Gonzaga arrived from Mantua, asking him to

appraise some precious vases that had belonged to Lorenzo the Magnificent. After the flight of Piero the Medici palace on Via Larga had been sacked by the people. Now the avaricious Marchesa, instead of returning those objects to the young Cardinal de' Medici who was searching for them over land and sea, ready to pay any price, was asking such an artist as Leonardo to appraise them before she bought them from an anonymous Florentine receiver of stolen goods.

«...He likes the agate one even more, as it is something rare, and is made of one piece alone, except for the base and the cover».

At least this, the Marchesa hoped, if not a portrait. Meanwhile Leonardo, with his faithful escort of friends and pupils, was departing from the San Frediano Gate for Piombino to visit the fortress.

It must have been about the end of May when he arrived at his destination. The sea was tossing in a storm and immediately that observer of every natural phenomenon drew a wave breaking and wrote:

«Done at the sea near Piombino. The water ABC is a wave, running over the oblique plane of the shore, which in returning backward strikes the next wave, and striking together they leap up, and the weaker yields to the more powerful, which again slides across the oblique plane of the aforesaid shore».

From Piombino Leonardo was urgently called to Urbino, where Valentino had already taken possession of the whole State. Passing through Siena he climbed to the top of the Torre del Mangia to examine the clock. «Bells of Siena», he wrote beside a drawing, «that is, the mode of its motion and site of the releasing of its clapper». Then, the Duke of Valentino having arrived, he was assigned the task of providing for the defense constructions.

«Stairways of Urbino», he noted, «empty stairways in the wall».

Borgia and Vitelli, aware of Leonardo's love of mathematics, promised him two codexes, and the artist enthusiastically noted: «Borgia will get you an Archimedes from the Bishop of Padova and Vitellozzo the one from Borgo a San Sepolcro».

Meanwhile the Duke had conquered Camerino and Leonardo was ordered to go immediately to Cesena to design a great canal navigable up to the port of Cesenatico. A document of the times recalls that project assigned to a «Ducal architect».

While the army was engaged in Romagna the Duke of Valentino hurried to Pavia to render homage to Louis XII who had just arrived from Paris. From Pavia Leonardo received, on the date of August 18, 1502, the famous «Ducal patent» appointing him general engineer and architect for all of the states possessed by Valentino.

But events were proceeding even more swiftly than the precipitous actions of the Duke.

Leonardo, along with Machiavelli and two other Florentine artists – Torrigiani and Antonio da Sangallo – found himself besieged at Imola by the troops of Valentino's own captains and the minor lords of the conquered cities.

The Fortress of San Leo fell into the hands of the rebels. Borgia took refuge at Faenza, awaiting aid from the French. Then he turned to counterattack, taking Forlì and Senigallia.

«I am in very great trouble», wrote Machiavelli to the Council of the Ten, «I do not know if I will be able to send this letter...»

On the night of December 31, 1502, Valentino had his deputies Vitellozzo Vitelli and Oliverotto da Fermo taken by surprise and strangled. Then he conquered Perugia, from where he moved against Siena, until his father Pope Alexander VI ordered him to return to Rome.

Leonardo too, who was a member of his entourage, went to Rome.

Suddenly, after hurriedly scribbled notes such as: «From Bonconvento to Casanova 10 miles... From Acquapendente to Orvieto...», denoting the confusion of that trip, appears a note that seems the return of the calm after a storm.

«Saturday March 5th I had from Santa Maria Nuova 50 gold ducats (450 remaining deposited there), of which that same day I gave five to Salaì, who had lent them to me».

The general engineer and architect had come home: Piombino, Siena, Urbino, Pesaro, Rimini, Cesena, Imola, Sinigallia,

Perugia and Rome had marked the stages of a great illusion. The idol taken by Machiavelli as symbol for his «Prince» had shown himself to be not only a monster but a bungler as well.

Back in Florence Leonardo, as if awaking from a nightmare, noticed his fellow citizens for the first time and decided to do something for them.

Michelangelo's jealousy

GIOVANNI BENCI HAD a marvelous globe and Leonardo, still perturbed by his war experiences, often visited his friend to speak of science, cosmography in particular.

«Giovanni Benci's map of the world», can be read in one of the notebooks. «Giovanni Benci, my book»: a sign that the two friends exchanged not only opinions but also books. Their discussions ranged far and wide, into the most intimate regions of being, from the stone that, falling into water, «makes circles around the place it hits, to the voice that reverberates in the air, to the mind, finite, that does not extend to the infinite».

Ginevra may have been Giovanni's sister. We know for certain that she was a daughter of that house, and a beautiful girl.

«He painted in Florence from nature», writes the Anonymous, «Ginevra d'Amerigo Benci, and so well that not a painting, but the real Ginevra, it seemed».

For Ginevra too, as for Cecilia, Leonardo had evoked the image reflected in an ideal mirror, to paint the face and the soul, to grasp the imperceptible trace of an inner smile, sign of purity, on the still, closed lips, and to read between her eyelids all the dreams of serene but impatient youth.

The painting, however, was lost, to be found again in Liechtenstein in the last century. Behind Ginevra, in the background, the author painted a symbolical «juniper bush» in deference to the girl's name. Today this portrait hangs in the National Gallery of Washington.

But Leonardo's return to Florence had thrown the Gonfaloniere into a state of agitation. Knowing that the artist would not stay long since the King of France wanted him back in

Milan, Soderini was searching for an idea, worthy of Leonardo and of Florence, to put him to work at once.

And one morning the idea, a splendid one, came to his mind.

Crossing the hall of the Great Council on the way to his studio, Soderini noticed its immense walls, still blank.

«One to Leonardo», he mused aloud, «and the other to Michelangelo!»

Leonardo, the mature artist at the height of his fame and glory, before whom even kings stood in admiration; and Michelangelo, the solitary, contentious youth, who after the Pietà at Rome was now breathing life into the most grandiose statue of all times, a David for the Signoria.

When Soderini sent for Leonard he had just finished the portrait of Ginevra and was studying the way to «sfumare» the miniature.

In his notebooks are entries on loans and repayment, and one on Salaì that reconfirms our suspicions. That vain, conceited young man who went around dressed like a prince was claiming to be a painter, accepting commissions in the certainty that the Maestro would always correct with his own hand his miserable attempts and, in addition to stealing, was having himself dressed and supported by Leonardo.

«I note how on the 8th day of April 1503 I Leonardo da Vinci lent Vante the illuminator 4 gold ducats. Salaì took them to him and consigned them with his own hand. He said he would pay me back in four days. I recall how on the aforesaid day I gave Salaì 3 gold ducats because he said he wanted to have himself made a pair of pink hose with accessories, and he still owed nine ducats. Note that he owes me twenty ducats, i.e., seventeen lent him in Milan and three in Venice».

In early May of 1503 the contract between the Signoria and Leonardo was concluded. The subject was to be one of the victorious battles fought by the Florentine army, of which Soderini had had a list drawn up. Leonardo chose the Battle of Anghiari, fought in 1440 between the Florentines and the troops of the Duke of Milan.

Immediately he began his studies with a long series of drawings.

«Leonardo, I am content with your choice. The Battle of Anghiari was full of surprises and I will tell you, if you wish, many interesting stories about it».

This was Machiavelli who, in those very days, had proposed to the Signoria, still at war with Pisa, a daring and perhaps impossible enterprise, the deviation of the Arno, indicating Leonardo as the architect who would be able to carry out this titanic work.

When Leonardo heard of Machiavelli's project he immediately abandoned his studies on the battle to plunge headlong into hydraulic engineering. In the company of Alessandro degli Albizi he spent his time listening to «masters of water», holding discussions with «commissars», and persuading military men.

Finally the Gonfaloniere of Florence was presented with a detailed report, accompanied by a great many drawings, in which Leonardo's proposal for channeling the Arno to deviate it towards Livorno was accepted. Two thousand workers and thirty to forty thousand days of work would be needed.

Soderini authorized the start of work. Then the doubts of the «water masters» and the commissars slowly prevailed and the initiative, barely begun, was abandoned.

On October 24 the Signoria ordered that Leonardo be given the keys to the Hall of the Pope in Santa Maria Novella so that he would have a comfortable, undisturbed place in which to draw the cartoons for the painting in the great hall.

Every morning Leonardo went to Santa Maria Novella to supervise the erection of the scaffolding. People waited to watch him pass, women stood at the door to see him, and craftsmen leaned out of the windows of their shops.

He was a tall man with thick wavy hair, more white than blond, hanging to his shoulders, a great beard that reached his chest, a strikingly handsome face, majestic gaze, high forehead and supple movements. Following him were Salaì and his other assistants, handsome and elegant, dressed in the latest fashion. Leonardo instead, who scorned frivolous changes in style, always dressed in the same extravagant clothes, of his own design, differing only in the fabric and the color combinations.

«He was of goodly aspect», writes the Anonymous, «well-

proportioned, gracious and handsome in appearance. He wore a pink jacket, short to the knee, when long robes were the fashion. He had a fine head of hair, hanging down his chest, wavy and well combed...»

No one was allowed to enter the Hall of the Pope. Leonardo worked without pause from early morning to sunset, stopping only at the end of the day to meet his friends for some scientific or philosophic conversation.

It was one of those evenings in autumn when, leaving Santa Maria Novella, he passed with Salaì and another pupil, Giovanni Gavina, «in front of Santa Trìnita, by the Spini bench», as the Anonymous relates, «where a group of worthy citizens had gathered to discuss a passage from Dante. They called to Leonardo, asking him to explain to them that passage. And by chance Michelangelo was passing by. Called upon to speak, Leonardo answered: "Let Michelangelo explain it to you". Michelangelo, thinking he had said this in mockery, angrily replied, "Explain it yourself, that you made a drawing of a horse to cast it in bronze, and you were unable to cast it, and for shame you abandoned it". And having said this he turned his back on them and went away, leaving Leonardo standing there, blushing with shame at these words».

Michelangelo had a profound knowledge of Dante, and everyone in Florence knew it. He had lived like a son in the home of Lorenzo the Magnificent, in the midst of the Humanists, and had heard Cristoforo Landino's erudite comments on Dante. Leonardo had spoken in deference to Michelangelo, and the sculptor's reply, mean and slandering, does him no honor.

But the real reason was that Leonardo's very presence disturbed Michelangelo. His jealousy was morbid and pathological. He had seen some of Leonardo's paintings and had been struck by their innovatory, inimitable message. The fame of the Last Supper had spread as far as Florence, along with the story of the gigantic horse, and Leonardo's young antagonist was suffering. Michelangelo had had a board fence erected behind Santa Maria del Fiore so that no one could watch him sculpting his colossus. But the David was only four and a half meters high while Leonardo's horse, according to Luca Pacioli, mea-

sured over seven meters – almost the double – and only by miracle could it have been cast in bronze in a single pouring. Even Donatello and Verrocchio would have become, by comparison, sculptors of secondary rank.

A few days later the Gonfaloniere appointed a committee of experts to examine the David and decide where it should be placed, either under Orcagna's Loggia or in front of the Palazzo della Signoria.

Leonardo was asked to participate in the committee, along with Andrea della Robbia, Attavante, Cosimo Rosselli, David del Ghirlandaio, Simone del Pollaiuolo, Filippino Lippi, Sandro Botticelli, Giuliano and Antonio da Sangallo, Sansovino, Granacci, Piero di Cosimo and Perugino.

The committee unanimously proclaimed the excellence of the work.

«I knew that block of marble», said Leonardo, «because I had been interested in it too. But it presented such difficulties, due to Maestro Agostino's blows of the hammer, that I could not decide whether or not to ask the Gonfaloniere for it. I can truly say, then, that Michelangelo, in sculpting from it such a beautiful statue, has done more than if he had revived a corpse».

Everyone applauded. Only Michelangelo felt a moment of rebellion upon hearing those words. And when Leonardo, in agreement with the Sangallos, proposed that the statue should be placed under Orcagna's Loggia, perhaps against a background of dark panels to set off the whiteness of the marble, Michelangelo objected that these were the opinions of painters and urgently requested that the statue be placed in front of Palazzo della Signoria, where Donatello's Judith now stood.

«But it is white marble, soft marble! As soon as it comes into contact with the air it will crumble», said Andrea della Robbia.

«That's not true, it is real marble, hard as stone, I know because I have sculpted it, and it must be placed outdoors!», retorted Michelangelo.

And so the statue was placed outdoors, to content its sculptor, in early June of 1504.

But between Leonardo and Michelangelo the quarrel had not ended. One day Leonardo, near Santa Maria del Fiore, was involved in a discussion with a group of painters led by Granacci, explaining to them his ideas on perspective.

«If you want to be painters», Leonardo had concluded, «never forget that the composition of any painting must always obey mathematical laws. I will try to write down these rules, and each of you can attempt to confute them».

«But what do you think you can write, when the only school you've ever been to was Verrocchio's?», exclaimed one of the painters called Rucellai. «Do you know what they say about you in Florence? That you haven't even learned the *donatello*».

«I know very well», replied Leonardo, «that since I am not a literate, every conceited fool will think he can criticize me on the grounds that I am a "man without letters"! But look how stupid they are! I could answer like Marius to the Roman patricians, saying that they make themselves beautiful with the wealth of others, while I adorn myself only with my own things. And these things are the fruit of my personal experience, which has always been the master of life for everyone, as it is for me».

Michelangelo had just arrived, in time to hear his rival's last remarks.

«And you also go around saying», he cried, «that sculptors are poor stone-cutters with callused hands, always dirty of mud and dust, while painters with their womanish hands maneuver light brushes while listening to music, isn't that right? And I'm sure you will write this too, to teach us the trade; but even if those capons of Milanese may have listened to you, nobody will believe you here in Florence!»

Leonardo made no reply, but happening to see on the ground a sturdy iron bar, he told Salaì to bring it to him. Then, staring calmly at Michelangelo, he bent the bar and threw it at the sculptor who had to grab it in the air to keep from being struck in the face, saying, «And now, if you are able, bend it back the way it was, with your big masculine hands!»

The great challenge

THE OTHER WALL of the Great Council Hall was commissioned to Michelangelo, who chose an episode from the Battle of Cascina, fought by the Florentines against the Pisans. He too was assigned a room in which to draw the cartoons, in the peaceful Monastery of Sant'Onofrio.

The great challenge had been hurled.

The two most significant moments of Humanism were about to confront each other: the period before Savonarola and the one that came after him; the pagan serenity of the time of Cosimo and Lorenzo – like a return to youth after the doubts and torments of the previous century – and the crisis that was emerging not merely between man and God but within the inner self of each individual.

The mournful bonfires lit by the Friar of San Marco which had consumed many codexes, many works of art and, above all, many aspects of fifteenth century man – and then the bonfire in which the Friar himself had ended his life – had became a reality that was not to be forgotten. Those flames inaugurated a new mode of thinking and of being. Mankind, courageously exalted by Humanism, fell back on itself, contorted, began to feel and express an inner struggle.

Leonardo impersonated the golden age of Humanism, in harmony with his physical beauty, his majestic posture, that of a Wise Man, his splendid dress, and his entourage of pupils as beautiful as angels. Michelangelo incarnated the crisis of Humanism, the demoniac opposed to the Olympian, the protest against all forms of wisdom, the rejection of any benevolent tolerance.

He was a young man of thirty, short, with a big head covered with unruly hair, knotty hands, and a feverish, exalted stare; badly dressed, quarrelsome and jealous, without friends or pupils. In his pocket, instead of a notebook, he always carried with him one of Savonarola's terrifying sermons.

The magistrates and citizens of Florence were perfectly conscious of how exceptional this confrontation was to be. Leonardo the genius and Michelangelo the genius were giving the best

of themselves, writing one of the most brilliant pages in Florentine history.

Leonardo, having started first, was also the first to complete the cartoons. On February 28, 1505, about a year after beginning, he had the scaffolding in the Hall of the Pope taken down.

People came running. Their amazement was equaled only by their admiration. Leonardo had shown his fellow citizens that he was not merely a painter «of grace», but one with the teeth and claws of a lion.

The clash at Anghiari, with the Florentines led by Francesco Sforza and the Milanese commanded by Niccolò Piccinino, had been extremely violent although there had been only one death, and that by accident. Leonardo had reconstructed, in rapid notes, the origins of the battle: «Begin with the oration by Niccolò Piccinino to the Florentine soldiers and exiles... from there show how he first mounted his horse armed and the whole army followed him... Here at this bridge is a great struggle, the enemies are winning...»

He had analyzed each episode and had even gone to Anghiari to visit the battleground, as proven by the notes he took. Then, in the final draft, all trace of geographical or historical realism disappears. The battle had become a clash between human forces, wills and passions. Leonardo had exasperated the movements, twisting warriors and horses in masses of muscles and conflicting expressions. The effect was strikingly impressive.

But his antagonist was his equal. Michelangelo too had exceeded himself. Instead of a battle scene he had chosen a marginal episode, when the Florentine soldiers were bathing in the Arno and a trumpet suddenly sounded the alarm. The ringing cry of the trumpet, in Michelangelo's re-evocation of the scene, had the effect of an explosion. Men were running for their clothes, their arms, swimming to the bank of the river, pulling themselves out onto land, in a play of muscles and skillful anatomical details expressed in a dynamics so vivid that it seemed the figures were about to leap out of the drawing.

The «encausto»

THE CONTRACT STIPULATED that the cartoons were to be completed by February 1505, and the Council was to pay 15 florins a month starting from April 1504. If the cartoons were not finished within this term Leonardo would have to return all of the money he had received. For the frescoing of the Great Hall a further agreement would be made after the drawings had been examined.

In early July of 1504 Giuliano da Vinci, the son of Ser Piero and «ser» himself, went to see Leonardo at Santa Maria Novella to tell him that their father was ill.

Leonardo followed his half-brother to Via Ghibellina. There he found Lucrezia in tears and an infant in the cradle – Giovanni, the last born.

Ser Piero, in the dim curtained room, gave no sign of consciousness. Leonardo, moved to tenderness, approached the bedside.

«Father», he whispered. The old man, as if summoned back to life by a friendly voice, opened his eyes, recognized that son so dear to him – and so despised by his so-called «legitimate» offspring – and tried to raise his head, murmuring into the ear of Leonardo, who was helping him:

«Pardon me, my son».

«On the 9th day of July 1504, Wednesday, at the hour of 7, died Ser Piero da Vinci, notary in the Palagio del Podestà, my father, at the hour of 7. He was 80 years old. He leaves 10 sons and 2 daughters».

Leonardo's distress is revealed by his lack of precision. Ser Piero was 77 years old, not 80. The day was a Tuesday and not a Wednesday. Not all of the children numbered were still living. Later, in the same notebook, Leonardo wrote, «Wednesday, at the hour of seven, died Ser Piero da Vinci, on the 9th day of July 1504. Wednesday, at about the hour of 7».

Like Michelangelo, who was working on the cartoons for the Battle of Cascina while executing his famous «tondi» in sculpture and painting, Leonardo was also engaged in other things, and not in the field of art alone.

For years he had been fervently studying the possibility of

human flight. Uncle Francesco's fixed idea was his as well. It went back to the time of the kite wheeling through the sky from Monte Albano to the sea and to the years in Milan, when he had had a board fence erected between his house and the Duomo to avoid being seen by those who were working on the lantern.

He had begun to study gravity by reading Marlini's *De proportione motuum in velocitate* and commenting, along with Luca Pacioli, on Euclid's *De ponderibus*. Now he was preparing an incredible secret «machine» that would hold a man up in the air.

Without knowing it Leonardo had discovered the first principle of mechanics, according to which «to every action corresponds an equal and opposite action». «As much force as is exerted by the object against the air, with equal force the air encounters the object».

As confirmation of this discovery he had designed a parachute. But his real dream was that of wings, which the birds moved so naturally, lightly and harmoniously.

Already in Milan he had begun a systematic, methodical observation of the flight of birds. «The bird will beat its wing lower on the side to which it wants to turn... The bird supports itself in the air with imperceptible balancing... When the wind does not blow hard, then the kite beats its wings several times in its flight...»

Beating flight, hovering flight, veering flight: on the basis of these observations he began to construct his equipment.

After days spent working on the cartoons of the battle Leonardo, assisted by the faithful Zoroastro, went by night to his laboratory to build the frame of the machine that was to carry a man through the air. Experiments convinced him that the vertical position was better than the horizontal one since the center of gravity was lower, improving the stability of the machine and providing more energy. A normal man, in the vertical position, would have been able to exert a force of 600 Florentine pounds, or about 2 quintals. These studies were intensified, but in the meantime the cartoons had been finished. Leonardo had kept his word: precisely one year. At the end of the established term he had announced that the preparatory

work was finished. Now it was time to erect the scaffolding in the Great Hall again and to begin painting. With him were Maso Masini, Ferrando Spagnuolo, Riccio della Porta alla Croce, Raffaello d'Antonio di Biagio, Salaì and Jacopo Tedesco.

«On Tuesday evening Lorenzo came to stay with me, aged 17; and on the 15th day of said April I got 25 gold florins from Camarlengo at Santa Maria Nuova».

It was another pupil, and extra money taken from his savings to support the numerous family.

But suddenly all work came to a halt. Leonardo had read in Pliny the recipe for a stucco used by the ancient Romans for their frescoes. It was called «encausto».

He decided to make it again and experiment with it. In great secret tests were conducted in the Hall of the Pope in Santa Maria Novella.

After having carefully prepared the mixture and applied it to a wall Leonardo had painted a portion of it with oils and then lighted a great fire before it to dry the colors. The effect had been immediate and successful. The flame had brought out all the light in the colors.

«We've found the answer!», exclaimed Leonardo joyfully. «Now we can go the Palazzo and prepare the wall. We will make a painting such as has never been seen before, a marvelous sight!».

That same night, borne high on the first wave of enthusiasm, he wrote a proud note on the future of the flying machine:

«The great bird will soar in its first flight from the top of Mount Cécero, filling the universe with amazement, filling all writings with its fame and shedding eternal glory on the nest where it was hatched...»

She

IT IS FUTILE to analyze every feature of La Gioconda, or Mona Lisa, to make of it an identikit. Too many words have already been written about that face of a sphinx, many perceptive thoughts but also a great deal of nonsense.

La Gioconda is, and remains, Leonardo's great secret. Only one thing is certain. This painting was not executed on commission, since the author, after having «labored at it» for four years, took it away with him «still imperfect», as Vasari states, and kept it for the rest of his life.

But in Florence oral tradition exists along with written history, and from one generation to another it has always been known that in Piazza Santa Maria Novella stood the houses of Francesco del Giocondo, and that Leonardo painted the portrait of his young wife Mona Lisa Gherardini.

The Hall of the Pope, assigned him by the Signoria as a place to prepare the cartoons, faced Giocondo's houses. Nothing is more probable than that Leonardo became friendly with old Messer Francesco and offered to paint a portrait of his lovely wife. Francesco del Giocondo had in fact taken as his third wife, in 1495, a young girl from Naples, a member of the Gherardini family. In 1499, while he was a member of the Council of the «Bonomini», one of his daughters died, perhaps the only one born of his marriage to Mona Lisa. «A daughter of Francesco del Giocondo», can be read in the Book of the Dead kept by the monastery, «was buried in Santa Maria Novella».

If Mona Lisa was about twenty years old when she married, and twenty-four at the death of her daughter, she must have been between twenty-eight and thirty when Leonardo painted her mature beauty.

At fixed intervals Leonardo left the Hall of the Pope to work on the portrait of this melancholy woman, who since her daughter's death had not attended any festivity, nor had she smiled.

Leonardo, «as Madonna Lisa was very beautiful, kept, while he painted her, musicians or singers, and always clowns, to keep her joyful, to banish that melancholy air that painting often gives to portraits», states the Anonymous.

It was not merely a portrait, but «a live thing» that Leonardo intended to paint. No one before him had undertaken such a daring endeavor – to challenge nature herself, to imitate her and surpass her – and «to conserve the semblance of a divine beauty, that time or death soon destroyed».

The image evoked by the mirror was no longer enough. Now Leonardo had to evoke this image «within himself», seeking to cast light on the obscure depths of his unconscious and in that timeless luminosity to find again that face, that image, unchanging but alive, were it only for the almost imperceptible curving of the lips in a knowing smile, the sign of a secret sympathy linking herself and the artist.

Leonardo had to employ all of his technical skill, reproducing with the patience of a miniaturist every pore in the skin, a veil of down on the cheek, the eyelashes, the barely perceptible lines in the face and neck and the smooth fabric of the skin. The scientist in him realized to his great astonishment that the human pupil dilates in the shade and contracts in the light. Painting Mona Lisa's eyes at different times of the day he discovered that they had changed, «and this thing had already tricked me in painting an eye, and from this I learned».

Occasionally as he painted Leonardo told the sitter his fables, taken from both reading and personal experience. He had fled from Rome and from Cesare Borgia. He had seen, in the fortresses besieged by Valentino's men, the massacre of the defenders. He knew that freedom is worth more than life, that it has no price; and had seen it offended, violated and destroyed.

«A poor little thrush», said Leonardo to Mona Lisa, «spent the whole day searching for worms and flies for her nestlings. But one evening, returning to the nest, she found it empty. Someone had stolen her children while she was away. The thrush sought for them everywhere, among all the branches and bushes. She called and cried, wept and chirped, so that was painful to hear. A chaffinch, feeling sorry for her, flew all around the forest and returned to say:

«"I think I have seen your children, down there at the peasant's house".

«The thrush flew off to the peasant's house; and saw, hanging at the window, a cage with her nestlings in it. With beak and claws she tried to tear open the bars, but to no avail. At last, screaming in grief, she flew away.

«The next day she came back. She had something in her

beak. Her children, behind the bars, trustfully opened their little beaks wide, and she fed them one by one, for the last time.

«For the last time, because the mother had given her children a poison plant to eat, and they fell dead in a moment. "Better death than the loss of freedom"».

«No, no», added Leonardo quickly, «don't be sad, Mona Lisa. Now I will play you something merry, and then I'll tell you the story of a pumpkin...»

Mona Lisa is Leonardo's secret; from the time of the cartoons to the tragic end of the great mural; from his joyful arrival in Florence to his disconsolate departure.

Vasari may be right. When Leonardo left the portrait was still unfinished; because it was no longer the image of a woman alive in time but had become the expression of Leonardo's soul.

A beauty in decline, her hands lying abandoned one on the other, and behind her, again, emptiness. Later in Milan, based on a deep inner motivation, Leonardo was to paint with hallucinating precision a landscape of rocks and waterways reminiscent of a precise point on the Adda at Paderno, that Lombard landscape so dear to him and that clear sky of Lombardy, «so beautiful when it is beautiful».

Mona Lisa was to become, more and more, La Gioconda, an autobiographical portrait. And that smile is the melancholy awareness of he who knows what others cannot yet imagine: a purposely ambiguous response to the new generation.

Raphael

BASTIANO DA SANGALLO, the son of Antonio and grandson of the great architect Giuliano, worked with Perugino in the Church of the Santissima Annunziata. He was a restless pupil, subject at times to «philosophical» crises that induced him to leave aside painting to study humanistic doctrines.

His dramatic reaction to the sight of Michelangelo's cartoon is thus understandable. He abandoned Perugino and literally moved into Sant'Onofrio to explain to the people the marvelous art and the underlying philosophic message of the Battle

of Cascina. His speeches were filled with so many quotations from the classics, Aristotle in particular, that he was given the affectionately admiring nicknamed of «Aristotile da Sangallo».

At this same time another young man, another of Perugino's pupils, was dazzled like St. Paul on the road to Damascus by the sight of cartoons, but this time they were those of the Battle of Anghiari exhibited in Santa Maria Novella. The overwhelmed admirer was named Raffaello Sanzio, later to be known as Raphael, from Urbino.

«Maestro», he said when he managed to be introduced to Leonardo, «I have studied the cartoon of St. Anne and have copied it several times, and now I am asking you to let me come and study these cartoons of the battle».

«Have you got any drawings to show me?», asked Leonardo.

The young man opened a folder to show his drawings: sketches, notes, studies of details and perspective. They revealed a sure hand, a gaze sharpened by observation, and a mind capable of guiding the hand.

«Good», said Leonardo». «You have made progress, your style has softened, I would almost say that you are freeing yourself from the Perugino influence».

Raphael blushed.

«I have already seen some of your paintings. They showed them to me in Urbino. Come back tomorrow. I have something to show you».

The next day Raphael punctually returned to Santa Maria Novella.

«Come with me», Leonardo said, leading him across the square.

«Here is a painter that the whole world will speak of», he told Mona Lisa. «He is from Urbino, and is called Raphael. I told Antonfrancesco Doni about him yesterday, suggesting that he have him paint his portrait. And now look», he added, turning to the young man and uncovering the canvas on the easel.

Raphael gazed long and wordlessly at the portrait of Mona Lisa. He felt he was dreaming. That painting went beyond any human possibility. It was something entirely new, never seen before.

«Well, Raphael, why don't you say anything?»

«I cannot», replied the youth in a strangled voice. «Now I understand, now I see what painting really is. I am so happy, Maestro, that I am moved to tears».

The lost battle

LEONARDO'S PUPILS AND assistants – the whole school – were at work in Palazzo Vecchio erecting the scaffolding. Even in this Leonardo the «engineer» had to impress his fellow painters. Not content with the usual carpenter nor the customary platform, «he built a most ingenious scaffolding», relates Vasari, «which rose higher when drawn together and lower when extended».

To hide the scaffolding and the wall the artist had a cane fence erected and covered it with 25 meters of canvas to form a protective barrier between his work and the eyes of the curious.

One after another the cartoons were brought from the Hall of the Pope to the Great Hall for the drawings to be transposed onto the «encausto». Up to the moment when the colors were to be applied Leonardo was in a state of feverish excitement.

His activities, commitments, and research projects were multifarious. In the morning he worked in Palazzo Vecchio. In the afternoon he painted in the home of Francesco del Giocondo or continued his studies for channeling the Arno. At night, when even his pupils were sleeping, he went with Zoroastro to the underground laboratory where the marvelous, mysterious flying machine was hanging from the ceiling.

Occasionally he went to Fiesole to see Don Alessandro Amadori. Although he was frequently invited to the homes of Florence's eminent citizens, aristocrats, magistrates, bankers and merchants, he did not neglect the bands of artists and his old companions from Verrocchio's workshop.

Then there were learned discussions with Luca Pacioli, which often included the young Bartolommeo Vespucci, mathematician and cosmographer, grandson of the great Amerigo, and the scientist Francesco Sirigatti, author of a treatise on experimental astronomy.

And there were trips to Vinci, to see his old Uncle Francesco, and to the upper Valdarno and the Val di Chiana for the project of channeling the Arno upstream of the city too and for draining swamps.

These were the most intensely serene months in Leonardo's life. Perhaps the verses written by an unknown hand, which may have been that of Mona Lisa, and then concealed by an enormous ink spot on one page of the notebook, date from this time:

«Oh Leonardo, why so many laborious endeavors?».

And immediately after, in the artist's handwriting, this bitter reflection on beauty:

«...Helen, looking in the mirror, saw the wrinkles on her face, left there by old age, wept, and thought to herself, why was I kidnapped twice...»

But suddenly the notes on purchases, payments, and the monthly withdrawal of money in Palazzo Vecchio broke off.

The notebooks remained closed; not a note, a sentence, a word. It must have been the winter of 1505-1506. Leonardo was feverishly painting the hall, proceeding from bottom to top. At the end of each day he lighted a fire to dry the colors. The results were reassuring.

But one evening, after he had painted a large section near the top, the fire was unable to dry the colors. Leonardo, alarmed, ordered more wood to be thrown on, so that the flames would arrive as high as the wet paint. But the colors began to run down the wall, dirtying and disfiguring the portions that had already dried. Uselessly his pupils throw wood, and even benches and chairs and all the boards they could find, on the flames. With the extreme heat the encausto began to swell like a bubble near the bottom, while the painting became a thick soup of mingled colors inexorably flowing downward, like lava from a volcano, to delete the rest of the work. Leonardo, petrified, could only watch while the crackling flames destroyed what he had accomplished.

The battle was lost.

Another defeat

ALESSANDRO AMADORI TOOK Leonardo into his house and locked the door behind him. No one was allowed to approach him, not even his friends. Leonardo needed solitude and silence. Criticism and malicious comments had to remain back in Florence.

In vain the Gonfaloniere tried to get a message to him, a message than was really an order.

«Leonardo is not well», they told him. «He is in Fiesole. He needs a change of air».

«But he has to repaint the picture. He has to begin again!»

«He can't do it now. Leave him in peace», answered the good Canon, hurrying back and forth between Fiesole and Florence.

Leonardo, in the meantime, was recovering by dedicating himself heart and soul to his flying machine.

Zoroastro had disassembled it and brought it to Fiesole, to Don Alessandro's storeroom. Together they had reassembled it, testing and retesting its complicated mechanism.

On March 14th Leonardo opened his notebook again to write of a hawk, a bird of prey, «that I saw going to Fiesole above the locality Barbiga». Then there is another note on the mount of «Cècero», which meant «swan» in dialect, and then again silence.

Some historians believe that this device was never experimented but remained in the stage of model, on a reduced scale, although Gerolamo Cardano wrote, in *De suptilitate*:

«...Leonardo too tried to fly, but with disastrous results...».

According to others an attempted flight was made, although by whom is not known, but the machine was a failure.

At Fiesole instead a persistent memory has been handed down from one generation to another: the story of the «cécero», the artificial swan that one day took flight from the hill bearing its name, only to disappear, plunging into the woods.

In Fiesole they still know the name of that mad follower of Icarus. He was called Tommaso Masini da Peretola, nick-

named Zoroastro, the famous mechanic faithful to the last to Leonardo.

According to tradition, garbed as legend, Leonardo did not trust his machine with its beating wings. His calculations showed him that the weight of a body could not be supported through muscular force alone. And he was already conceiving the idea of wings that were immobile but not rigid, designed for gliding flight achieved by exploiting currents of air.

But Zoroastro could not bear to forego experimenting a project they had worked on so long, in all those nights spent around the artificial bird. More confident than his Maestro, he decided to test it himself.

«I will fly it. I will show that our calculations are right. Have no fear, I will fly!»

And in fact he flew. From the bare top of Monte Céceri the bird-man ran to launch himself into the void, and began to fly. For a long stretch he stayed in the air, above the woods and stone quarries that, following the slope of the land, descended always lower than the line of flight, until, either through excessive emotion or an erroneous maneuver, Zoroastro fell.

Tradition also says that he was badly wounded, remaining marked by his fall for the rest of his life, and perhaps died soon after.

What is certain is that Tommaso Masini, after twenty-five years of faithful collaboration with Leonardo, was no longer mentioned in the notebooks. The history and the legend of Zoroastro end just at this time, in the sign of another failure.

Leonardo, disconsolate, returned to Florence, but with a soul longing to escape. By now his city showed him nothing but envy and hostility.

The good priest Alessandro followed him so he would not be alone, trying to persuade him to work for the Marchesa of Mantua, who had turned to him too in her vain attempt to have the long desired painting.

Leonardo cleared out his house, released his pupils, and requested an audience with the Gonfaloniere.

«Maestro Leonardo, when do you plan to resume work on the painting?»

«Soon, Magnificent Messere. I have come to ask you a three months' leave of absence, as I must go to Milan».

«And if you fail to return?»

«I will return».

Leonardo looked at the Gonfaloniere with a question in his eyes.

«I want a hundred and fifty gold florins», said Soderini. Then, realizing that he had exaggerated, he corrected himself.

«I mean, if you don't come back, you will have to pay the Signoria a fine of 150 florins».

«Agreed».

A few days later Leonardo departed. It was the end of May of 1506. Salaì accompanied him. On the third horse, loaded with baggage, was the painting of Mona Lisa del Giocondo, still unfinished.

PART FOUR

Soderini's rage

HERE WAS MILAN, with its canals, its rows of poppies and the light blue mist slowly dissolving with the dawn; and the Milanese businessmen, jovial and content with life.

Leonardo entered the city almost on tiptoe, for fear of finding here too the cold rejection of the Florentines.

Rather than facing a look from eyes that might pretend not to know him, as in Florence, he preferred to avoid people, to remain anonymous.

And immediately, as an anonymous visitor, he heard that Leonardo, in Milan, was still «the Maestro». His exploits as architect, engineer and magician had become legendary. His works, the Virgin of the Rocks and the Last Supper in particular, were a school for every painter. So many copies had been made of them, and sent everywhere, that it was impossible to count them.

Everyone thronged to greet him, welcome him, honor and revere him. The young Governor of Milan, Charles d'Amboise, who knew him only by fame, received Leonardo in the Castle with the honors of a prince. The words of the courtiers were a soothing balm to the wounds still throbbing in his heart.

But the leave conferred on him by the Signoria of Florence was for three months only. He could not remain longer, nor begin any work of art for His Majesty the King of France.

Charles d'Amboise understood what the artist wanted, and wrote to Florence to ask that the leave of absence be extended for at least one month «...because we still have need of Maestro Leonardo to finish a certain work that we have had him begin...»

The work is perhaps a Madonna and Child playing with a cat, of which only a few drawings remain. It is certain that a small painting by Leonardo was urgently sent to Blois, the King's residence.

Soderini reluctantly granted the extension. But when Charles d'Amboise, toward the end of September, requested another, the Gonfaloniere responded angrily, asserting that Leonardo had behaved badly with his city «...because he has taken a good sum of money, and made a small beginning of a great work that he was to have done...» Let him come back at once then, and finish his painting «...because the work must satisfy the universal...»

This was the point. Leonardo, faced with the technical disaster, had given up, but neither the Gonfaloniere nor the «universal», that is, the people of Florence, had abandoned the idea. Consequently, Leonardo had to begin again.

But a man like Leonardo could not leave such a severe, injurious accusation unanswered. Soderini, with the vulgarity of a merchant, had rebuked the artist for having received too much money for a «small beginning» and Leonardo, from Milan, sent him back the money.

A few days later Alessandro Amadori – after having put together the sum of 150 gold florins, recurring also to the aid of the artist's friends – appeared before Soderini and consigned him the money in the name of the painter. The Gonfaloniere, flushing with anger, refused to accept it at first.

«Leonardo's message to you is that the earning of honor is much greater than the honor of wealth. So take your florins and leave him in peace».

«I do not want money, I want Leonardo. Write this to the Governor of Milan!»

By mid-December Leonardo was ready to depart. Charles d'Amboise gave him a letter for the Signoria of Florence which

remains, still today, one of the greatest testimonies to the young condottiere's esteem for the great artist.

«...The excellent works which he has left in Italy, and particularly in this city, would have been reason enough for loving Leonardo da Vinci, your fellow-citizen to a singular degree even if we had never seen him... And we wish to confess that we ourselves number among those who loved him before we ever met him...»

The humility and sincerity of Charles d'Amboise, who declared that he had loved Leonardo even before he met him, only because of having seen his works, are striking. And he goes on: «But since we have known him, and experienced his many and various talents, we see truly that his name, celebrated for painting, is obscure as compared to the praise he deserves for the other parts, which are of the greatest ingenuity. And we wish to state», continued the Governor, «that the proofs he has given of anything that we have asked of him, of Drawings and Architecture and other things pertinent to our condition, have been so satisfactory that not only have we been satisfied of him, but we have become his admirer».

And here is the final blow, that would have felt like a slap in the face to anyone more sensitive than Soderini:

«Accordingly, it having been your pleasure to leave him here these past days for our gratification, should we not thank you, on his return to his homeland, we would seem not to satisfy a grateful soul.

«And so we thank you as much as we can, and if it be suitable to recommend a man of such talent to his own people, then we recommend him to you as highly as we can».

But meanwhile a note arrived for Leonardo from Blois. It was his friend Francesco Pandolfini, Ambassador of the Florentine Republic to the court of Louis XII, telling him not to leave and to await further instructions.

What had happened? A minor conspiracy, perhaps. Soderini wanted Leonardo, and Charles d'Amboise, in the end, was forced to give in; but in the meantime the King had received the artist's painting and certainly a message from the Governor of Milan as well. Louis XII had called for Pandolfini and told him:

«Dear friend, your Signoria must do me a favor. Write at once that I wish to make use of Maestro Leonardo, their painter, who is now in Milan. Have your government order Leonardo to put himself immediately at my service, and not to leave Milan before my arrival!»

Pandolfini tried to gain time through a diplomatic reply:

«Since Leonardo is in Milan, Your Majesty being in his own home can give Leonardo this order much better than the Signoria».

And Louis XII, about to lose patience, retorted:

«Signor Pandolfini, don't make me repeat what I have already said!»

At this point the Ambassador, to appease the King, began to speak in praise of Leonardo.

«Do you know him?»

«Certainly, Your Majesty, he is a good friend of mine».

«Then write him a verse immediately, not to leave Milan, while your Lords are writing him from Florence». «And for this reason», concluded Pandolfini in a letter to his Government, «I have written a verse to the aforesaid Leonardo, to show him the good intentions of his Majesty and advise him to be wise».

While the Ambassador's lengthy report was being read to him Soderini was squirming as if on pins and needles. He could not understand why a King of France cared so much for a painter, and above all he could not swallow the bitter pill that the King was forcing on him, obliging him to write Leonardo the exact opposite of what he really wanted to say.

«Leonardo, you fraud, here there is a painting to be redone because you have spoiled it, a wall that is waiting for you because we have paid you to paint it, and a people that refuses to be disappointed after having admired your cartoons, and you, instead, are actually obliging a king to make me write you not to come and order you to remain at the service of His Majesty».

At that moment a special courier from Louis XII arrived in Florence, bringing a letter written in the King's own hand.

«Dear friends – *très chers et grans amys. Nous avons néces-*

sairement abésognes – we have absolutely need of – *de maistre Léonard à Vince, paintre de Votre cité de Fleurance, et que intendons de luy faire fer qualque ouvrage de sa main* – because we intend to have him make some work as soon as we come to Milan – *incontenent que nous seron a Millan, qui sera in briev, Dieu aidand* – that is, soon, with God's help. And as soon as you receive this letter write him not to move from Milan before our arrival...»

Soderini, tearing his hair, read and reread the letter with the royal seals and could only recall the three Papal Bulls, each more threatening than the last, that had arrived on his desk the year before with the order to send the fleeing Michelangelo back to Rome.

«These artists may be a great honor to us, but what problems they cause! The quarrel with the Pope is barely over, when he wanted to wage war on us unless Michelangelo returned to him, and now another thunderbolt is threatening a storm if we don't tell Leonardo to stay in Milan. Then let him stay as long as he likes, let him never show his face here again!», cried the outraged Gonfaloniere, ruler for life of the Florentine Republic.

At Vaprio d'Adda

«THE WATER THAT you touch in the river is the last of that which goes, and the first of that which comes: so is the present time».

Leonardo laid down his pen and closed his notebook. Spring was brightening the countryside again and the Adda flowed swift and solemn, swollen by thawing snow from the distant Alps.

The youth Francesco was waiting for the Maestro in the garden. Another calm, quiet day was beginning.

After the King's letter the Gonfaloniere of Florence had no choice but to obey, writing Leonardo to stay in Milan.

«Maestro, we've done it!», had smiled Marshall d'Amboise, showing Leonardo the reply from the Signoria. You will await the arrival of His Majesty in Milan!»

Gerolamo Melzi, the Marshall's friend and captain of the Milanese Militia, had invited the artist to spend some months in his villa at Vaprio d'Adda.

«You can rest there, after all this turmoil, and you will finally make my son Francesco happy. He can't wait to meet you».

Leonardo accepted. It was winter. The plain was covered by a blanket of snow. The trees in the park at Vaprio looked like pale ghosts.

The captain's son was not yet seventeen years old. He wanted to be a painter and often went to Milan to gaze in wonder at the Last Supper. «Francesco Melzi, a gentleman of Milan, at the time of Leonardo was very handsome and very much loved by him, as today he is a handsome, gentle-mannered old man», wrote Vasari.

Leonardo accepted Francesco as a pupil and from that day on the young man was never to abandon his extraordinary Maestro. Now, in Vaprio as elsewhere, winter was over. Leonardo had spent some days in solitude, meditating and taking notes. With the return of good weather he had resumed his outdoor observations and young Francesco had become his assistant.

Occasionally the boy accompanied Leonardo on more distant excursions. Perhaps a trip to Bolca – «in the mountains of Verona the red stone is all mixed with fossil shells» – and a new study for a network of irrigation canals date from this time.

Leonardo loved to idle along the banks of the Adda, contemplating the flow of the stream, identifying himself with the flowing currents. In all of nature he felt the almost tangible presence of the «Prime Mover». To him it seemed that the air, the land, the water breathed, had a life of their own, that the waves were like a momentary rupture in the skin of the water, and the wind the heavy sighing of the air. And all the while he was imagining a new shape for the hulls of boats, a deep Vee, plunging into the heart of the water like a plow into the earth. Almost five centuries in advance, he invented the ship of today.

While still at Vaprio he drew a design of locks «with corner». He resumed his studies of waves. «A stone thrown into the water becomes the center of various circles having as center the place it struck». He observed their apparent motion – called

entropy by modern physics. «...The wave flees the place of its creation, but the water does not move from its place, like the waves among the oats in May provoked by the course of the wind, that can be seen to run, and the oats do not move from their place».

Leonardo remained at Vaprio almost up to the end of May, returning to Milan only when informed of the imminent arrival of the King.

The long-awaited meeting took place simply and naturally. Louis XII, without having himself announced, went to see the artist in his studio, «*Notre chier et bien aimé Léonard de Vinces*», then welcomed him to his court, appointing him «*peintre du roy*». Lastly, after having conversed at length with Leonardo, the King promoted him to the rank of «*peintre et ingénieur ordinaire*» and assigned to him, for his vineyard outside of Porta Vercellina, twelve *once* of water from the Naviglio of San Cristoforo, to be utilized as soon as the exceptional drought of those days was over.

The insult from Soderini was only a faint memory, a wound that had healed.

Florentine bureaucracy

«LEONARDO IN FLORENCE? I don't want to see him!» «But he», replied Machiavelli to the choleric Gonfaloniere, «has not asked to be received. He is here to see about some business, an inheritance, and the King of France has written this letter, which arrived this morning, asking the Signoria to help Leonardo take care of it quickly, in the time *plus brefve que se pourra*».

Soderini would have liked to ask another question, whether Leonardo was willing to repaint the wall, but he resisted the temptation.

Michelangelo, in Bologna, had almost finished the bronze statue of Julius II and would soon be coming back to Florence to paint the Battle of Cascina. This rivalry might have more effect on Leonardo's heart than any words.

«If it is for this», said the Gonfaloniere to the Secretary of

the Republic, «we will make an urgent request; but it will come to nothing».

The peace and quiet of Vaprio had been broken by the first news of Ser Piero's inheritance. Leonardo's brothers, the legitimate heirs, had divided their father's estate, excluding their «bastard» brother. Leonardo had not protested. He could have appealed to the law that gave «recognized natural children» the same rights as legitimate ones. But while that law was perfectly valid for the nobility, for reasons of dynasty or political balance of powers, it was not as binding for the people, including the sons of so-called «respectable men» such as Ser Piero da Vinci.

But when in the following spring of 1507 Leonardo received the news that Uncle Francesco had died and found out that his brothers wanted the little property left by a will that named him the sole heir he decided to leave for Florence, bitterly offended, to claim his rights.

The heredity was more symbolic than real. Uncle Francesco had owned only a house in Vinci with a little land around it and a small farm in Fiesole. «I live at home without business or profession», he had declared in his last tax statement.

Leonardo had often helped him in secret, sending him some of his earnings. And Francesco, on his deathbed, had shown his nephew his gratitude and affection by leaving everything to him.

But in the Vinci family there was now another notary, Giuliano, the second son of Ser Piero. Quibbling, intriguing and interfering, he was searching for any pretext to invalidate that will or delay its execution.

Leonardo had arrived in Florence in the summer, accompanied by Salaì, and had taken lodgings in the home of his friend Piero di Braccio Martelli, in the street of the same name between the Medici palace in Via Larga and the Baptistery.

He had gone at once to the Secretary of the Republic, his friend Niccolò Machiavelli, to announce his arrival and ask for advice. Then, convinced that the matter would be settled quickly, he had requested an audience of the city magistrates, not including the Gonfaloniere.

It was a mistake. He conferred with important persons and had letters of recommendation sent to the Signoria from notables such as Cardinal Ippolito d'Este and the Governor of Milan. In the meanwhile shrewd Ser Giuliano had the «file» disappear, with the complicity of clerks and archivists who sent it from one office to another so that it was «irretrievable» each time it was requested.

It is sad to imagine the elderly Leonardo hurrying up and down the steps of the Law Court, waiting in one antechamber after another, only to hear the vague, elusive response, the usual «we'll see», «don't worry». Leonardo wrote to Milan asking for new and stronger recommendations, but the Government of his fellow citizens paid him no heed.

«Leonardo», remarked Machiavelli one day, «you are wrong to seek the aid of the King, of Marshalls and Cardinals. They are all very important people, but are far away. Here, instead, that Ser Giuliano your brother has control over all the officials in the Bargello. Do as he does, go into the archives, speak with the clerks and secretaries».

Machiavelli knew Florentine bureaucracy well. Leonardo humbly began to roam from one room to another, from one office to another, listening with patience to the complaints of servants and ushers – the great Leonardo standing before their dusty shelves. And the «file» escaped from his grasp at the last moment every time, like a mouse from the sharp claws of an old cat.

«Messer Niccolò my very honored elder brother, I went to look in the register, to see if the name of my brother was entered there. The book was not there. I was sent to many places before I found it. Lately I went to the Signoria del Datario, and I told him... that I wanted to have my plea read. The Signoria said that the thing was very difficult...»

And so the months and the seasons passed. Leonardo tried to compensate for the daily dose of bitterness by discussing mathematics with his friend Martelli and affectionately assisting the young sculptor Giovan Francesco Rustici who was modeling a statue of John the Baptist to be cast in bronze for the Florence Baptistery.

He was painting two Madonnas – probably the Madonna Litta, now at St. Petersburg, and the Virgin of the Scales, which is in Paris – commissioned by Louis XII, and reorganizing his notebooks.

To the researches in Perspective and in the Proportions of the human body were added studies in Optics, in Anatomy and in Architecture and new research in Mechanics, Hydraulic Engineering, Cosmology, Thermology and Acoustics.

There was also a vast amount of literary material, fables and legends taken from Medieval bestiaries or from the living tradition of the people, prophecies, and comments on the day-to-day world. There were the Treatises: on Painting, on the Flight of Birds, and numerous investigations of the marvels of the universe and the mystery of human life.

Leonardo's notebooks contained the «Summa» of his interests, which were infinite. He himself realized that they were lacking in organic form and planned to rearrange them by subject matter, in systematic order, to form an encyclopedic whole.

«Meanwhile», he said to himself, «the important thing is to write, even at the risk of repeating the same concepts. Only later will it be possible to make a critical revision of the text».

It was spring. The «file» was still sleeping on some dusty shelf. Leonardo opened a new notebook and wrote:

«Begun in Florence, in the home of Piero di Braccio Martelli, on the 22nd day of March 1508. This is a collection without order, taken from many papers which I have copied here, hoping to arrange them in order according to the subject with which they deal. I believe that before I have come to the end of this I will have repeated the same thing many times. For this, my reader, do not blame me, because the things are many and memory cannot retain them all, and say: this I will not write because I have already written it. To avoid falling into such an error, for each case that I wanted to copy, so as not to repeat it, I would always have to reread all of the past, and this in particular due to the long intervals of time between writing one thing and another».

«Maestro, have you heard?», asked the young Rustici one day. «Michelangelo has come back from Bologna. Soderini

wants him to make a Hercules to be placed in the square beside the David, in addition to painting the wall of the Council Hall».

«But in Bologna», added Piero Martelli, «he had to make the statue of the Pope in two castings. It was publicly confessed by Master Bernardino, the foundryman of our artillery, who was sent by the Gonfaloniere to help Michelangelo. The first casting only filled the form half-way, from the feet to the belt».

Leonardo listened in silence. In his mind he saw again the model of his horse, now ruined forever. He grieved for the wasted time, the casting that had remained a dream.

«Michelangelo», continued Martelli, «is even more intractable. He refuses to speak. He won't see anyone. He has almost fallen sick over it».

A loan

THE OLD FURY had died down. Leonardo felt he could no longer combat an invisible enemy, one without name and without face. He knew that Michelangelo had gone to Rome to paint the ceiling of Pope Sixtus' chapel, and suddenly he realized that he had wasted too much time over an absurd lawsuit.

«I sent Salaì there», he wrote the Marshall of Amboise, «to explain to Your Excellency how I am almost at the end of my lawsuit with my brothers, and how I think to be there for Easter and to bring with me two paintings, which are two Our Ladies of different size... I would very much like to know», he added, «where I am to stay, since I would not wish to put Your Excellency to any trouble...»

Salaì brought with him two more letters: one for the President of the Waters, the other for the young Melzi.

The King's gift, the assignment of 12 *once* of water to Leonardo's vineyard, had provoked a protest from the Magistrates of the Chamber, who objected that the water given to Leonardo was to the detriment of the citizens and to the King's income. Leonardo, with proof in hand, had demonstrated that «the mouths» of the Naviglio were not regular and that the water granted him was not taken from the King «but from

those who robbed it by illegally widening the mouths of the basins». Once these irrigation outlets had been adjusted the flow of water would be the same and sufficient for all.

«Good day, Messer Francesco», Leonardo then wrote ironically to the young Melzi. «What can God do, that of so many letters I have written you, you have never sent a reply?»

Leonardo wanted to conclude the lawsuit, find a compromise, accept the judgement of mutual friends. By now, for him, it was only a question of sentiment. Uncle Francesco was still unable to accomplish anything, even after death, could not even give him the old house of his childhood days.

«Give me whatever you want. The farm in Fiesole? Agreed. On condition that I leave it to you? Of course, who do you think I would leave it to? At my death it will be yours, and you haven't long to wait because I am old enough to be the father of all of you, rather than the brother».

And so he left, returning to Milan where friends were eagerly awaiting him – Charles d'Amboise, Francesco Melzi, the painter Bernardino da Treviglio, the poet Gian Giorgio Trissino – and where he still had to convince some Magistrate of the Chamber to let him have the water for his vineyard.

Again he plunged into his favorite studies, those on the world of waters in particular.

In his notebooks he confutes Plato and Epicures, quotes Aristotle and Archimedes, Vitruvius and Alberto Magno. He completely re-designed the Naviglio della Martesana, superintended the construction of a lock on the Naviglio Grande, designed new hydraulic machines and resumed his studies on flight. These were the days of the trips to Brianza and Valsassina, the excursions in the woods of the Savoia and on Mount Cervino, where he observed «the greater darkness of the serene sky at very high altitudes». He traced the course of the Ticino and the Po, the Adda and the Oglio. In his spare moments he painted the landscape that forms the background to Mona Lisa. Often, by night, he dissected cadavers to complete his Treatise on Anatomy.

«Maestro», said Salaì one day, «my sister is getting married and I would like to give her a good dowry».

«I understand», replied Leonardo with a smile, «how much do you need?»

«Thirteen ducats».

«Take them, they are in the usual drawer», answered Leonardo.

But that same night, upon sitting down at his desk Leonardo opened his notebook and wrote, with bitter irony, a rhyme familiar to usurers, about money lent never to be seen again.

Gian di Paris

ON MAY 1, 1509 Louis XII arrived at Milan and immediately asked news of Leonardo.

«He is not here», replied the Governor. «He is working on the Martesana project, but I will have him summoned at once».

A few days later, having been informed that Leonardo had come back to Milan, the King decided to visit him. The painter, notified at the last moment, barely had time to set up his works, selecting for each of them, like a skillful director, the right position under a suitable light.

After having repeatedly expressed his profound admiration and having scrutinized the paintings, drawings and studies collected in the famous «Treatises», the King turned to go, saying:

«Maestro, I have seen the Our Ladies that you brought from Florence. I thank you, and I have already ordered your pension to be paid also for the period spent in your city. But now I want to ask you one thing. Forget about that business of the water and dedicate yourself to painting. I cannot allow an artist such as yourself to waste time with the Navigli of Milan».

The King was accompanied by some gentlemen who had come with him to Italy, among them the Count of Ligny, Count Torello and Jean de Paris, *«peintre, ingénieur et architects»* to His Majesty.

«Gian di Paris», as Leonardo called him, was the son of the poet and painter Claude Pérreal and a favorite of Louis XII, as he had been of Charles VIII and was later to be of Francis I.

Expert in architecture and military arts, he depicted his

sovereigns with extraordinary skill amidst the clamor of imaginary battles. He had many interests in common with Leonardo, both artistic and scientific, and the two men soon became friends.

«The measurement of the sun promised me by Master Giovanni the Frenchman», wrote Leonardo, perhaps alluding to a system for measuring the real size of the sun; «learn from Gian di Paris the way of applying colors dry».

Leonardo's humility was an unmistakable sign of his greatness. Writing to himself, he often notes «learn», «have him teach you», «have him explain to you», without the least concern for social position, age or fame.

It was not a question, this time, of the «squaring of the circle» or of some mathematical law to be asked of the great Luca Pacioli. The author of a «Treatise on Painting», the greatest innovator of the Renaissance, had something new to learn – «the way of applying colors dry» – and was asking to be instructed.

«Leonardo, who has superb grace...», wrote a poet favored by Gian di Paris, in a poem in praise of his protector.

It was perhaps at this time, and consequent to conversations with his friends Ligny and Gian di Paris, that Leonardo began the «Bacchus». The two Frenchmen had told him that the King of France wanted a painting with a pagan theme, after so many Our Ladies.

Leonardo's work, now in the Louvre, represents a beautiful young man, his legs crossed, leaning against a rock covered with wild plants. With his left hand he points to a distant horizon. His face bears an ambiguous smile, slightly inebriated. The background is a wild landscape with two deer and a sinuous tree-trunk winding toward the sky.

For Leonardo that Bacchus was a return to nature, a synthesis of numerous observations and secret discoveries.

«Nature is full of infinite reasons, that never were in experience», he wrote in his notebook.

The Count of Ligny, the brave condottiere and rival of Trivulzio, often visited Leonardo in his studio. They even planned a trip to Rome and Naples together, and the artist

wrote this in his notebook in great secrecy, reversing the names to shield them from curious eyes.

«Find Ingil and tell him you will wait for him at Morra and go with him to Lopanna».

Reading the names from right to left, «Ingil» means Ligny, «to Morra» means to Rome and Lopanna is Naples.

More than a trip, this was an appointment. But the project was never carried out, Leonardo stayed in Milan and the Count of Ligny followed his King.

Lights and shadows

NOT CONTENT WITH studying the waters of the land, the motion of oceans, the waves of seas and rivers, the sorcerer turned this thoughts to extra-terrestrial waters, those of the moon.

Night after night he spent at the window, observing the darker and lighter parts of the earth's satellite, deducting that the more opaque parts must be solid and more luminous parts liquid. Unfortunately he had no lens to bring the moon closer, no telescope, invented later by Galileo.

Leonardo drew the moon in its waxing and waning phases to analyze the «nocturnal star when, at the full moon, it shows itself entire».

«Reply to Master Andrea da Imola, who denies that the bright portion of the moon has the nature of a mirror...»

«...All the contradictions of the adversary to say that there is no water on the moon».

But this time the adversary was right.

The brightness of the lighter areas had led Leonardo to think of a «mirror» reflecting the sun's rays, which could only consist of a liquid surface. His adversary was sure of the opposite, that there was no water at all on the moon.

The discussion spread among friends who were scientists and painters – Cristoforo Solari and Andrea da Fusina, Trissino and the anatomist Marc'Antonio Della Torre.

«Forget about it, Maestro Leonardo. Until we have sharper vision, with eye-pieces designed to look far into the distance,

none of us can state with certainty whether or not there is water on the moon. Keep working on your Anatomy instead, and call on me whenever you want».

Della Torre, from Verona, was the greatest anatomist of the times. He was familiar with the work of the Greeks and Arabs, and had offered to collaborate with Leonardo in compiling an organic treatise on human anatomy.

«And so», wrote the artist after these stimulating discussions with a friend who was both scientist and physician, «you would give true information on the human figure, which is impossible. Neither ancient nor modern writers could ever give true information on it without immense, tedious, lengthy writings and great expenditure of time. But with this very brief mode of drawing them in different aspects, full and true information will be given. And so that this benefit that I give to mankind will not be lost, I will teach the way to reprint it in orderly manner».

But the artist's friendship with Della Torre was tragically interrupted. The physician had hurried to Riva del Garda to care for victims of the plague, and had died there himself in 1511, at the age of thirty.

That same year the young Marshall Charles d'Amboise, Duke of Chaumont and Leonardo's great protector, also died in Milan.

Appointed to take his place as military commander was the young condottiere Gaston de Foix, a cousin of the King, under the control of the elderly Gian Giacomo Trivulzio, for whom Leonardo was supposed to make an equestrian monument, still another horse, to be modeled and cast there in Milan with no limitations in size and expense. It was a great temptation.

But the belligerent old Pope Julius II had decided to break the fragile peace that reigned in Italy. To drive the French out of Lombardy he had formed a «Holy Alliance» with Spain, England and Venice, while simultaneously favoring the incursions of the Swiss in the territories of Milan.

On Easter Day of 1512, near Ravenna, a terrible battle was fought between the Pope's allies, commanded by the Viceroy Raimondo di Cardona, and the French army.

The young Cardinal Giovanni de' Medici, the Papal legate,

watched the bloody spectacle dressed in his priest's robes, riding a white horse, as at the time of Carroccio.

The French won the battle and captured the Cardinal, but paid a high price for their victory. The heroic Gastone de Foix lay dead on the battlefield.

Julius II, defeated but not conquered, then called for the aid of Cardinal Matteo Schiner, the Bishop of Sion, who commanded 20,000 Swiss soldiers, while contemporaneously bringing in the reinforcements of Cardona from Emilia and those of Venice from the Veneto.

Trivulzio then decided to retreat beyond the border, ordering the city of Milan to surrender to avoid being ferociously sacked.

At a ford on the Po River the Medici Cardinal was freed by a group of peasants who managed to rescue him from the soldiers escorting him.

After Christmas Massimiliano Sforza, the second-born son of Ludovico il Moro, made a solemn entry into Milan at Porta Ticinese, escorted by Cardona. The Swiss were recompensed by giving them Bellinzona, Lugano, Locarno, Chiavenna and Chiasso. Great festivities were held in Milan for the victorious allies. But the banquets and tournaments were interrupted by news of the death of Julius II, on January 21, 1513. Great suspense reigned until March, when a puff of white smoke announced that the «little cardinal» Giovanni de' Medici, the son of Lorenzo the Magnificent, had been elected pope under the name of Leo X.

The drunk capon

«ASK BIAGIO CRIVELLI's wife how the capon hatches the hen's egg while drunk».

Italy was now a battleground where the armies of France clashed with those of Spain, and Milan ran the daily risk of being invaded and sacked by the Swiss and the Venetians. While all this was going on, Leonardo was entering these strange words in his notebook.

There could be only one of two explanations. It was either a case of supreme indifference or of childish irresponsibility.

Perhaps it was both, and even more the knowledge that it was materially impossible for an artist and scientist to play any part in the drama, or rather the tragedy, of the times.

The King had explicitly asked him not to distract himself with inventions, but to paint; and yet those inventions included such things as fragmentation bombs – the modern shrapnel – machine guns and tanks!

Ignored by the men of war, Leonardo turned his mind to hen's eggs, and how to have them hatched even by capons after soaking their feed in wine.

From his window he witnessed the retreat of the French and the return of the Sforza. The new government did not punish him as a collaborator with the enemy, but ignored him.

Leonardo left the city to take refuge at Vaprio, in the home of his young friend Melzi. An icy wind was paralyzing all of Italy, now become the prey of avaricious foreigners.

In the solitude of the country Leonardo rearranged his papers and wrote caustic notes on the fragility of human nature.

News from Milan or Rome arrived only rarely, brought by some traveler or soldier passing through the little town.

But when the Medici Pope was elected the fires of jubilee lit up Lombardy too, and the news spread in a flash all over Europe.

«Maestro, what are you going to do?», asked Melzi one day.

«I am waiting for some news».

But the news did not arrive, and it was not even necessary. One thing only mattered now. In place of a warrior pope there was the son of Lorenzo the Magnificent. The cold winds of decadence were followed by clear skies and the hope of rebirth.

One by one the most famous artists were going to Rome, and calling their friends to come: Giuliano and Antonio da Sangallo, Bramante, Raphael, Sebastiano del Piombo, Fra Bartolommeo, Luca Signorelli, Andrea Solari, Trissino, Sodoma and Caradosso. This unprecedented gathering of great artists included Michelangelo, Sansovino, Rustici, Filippino Lippi and Andrea del Sarto.

Although no one told Leonardo to leave, or informed him that so many others had already left, he felt the need to end that solitude, which now, after the departure of the French, had become abandonment, and his hopes revived at the name of Medici.

From Vaprio he first returned to Milan, where he calmly rearranged all his possessions, making lists of what he was leaving and what he was bringing with him. He even transcribed the titles of all of his books. And one morning in autumn, when the first fogs of the year were arriving, he set off on his journey.

«I left Milan for Rome on the 24th of September 1513 with Giovan Francesco de' Melzi, Salaì, Lorenzo and Fanfoia».

The bird fair

THE PARTY LEFT Florence by Porta San Pier Gattolino, where Porta Romana now stands, riding fast up the San Gaggio hill toward the Certosa. It was a fresh clear morning in late October. The fields were red with vine-leaves after the recent grape harvest. Salaì rode a little ahead, followed by the Maestro with Francesco Melzi at his side. In the rearguard came Lorenzo, responsible for the horses and the baggage, and Fanfoia, manager of the household.

From Milan to Florence they had traveled fast with only brief stops. Leonardo had business to take care of in the city and wanted to see how his old friends were after the recent disorders. Pier Soderini, they told him, had fled «half-dead» from the Palace by night «pretending to escape to Rome» but taking refuge instead in Ragusa, safer and further away.

Threatened by the armies of Raimondo Cardona camped outside of Porta San Frediano and terrified by the tragic news of the sack of Prato where over 5000 persons had been killed in a few hours, the Florentines had lived days of great anxiety. Then in the frightened city a cry had rung out – «Balls! Balls!» – a cry of hope that the little Cardinal Giovanni de' Medici and his brother Giuliano, among the besiegers, would save their city from pillage and sacking.

After eighteen years of exile the Medici had re-entered the palace on Via Larga. Giovanni, the Cardinal, was thirty-six, Giuliano thirty-three.

Their return had been hailed as salvation, since it meant the end of the siege. The city offered no opposition and the Medici made no attempt at revenge.

But the ancient republican regulations and Savonarola's statutes had been suppressed immediately. The Great Council had been dissolved and that of the Hundred, made up of faithful, trustworthy men, had been restored. Machiavelli had been confirmed Secretary of the Ten of Balia – that is, of the Government – but shortly afterward, unjustly accused of involvement in the foolish conspiracy of two rash young men, he had been deposed, tortured and exiled.

«He is living on his little farm at Sant'Andrea in Percussina», Piero Martelli told Leonardo, after having related the dramatic vicissitudes of the city.

«...And Giuliano de' Medici has certainly tried to imitate his father. He too is a friend of artists, highly educated, of good character. He began by shaving his beard, in homage to the republican institutions, and wearing the old republican gown. Now that his brother is the Pope, he has gone to Rome too».

But what a sight Florence was on that night when the news of the white puff of smoke arrived! Bonfires everywhere, «fireworks and explosions», and what didn't rain down from the windows of the Medici palace! Bags of money and «caps, hats, capes, gowns and other clothes of the Magnificent Giuliano that was a stupendous thing».

«Today», concluded Piero Martelli, «we are governed by Lorenzo, Piero's son, assisted by his uncle Giulio the Archbishop of Florence».

Passing in front of the cloister of Santa Maria Novella Leonardo remembered that he still had the key to the Hall of the Pope. He opened the door, not without emotion, and entered. To his surprise he saw that his cartoons had been brought back. He examined them at length, in silence, for the last time. Only a few years later they no longer existed. Excessively admired by all, they were cut into pieces and stolen, like

those of Michelangelo, after having been, as Cellini was to write later, «the school of the world».

Having deposited 300 gold florins in the bank of the Hospital of Santa Maria Nuova, Leonardo journeyed on toward Rome. This time he was in no hurry.

The weather was splendid, and Piero Martelli had written a letter to his friend Giuliano de' Medici to announce that the artist was arriving.

The group had just reached Falciani and begun to climb the hill up to the Sant'Andrea woods when Leonardo remembered that these were the lands of his unlucky friend Machiavelli.

At the top of the hill stood the simple, austere house of the former Secretary of the Florentine Republic, and there the five travelers stopped.

«I am here, my dear Leonardo, to smell the air of Florence borne by horsemen and couriers passing through or by friends like you. I work in the woods and vineyard, I lose my temper with these peasants who try to steal from me even at cards. Then by night I put on my official robes, and in my imagination I live again in the courts, conversing with the great, questioning them and listening to them. And here» – Machiavelli pulled out a thick pack of paper covered with writing – «is the result of these discussions».

The two friends dined together. Leonardo told Niccolò of the latest events in Milan, the feeble return of the Sforza met by the indifference of the people, the first festival held at the Castle degenerating into a sack by the Spanish. At the sight of so many jewels sewn onto the dresses worn by the ladies of the court, Cardona's officers had pulled out their daggers and begun to cut the clothes off the Duke's guests, men and women alike.

It was almost evening when Leonardo arrived at Barberino Val d'Elsa, where he decided to stop for the night.

Early next morning the party was preparing to leave. In the public square Leonardo saw a pile of cages and baskets filled with birds, exhibited by an itinerant vendor. He approached. There were sparrows, chaffinches, thrushes, warblers, robins, blackbirds, owls and other birds as well – turtle-doves, hoopoes and owls.

«How much do you want?», asked Leonardo.

«For which one?»

«For all of them».

«All these birds?», demanded the vendor incredulously.

«Take this», said Leonardo, handing him a bag of money. Then, one by one, he opened each cage, delicately pulled out the birds and «launched them in flight in the air, restoring to them their lost freedom», as Vasari remarks in amazement. To the young Francesco Melzi who was watching the Maestro in wonder Salaì, shaking his head, said, «Nobody can stop him. He's always like this, whenever he sees some bird locked in a cage».

The Magnificent Giuliano

THE CITY OF Rome in the Renaissance was a very different place from the imperial capital of antiquity with its six million inhabitants, or the chaotic metropolis of today.

At the start of the sixteenth century Rome was a turbulent little city, poor and corrupt, with no commerce but with a swarm of traffickers in obscure transactions.

The whole population of about one hundred thousand people gravitated around the papal court. Three or four broad streets lined with magnificent palaces traversed the length and width of the city. The rest of it consisted of an intricate web of dirty, stinking alleys, interrupted by vast «dead zones» where the marble remains of ancient glory lay covered by weeds.

The sumptuous splendor of the papal court nourished an underworld of suppliers, servants, procurers, dealers, prostitutes and artists.

Giuliano de' Medici, appointed Gonfaloniere of the Holy Church, welcomed Leonardo with open arms, meeting him for the first time after having heard so much of him. He gave the artist lodgings in Fort Belvedere, with a studio and several rooms for his companions. Immediately Giuliano commissioned two paintings, a Leda and the portrait of a «certain Florentine woman» who had followed the Magnificent brother of the Pope to Rome.

Leonardo and Giuliano quickly became friends. Both of them felt that they had found each other again, like two old friends meeting after years. Each discovered in the other the same interests, the same love for «speculative nature», and similar thoughts and feelings.

Giuliano too, like his father Lorenzo the Magnificent, could boast of being the friend and protector of many artists in Florence and Rome. But the sudden friendship between him and Leonardo was not based on painting alone but also, and above all, on their mutual love of mathematics and mechanics. «They studied together», says Vasari, «the things of philosophy, and alchemy in particular».

Giuliano's protection gave new security to Leonardo and a new impetus to all his interests. In addition to painting he devoted himself to preparing a «mysterious device» kept secret from everyone but Giuliano, for which he requested the collaboration of two German technicians specialized in manufacturing mirrors.

He continued to pursue his studies in geology, making excursions into the Roman countryside – «have them teach you where the shells are on Monte Mario» – without neglecting his archeological research, which had become a contagious passion. Every artisan and artist had a little vineyard or field to dig up in search of a Laocoon or an Apollo.

Experimentation in human flight took a new direction. From big models Leonardo went on to tiny ones. He experimented with gliding flight and the curvature of wings by modeling miniature birds in thin wax. Absorbed in this new activity, he made other strange animals to be launched in the air and carried on the wind to frighten people.

«He formed a paste of a certain kind of wax», states his biographer, «and as he walked he shaped animals very thin and full of wind, and by blowing into them made them fly through the air».

In Rome Leonardo found two old acquaintances: Bramante, now laden with years and with honors, and Raphael, the Pope's favorite, who was frescoing the Stanze della Segnatura and holding court like a prince.

At the head of a group of horsemen, all young and elegant, Raphael rode past the Belvedere one day just as Leonardo was leaving on foot.

As soon as he saw Leonardo, Raphael dismounted and ran to meet him.

«Maestro», he said bowing his head, «I must apologize for not having come to see you yet».

Leonardo gazed affectionately into his eyes, which were not those of the past. Now they expressed haste, anxiety to accomplish immediately, and a strange fear.

«I know», he answered, «you have the Pope's Stanze to paint, and I have heard that what you are doing is magnificent. I will come to visit you».

Now Raphael's pupils, led by Giulio Romani, had approached, and Raphael turned to them to exclaim:

«Friends, never forget this day! Today you have seen Leonardo».

Jokes and jests

«LOOK WHAT A beautiful lizard», said the gardener of the Belvedere one morning to Leonardo who was strolling through the fields. «It's so unusual that I didn't want to kill it. I put in under this», he added lifting the edge of a vase and pulling our a bright green lizard with a blue throat, «to show it to you».

Leonardo picked up the reptile.

«Could you find me others?»

«Of course, Maestro. Alive or dead?»

«It doesn't matter. Even dead».

And with his live lizard, and a strange idea in his head, Leonardo returned to his studio.

«...To a very strange lizard», writes Vasari, «found by the gardener of the Belvedere, he fastened some wings with a mixture of quicksilver made from scales scraped from other lizards, which quivered as it crawled about. After he had fashioned eyes, a horn, and a beard for it, he tamed the lizard and kept it in a box, and all the friends to whom he showed it fled in terror...»

This is the Leonardo of the jests and practical jokes, an artist who had not lost the bizarre sense of humor native to the Tuscans. He was the fellow citizen of Bruno and Buffalmacco, the reader and admirer of the biting witticisms of Poggio Bracciolini.

Michelangelo, secluded in his house in Macel de' Corvi, was sculpting the captives for the tomb of the Della Rovere pope. At the head of the stairway in his house he had painted a skeleton with a coffin under his arm, to have always before him, not only in his thought but even before his eyes, Savonarola's terrible *memento mori*.

Leonardo, with a box under his arm containing the lizard, tamed and transformed into a dragon, wandered through the streets in search of friends who would ask him, «What have you got in there?», so that he could raise the lid. Immediately the dragon leaped out, climbed up on his shoulder, its wings, crest and beard quivering, the mercury glistening on its scales and around its eyes, while the friend of the moment fled in terror, followed by the sorcerer's delighted laughter.

Just as he had wasted so much time painting the small shield, now he was wasting days in rearranging his lizard's costume, devising new color schemes and inventing amusing accessories.

For greeting visitors at home he had found another joke: «...He had the guts of a steer cleaned of fat», wrote Vasari, «and they came out so small that they could be held in the palm of one hand. In another room he placed a pair of smith's bellows to which he attached one end of these guts so that by blowing them up he filled the whole room, which was enormous, so that anyone standing there would have to move to one corner. Pointing to those transparent forms full of air, Leonardo compared them to talent, since at first they occupy little space but later come to occupy a great deal».

A pair of bellows had been purposely installed, with an air inlet in the wall and one or two boys trained to work it, and all this to impress a friend, Giorgio the German or «degli Specchi» or a visiting artist from Florence, concluding with such a moral, the comparison to talent which grows immeasurably when well used.

This too is Leonardo, and we can imagine his conciliating smile after these jokes, his affectionate demonstration that the dragon was only a lizard, his ironic good humor with the visiting friend.

But Giorgio the German was one who did not appreciate jokes. He had been assigned to Leonardo by the Magnificent Giuliano, but the artist, who tried to teach him drawing and Italian, felt he was wasting his time and exhausting his affection. In conspiracy with another German, a certain Giovanni, also called «degli Specchi» because he produced mirrors for all of the prostitutes in Rome, Giorgio had in fact decided to evict Leonardo from his rooms in the Belvedere, and was disturbing him in every way possible.

More than once Salaì had fought with those two scoundrels who liked to get drunk with the Pope's Swiss guards and go around armed with harquebuses to shoot at pigeons, swallows and turtle-doves in the papal courtyards.

Giovanni the German wanted Leonardo's rooms, and occupied them by force to enlarge his mirror factory, visited every day by a horde of customers entirely lacking in respect for the private studio of an artist. Exasperated, Leonardo wrote Duke Giuliano a lengthy, violent protest against the two intruders.

Giuliano de' Medici stepped in, ordering the Germans not to disturb Leonardo upon penalty of being evicted immediately from the Belvedere and having to leave Rome. Giovanni degli Specchi obeyed, but swore vengeance in his heart. Requesting an audience with the Pope, he publicly denounced Leonardo for engaging in magic practices and sorcery and for dissecting cadavers with the complicity of the director of the Hospital.

The Pope, having been given this information in front of the whole court, could not ignore the accusation and ordered that Leonardo be denied access to the Hospital of Santo Spirito.

«He has kept me from anatomy», noted the artist in his notebook, «with the Pope by reproaching me and the same at the Hospital».

Surely Leonardo could not imagine that, only a few years

later, for these same accusations, prisons would be open, the torturer ready to act, and the fire lit at the stake. The Pope's prohibition was nothing more than a simple formality.

«Leonardo», said Leo X to the painter kneeling before him, «if you forgot about those cadavers and took your brushes in hand again, wouldn't it be better for you and for all of us?».

Leonardo had just finished a «Woman with a Child in her Arms» and the Pope, who had received it as a gift from his brother Giuliano, was lost in admiration of it.

«I am at the service of Your Holiness», replied the artist.

«Good. Then go and have a look at the wall behind the altar in Sant'Onofrio on the Janiculum and decide what you could paint on it».

Some months later the Pope asked his courtiers how Leonardo was progressing with the painting.

«Holy Father», they answered him, «Maestro Leonardo has not started painting yet, but he is distilling special oils and herbs for the varnish that will protect the painting».

«Alas!», exclaimed Leo X, «he will never do anything, since he begins by thinking about the end before the beginning of the work!»

Instead, as some authoritative scholars assert, the mural was soon completed. According to the descriptions of the time, it was a Madonna with Child, her hand resting on a pillow, gazing at her Son who is raising his right hand in blessing. The Madonna's hands, one at rest, the other slightly raised, express maternal vigilance to keep the child from falling.

It is certain however that Leonardo did not stop at the device for distilling the paint. Some drawings now in the museum at Windsor, showing a putto in various attitudes, lying on a cushion and in his mother's arms, are undoubtedly studies for the Sant'Onofrio fresco.

And Leo X, standing before that painting, must have exclaimed with great satisfaction to his entourage:

«What do you think of it, my children?»

Marignano

«THE MEDICI MADE me and unmade me». It is possible that Leonardo's embittered remark dates from this period. Certainly the artist, like Michelangelo, found no room for himself in the Rome of Leo X. The Pope had eyes only for Raphael, while for Leonardo he felt an instinctive awe that took the form of plain dislike.

The favor of the Duke of Nemours, who was that Giuliano de' Medici appointed Gonfaloniere of the Holy Roman Church by his brother the Pope, managed only in part to soothe the artist's pain at feeling himself ignored, or misunderstood, not so much as painter but as researcher and scientist.

Leo X, like his predecessor, «was in a hurry» and he surrounded himself with persons capable of carrying out his grandiose projects for changing the face of Rome and of the world. «Beauty and dynamism» could have been his motto. And it was inevitable that Leonardo, with his perplexities and proverbial slowness, would be excluded not only from court circles but from artistic ones as well. He alone, in fact, was not infected by the fever for antiques, he alone did not ask for walls to fresco in the Pope's rooms and chapels, while he enthusiastically accepted an assignment to study a project for draining the Pontine swamps. The Pope had decided that the swamps should be drained and had assigned to his brother Giuliano, in a Brief dated December 1514, the task of undertaking a project for *pigram paludem pontinam.*

Leonardo the hydraulic engineer was in his element. He had already drained the swamps of Vigevano for Ludovico il Moro and had devised a plan for draining the Val di Chiana for the Republic of Florence. Now he asked nothing better than to put the wealth of his experience at the service of his protector.

The testimony to this initiative is a beautiful map of the Pontine swamps conserved among the Windsor manuscripts. It is a bird's-eye view of the whole swampy area from the slopes of the Lepini as far as the Circeo.

But less than a month later, on January 9, 1515, «Giuliano de' Medici left Rome at dawn to take a wife in Savoia».

Giuliano was not enthusiastic about this marriage, arranged by his brother the Pope; but obedient to reasons of State he had set off for Turin with a retinue of courtiers and friends.

Probably Leonardo accompanied his protector and patron, returning to Rome with him and the noble Filiberta, the first lady from a royal family to marry one of the Medici.

But the tranquil stay in Rome was about to come to an end. In France Louis XII had died and Francis I, his successor, was pawing the ground in his eagerness to invade Lombardy and drive the Sforza family and the Swiss out of Milan.

The news arrived in fragments, always more alarming. Giuliano, commander of the forces of the Church, was about to move toward Parma and Piacenza to defend the papal territories.

This time too Leonardo followed his protector, but this time, unlike the other, he carried with him all his household goods, as if obeying some obscure forewarning.

Upon arriving at Florence Giuliano fell severely ill. His hereditary tuberculosis suddenly exploded violently, so that he was forced to rest in the palace on Via Larga, yielding command to his nephew Lorenzo, the Duke of Urbino and son of Piero the Fatuous.

Leonardo joined Lorenzo's retinue, following him through the Apennines up to Piacenza.

Meanwhile Francis I, instead of taking the usual Monginevro road that led to Susa, had crossed the Cottian Alps and conquered Villafranca in a brilliant maneuver, surprising Prospero Colonna, head of the Sforza militia, and capturing him seated at table with his captains.

He went on to defeat Novara and Pavia, then occupied Magenta and Corbetta and camped at Melegnano.

On September 13, wearing a purple mantle and preceded by the cross of the papal legate, the Swiss Cardinal Schiner, who had been waiting at Marignano, gave the battle signal, riding at the head of six thousand horsemen. It was a bloody clash, the outcome uncertain up to the last moment. The drums rolled for a day and a night, but in the evening of the following day the battle «not of men but of giants» was won by the French,

thanks to their highly mobile artillery and the strategic skill of Gian Giacomo Trivulzio.

The defeated Swiss retreated in perfect order toward Milan, transporting their baggage and their wounded. The catastrophe of Marignano shocked the Pope, who hastily requested a meeting with the King of France to start negotiations.

Leonardo, at Piacenza with the papal troops, was ordered to join the Pope at Bologna. Leo X wanted to present himself to the King of France with his entire court, including the famous artists such as Raphael and Leonardo.

Francis I

THE MAGNIFICENT GIULIANO was dying. The Pope entered Florence lavishly decorated for a festival – all of the artists had been mobilized to beautify the city – and went to the palace on Via Larga as soon as the official ceremonies were over.

«Do not forget Leonardo», murmured Giuliano, «he can be useful to you. King Louis loved him dearly».

For this reason Leo X had sent a messenger to Piacenza. His nephew Lorenzo was to join him at Bologna, bringing Leonardo with him. In the artist's notebook is a description of the various stages of this hurried journey, «Fiorenzuola, Borgo San Donnino, Parma, Reggio, Modena, Bologna».

And finally the French King and the Florentine Pope met. The encounters lasted three days. Pope and King were lodged in the same palace, each surrounded by his own gentlemen, knitting tighter every day a friendship that was initially fragile and cool.

At the conclusion of the meetings came the presentation of the dignitaries from each entourage. The Pope, unlike the King, had some rare pieces to display:

«This is the painter Raphael, whose works your Majesty already knows, and who is now painting our rooms in the Vatican», said the Pope with a smile.

«And here, your Majesty, is the great Leonardo da Vinci».

When Francis I heard the name of Leonardo and raising his eyes saw the artist bowing before him in dignified respect, he

rose to his feet, held out his arms, and going to meet him exclaimed with heart-felt sincerity:

«Leonardo, *mon père...*»

And so Leonardo took his leave of the Pope and of Italy. After the official ceremonies Francis I had summoned him to his rooms to express his affection again.

«Come to France with me», he said. «I will ask of you nothing in return. It will be enough for me to speak with you sometimes, to listen to you as my great father did».

Leonardo, deeply moved, looked at the noble head of this young man and read in his eyes the sincerity of an offer, the warmth of friendship, the security of protection. By now Giuliano de' Medici could give him nothing more. He was fast approaching death and after him Leonardo would have no friend to protect him, not even the Pope. The artist bowed his head in sign of assent. Francis I grasped his hand in a wordless pact.

The carafe of tasteless wine

SALAÌ HAD DECIDED to remain in Milan. He was over forty now, he said, and felt old. In reality he understood that the young Francesco Melzi had taken his place in the heart of the Maestro. Although recognizing that the fault was his own, he was more angry than regretful.

Leonardo allowed Salaì to build a house in the vineyard beyond Porta Vercellina given him by Il Moro, and left him all the household goods that he could not take to France.

These were the last days of preparing to leave and saying farewell, of visiting the few friends who had survived the tragedies of the Duchy. Leonardo went to Santa Maria delle Grazie for a final look at the Last Supper and noticed in silence the progress of the secret evil that was now spreading under the paint. The manager of his farm in Fiesole had sent him a sample of the new wine still fresh from the cask. Planning to drink some of it as a stirrup cup, to bid farewell to his companions and to Salaì, Leonardo tasted the wine. It was insipid, destined to become sour as vinegar during the journey.

«From Milan to Zanobi Boni, my steward, on October 9, 1515.

«The last four carafes did not meet my expectations and I was sorry. The vines of Fiesole when cared for in the best way should furnish our Italy most excellent wine, as for Ser Ottaviano. Remember that I said you should fertilize the rib when it rests in the rock with the rubble of mortar from demolished buildings or walls, and this dries the root. And this and the breezes of the air will attract the substances needed to perfect the grapes».

This clearly shows that Leonardo was already aware of the properties of mineral fertilizers, a discovery that was to be attributed to Priestley in 1771; and that he also knew something of the respiratory functions of the aerial parts of plants, a phenomenon discovered and described three centuries later.

«Then», he continues, «we do very badly in our days to make wine in uncovered vessels, so that the air escapes, and nothing remains but a damp insipid deposit from the skins and the pulp. Today it is not done as it should be, changing the wine from vessel to vessel, so that the wine becomes turbid and heavy in the viscera.

«If you and others would only listen to this reasoning, we could drink excellent wine.

May M.N.D. protect you.

Leonardo»

A bad wine was all he had gotten from Uncle Francesco's farm. A good piece of advice, and a precious recipe was all he could bequeath to his heirs, as he left Italy forever.

On Monginevro

THE TRIP ACROSS Monginevro was pleasant. The King called for Leonardo constantly to converse with him, or rather to listen to him. The old artist confided to the young King his still occult knowledge, the fruit of his observations and the essence of

his meditations, which our own century has just begun to rediscover. He showed the King the falcons wheeling above the snowcapped peaks and spoke to him of flight, of its dynamics, its laws. He recounted his own attempts and the disastrous flight of Zoroastro, but confirmed once more his deep conviction that man would one day fly like the birds, and even higher and further.

«Man is a citizen of the universe, Your Majesty, and in the universe he will move to discover new worlds».

He spoke of mathematics and mechanics, of geology and hydraulics, of astronomy and physics. When they stopped along the journey he showed the King his Treatise on Anatomy, describing the lonely dread of so many nights spent beside cadavers in hospital morgues. «I have dissected over thirty human bodies», he recounted, «destroying every member, consuming with the most painstaking care all the flesh which lies around the veins, without causing them to bleed except a little from the capillaries. And one body alone was not sufficient for the time required, but I had to proceed gradually to many bodies before the whole study was completed, which I repeated twice to see the differences».

Francis I listened enthralled. The royal entourage had not yet entered France and the King was already thinking of a way to assign the artist a residence not far from the court, so he could visit him as often as possible.

In Provence they were joined by Luisa di Savoia, the King's mother, who was also traveling to the capital. The two royal retinues journeyed on together and the Queen too was fascinated by the great «philosopher», remarking to her son that Leonardo was an extraordinary man. Suddenly, as if struck by an idea, she exclaimed:

«At Amboise! Of course our great Leonardo will live at Amboise, near us. I will give him the residence of Cloux which belongs to me».

Leonardo had not yet been informed of that decision. He rode in silence, observing the plain extending below him. Francesco Melzi followed him, along with a young man named Battista de' Villanis, hired as servant before leaving Milan.

Riding in a cart was Maturina, a frightened, lost girl, alone in the midst of all those people speaking another language.

Occasionally Leonardo felt a tingling in his right hand that rose along the arm, leaving it sluggish for a while. The King's herald had suggested to him a remedy, which he diligently transcribed in his notebook: «Medicine to be rubbed on, taught me by the herald of the King of France; four ounces of new wax, two ounces of incense, and each thing kept separate, and melt the wax and then put the incense in it, let it pervade, and apply it to the suffering part».

«Draw, Francesco»

THE CASTLE, OR rather the hostel of Clos-Lucé, also called «the Cloux», was a solid Medieval building composed of two square constructions. In the inner corner between the two buildings an elegant octagonal stairway led from the courtyard to the first floor. The steep roofs housed comfortable mansards with large windows projecting from beneath the slate gutters. The hostel, originally built by the Amboise family for the local priests and monks, had later become the fortress of a favorite of Louis XI. In 1490 it was purchased for 3500 *scudi* by Charles VIII, who had it restored and enlarged. Now it belonged to the King's mother Luisa di Savoia and his sister Marguerite d'Angoulême, the «Marguerite of the Marguerites» author of lively novellas. These two ladies had generously offered it to Leonardo, to be his home for the rest of his life.

The King had also arranged for the elderly artist to be paid an annuity of 700 gold *scudi*, to relieve him of any shadow of worry about money. In exchange the young King asked only friendship. Whenever he could he went to Cloux – less than a kilometer from Amboise as the bird flies – or sent a carriage to bring Leonardo to his castle.

Endowed with lively intelligence and a prodigious memory, Francis I assimilated information from every field of knowledge, so that soon «there was no science», wrote a historian of the times, «which he could not master».

«Vinci», reported Cellini later, «was filled with such great learning, having knowledge of Latin and Greek literature, that King Francis was most greatly enamored of those talents...»

«I must not fail», he continued, «to add those words which I heard the King say of him in the presence of the Cardinal of Ferrara, the Cardinal of Lorena and the King of Navarre. He said that he believed that no other man had ever been born who knew as much as Leonardo, of sculpture, painting and architecture, and that he was a very great philosopher».

In slowly returning to a peace that was not merely external, Leonardo had begun to work on a painting he had brought with him from Rome. It depicted a young man with almost feminine features, an excessively gentle face, pointing with his finger to something above, outside of the picture. Leonardo had painted no landscape in the background, leaving the figure wrapped in shadow.

«Maestro, who is it? what does it mean?», asked Francesco Melzi occasionally, his curiosity aroused.

And Leonardo, barely smiling, like his ambiguous and disturbing creature, replied each time:

«Draw, Francesco, draw».

«A life well spent is long»

NEAR THE HOSTEL of Clos-Lucé flowed the Loire, and a man like Leonardo could not fail to take an interest in its waters. «Never was his mind at rest», states the Anonymous, «and always with his ingenuity Leonardo fabricated new things».

Here he was then, making the first surveys of the terrain, extensively exploring all of the water courses in the area. He covered the whole region of today's Berry in his desire to give the King, as quickly as possible, a gigantic project for channeling these waters.

The Romorantin canal was to have joined Tours and Blois to the Saône, serving both as navigable waterway and reservoir for irrigation. The two points of departure would be served by a port at Villefranche. Then, passing beyond Bourges and receiv-

ing the waters of the Dore and the Sioule, the channel, now filled with water, would have flowed back into the Saône at Maçon.

But the winters at Cloux were long and cold, and Leonardo often had to stay at home.

Then he rearranged his notes, taught Francesco Melzi «mirror writing», so that he could not only read it but also write it, and painted for many hours.

The cartoon of the Virgin in St. Anne's lap, exhibited so many years before in a room at Santissima Annunziata in Florence, had finally become a painting, finished in every detail. The Gioconda now had her landscape of streams and rocks; and the figure of an adolescent, still undefined, stood on the easel hidden by a great cloth.

«Maestro, there are visitors for you», said Battista de' Villanis as he entered the studio.

It was Marguerite d'Angoulême, the King's sister and her cousin Filiberta di Savoia, the widow of Giuliano de' Medici Duke of Nemours.

«Maestro», said the young sister of the King, «we have come to ask your help. We want to celebrate the arrival of His Majesty, and we have heard of the magnificent things you did in Milan. You alone can make the festivities unforgettable».

Leonardo smiled and nodded in assent.

«We will do it... we will make something».

And he arranged a production that was to be spoken of by the chroniclers for years. In a fantastic carousel, moved by invisible rods and springs, Leonardo had put the King at the center of allegorical jousts in which he was always victorious. At the end a hermit ran onto the scene imploring the King to free the land from a ferocious lion that was terrorizing the countryside. At once the lion – a masterpiece of automation – entered the scene, stopping menacingly in front of the King and emitting a deep roar. But the King, unafraid, touched it with his scepter and the beast fell quiet, assuming the heraldic position, seated on its rear legs. Then with its claws it tore open its breast, from which a cascade of golden lilies spilled out.

«Leonardo, my dear Maestro», exclaimed the King, «you are a magician! King Arthur himself had no such extraordinary man at his court!»

Returning home Leonardo still had the energy to sit down at his desk until far into the night to resolve some complex exercise in geometry. Early next morning, along the banks of the Loire, he stopped to contemplate the water, listening to an inner voice:

«Oh admirable justice of you, Prime Mover, that you have given to each power the order and quality of its necessary effects».

The Prime Mover was the Logos, the Verb that justified everything in existence, even the cloud dissolving in the calm heavens, even the water flowing in the river.

«Because», said the elderly Leonardo to himself, «it is indispensable, since no thing by itself alone can be cause of its own creation».

These were the fecund thoughts of the Clos-Lucé years, free from any material concern. But had Leonardo ever really had such concerns? Vasari, with a touch of envious wonder, says that «he having nothing, it may be said, and working little, always kept servants and horses...» In reality Leonardo had always considered money to be a means, not an end, and a means can always be found. Here he felt no more the blind jealousy of other artists around him, as would have been the case had he stayed in Italy. Housed in a princely residence, assisted and comforted by the filial affection of his pupil, Leonardo lived the twilight of his life in an oasis of gentle melancholy.

Feeling that the night was approaching, he saw his life again in a single image, as in an immense fresco, and consoled himself by writing: «As after a day well spent it is good to sleep, so after a life well used it is good to die». And so as not to count the years, not to compare his age with that of younger men, which might have seemed to oppose the will of the Prime Mover, he added with a glance at his codexes: «The life well spent is a long one».

His inimitable left hand

ONE DAY CARDINAL Louis d'Aragon, on his way to Tours, stopped to render homage to the great Italian painter.
Don Antonio De Beatis, the Cardinal's secretary, has left us a detailed report on that visit:

«My Lord with the rest of us went to Cloux to see Messer Lionardo Florentine, an old man of more than seventy years...»

It must have been the autumn of 1516. Leonardo was not yet 65, but looked much older. Almost certainly dating from that time is a red-chalk drawing now in the Turin Library which shows a prematurely aged face with hollow cheeks, a towering forehead, and eyes fixed in the frowning gaze of an ancient prophet.

«...he showed His Illustrious Lordship», continues the report, «three pictures, all of them most perfect, one of the Madonna and her Son, which are placed in the lap of St. Anne, the other of a certain Florentine lady, done from life at the instance of the late Magnificent Giuliano de' Medici, the other of St. John the Baptist as a young man...»

Melzi could not believe his eyes. When Leonardo unveiled his latest work to show it to the Cardinal, the personage in the painting was no longer a Bacchus nor an ambiguous adolescent, but a St. John the Baptist.

The Maestro had added a cross as slender as a reed, following the line of the arm from the floor, then a finger pointing heavenward and the picture had suddenly taken on unmistakable significance.

Melzi looked at Leonardo in amazement. The artist looked back at him and smiled, nodding.

Then he turned again to the Cardinal, showing his Treatises on Flight and on Anatomy.

«...He has compiled a particular treatise on anatomy, with the demonstration in painting not only of the members, but also of the muscles, nerves, veins, joints, intestines and everything else imaginable in the bodies of both men and women, in such a way as has never before been done by anyone else. All of which we have seen with our own eyes», repeated De Beatis, to

dissolve any doubt, «and he says that he has already dissected more than thirty bodies, both males and females of all ages...»

Leonardo then showed his guests his studies «On the nature of water» and on «Various machines». But the guests, the Cardinal d'Aragon in particular, observed with sadness that right hand «that will never again do anything good» because, struck by paralysis, it was withered and atrophied.

They did not know that Leonardo had continued to paint his John the Baptist as the disorder progressed. Only Melzi, who still could not take his eyes off the painting, knew that the Maestro had painted almost all of it with his left hand.

It was his famous and «inimitable left hand» that had made the luminous sign of a cross descend here, as if from heaven, like a symbol of hope.

The gift of life

«MESSER LEONARDO DA Vinci painter to the King, at present residing in the place called Cloux, ... considering the certainty of death and the uncertainty of its hour, acknowledged and confessed... his will and last testament in the following manner.

«First of all he commends his soul to our Lord God, to the glorious Virgin Mary, to Monsignor Saint Michael, and to all the holy Angels and Saints in Paradise.

«Item...»

It was April 23, 1519, Holy Saturday. Leonardo, now bedridden for months, had summoned Maestro Guglielmo Borian, Notary to the King, and five witnesses in addition to Francesco Melzi. They were the vicar and the chaplain of the Church of St. Denis, and the prior and two friars from the nearby Monastery of the Minors.

The witnesses listened to what the Maestro, his head raised on a pile of cushions, said with appropriate words and a fully lucid mind and spirit.

First the soul, which does not die but lives and has need of so much pity; and thus «three solemn masses and thirty low

masses» were to be held in the Church of St. Denis and in that of the friars; then the body, to be buried in the Church of San Fiorentino; last his property, the goods of life.

«...To Messer Francesco da Melzo, Gentleman of Milan», all of his paintings, drawings, manuscripts and books «and other Instruments and Portraits concerning his art and the industry of Painters». And as token of his great affection, «all and each of his garments».

To Battista de' Villanis was left half of the vineyard outside the walls of Milan and the water from the Naviglio. The other half was left to Salaì «in which garden the aforesaid Salaì has built and constructed a house»; and this «in remuneration of good and appreciated services, which the aforesaid de' Villanis and the aforesaid Salaì his servants have rendered him in the past».

Leonardo was conscious of what he was saying. Salaì was no longer a son and not even a pupil. Even in his heart the figure of that dearly beloved and unfaithful disciple had dwindled. Salaì was nothing more than a servant; fond of his Maestro perhaps, but nonetheless a thief and an ingrate.

«Item.. give Maturina his serving girl a dress of good black felt lined with fur... and two ducats».

Then he thought of the funeral, which was to be solemn, because such occasions are always a family procession which leaves the house and walks through the streets under the eyes of all. And Leonardo, half-closing his eyes as if he were already watching the funeral ceremony, said:

«...sixty torches which will be born by sixty poor men to whom money will be given», then the whole College of the Church of San Fiorentino – Rector, Prior, Vicars and Chaplains – and that of St. Denis and of the Monastery of the Minors. There was to be Gregorian chant and incense during the mass, and many candles, «ten pounds of wax in big candles that will be placed in the aforesaid churches to serve all day while these services are celebrated».

To his «blood» brothers, not those of his heart, he left the 400 gold *scudi* deposited in the bank of Santa Maria Novella and the little farm in Fiesole. The executor of the will, with «full

and integral effect» was to be Francesco Melzi, there present, who signed in acceptance before the witnesses.

After Maestro Guglielmo and the others had gone, Leonardo looked at Francesco, who could not restrain his tears.

«Francesco», said Leonardo, «to arrange these things is normal foresight. I do not wish to leave you, as I have no reason to suddenly abandon this earth. I have always said that life is a gift, and that he who does not appreciate it does not deserve it. So that we must deserve it to the last, without failing to honor it in the fear of death».

«Look», he added turning his head toward the window, «the winter was long but now the trees are awakening, all of nature is reviving under the sun. It is born again, do you see?»

The last experience

LEONARDO, HALF ASLEEP now, saw again the last festival, organized for the baptism of the first-born son of Francis I and for the wedding of Lorenzo de' Medici.

The son of Piero the Fatuous, appointed by his all-powerful uncles – the Pope and the Archbishop of Florence – Gonfaloniere of the Republic and Duke of Urbino, had come to France to marry the very young and beautiful Madeleine de la Tour d'Auvergne, cousin to the King.

Lorenzo had entered Amboise accompanied by a splendid retinue, led by the valets of the Republic, to the trumpeting call of clarinets, followed by flag-throwers launching on high the banners of the Tuscan provinces. Then came the flags of every quarter of the city and lastly the representatives of the French nobility, dressed in crimson velvet.

Leonardo had been at the height of his fame. The baptism of the heir to the throne, Lorenzo's godson, had taken place in the cathedral decorated as a great amphitheater filled with angels like heaven itself, while the wedding had been animated by magic and technical feats worthy of and perhaps even surpassing those devised in Milan for Ludovico il Moro and for the arrival of Louis XII.

Once again Brunelleschi's marvelous «earth-heaven» mechanism had been used, and the King in his joy had embraced his «sorcerer» before everyone.

«The King», murmured Leonardo every once in a while, his hands abandoned on the blanket, his eyes closed, his white head reclining on the pillow as if he were asleep.

«The King». But from his lips issued only a slight panting, a sound of heavy breathing.

Then, he recalled, but vaguely, there was the birth of the second son of Francis I. A courier had arrived with an invitation from the King, but Leonardo was already ill, had been confined to his bedroom since the beginning of winter.

It was spring by now. Everything was taking on new life and color. Only Leonardo's face, his hands and his hair had become whiter. At times he asked for a mirror and gazing at himself he remembered a pale old man, very tired, who had spoken with him all night long in the ward of the Milan hospital, and had then closed his eyes, as if to rest a moment, never to open them again. «And I practiced anatomy on him», Leonardo repeated to himself, while his breathing became more labored. The old man, abandoned by all, seemed to appear before his eyes, telling him that he was over a hundred years old and that he felt no pain, only drowsiness, and was overwhelmingly tired of life.

Leonardo had fallen into a light sleep. Outside, high in the serene sky, a kite wheeled between the Castle of Amboise and the roofs of Clos-Lucé. Francesco Melzi and Battista de' Villanis, from the loggia outside of the sick man's room, followed it with their eyes, remembering the Maestro's observations, the dream from his childhood, the forked tail of that bird of prey, the bearing wing, the wheeling flight.

«Is he sleeping?», Battista asked Maturina who was leaving the room.

«He is sleeping», said the girl.

But Leonardo was not sleeping, but delirious. In his delirium he saw the King, discontented in spite of the festivities for his second-born son. While everyone exulted, Francis I wandered uneasily through the rooms of the castle, went down to

the stables, had a horse saddled and started off at a gallop in the direction of Amboise.

«Maestro, *mon père*, wait for me», the King cried aloud as he galloped along the Loire. But Leonardo saw that Melzi and de' Villanis did not even notice the King. They were still engaged in conversation out on the loggia, and Maturina came and went as if nothing special were happening.

«The King! The King!», someone announced. They had seen him appear on his horse at the end of the park. But no one came to raise the sick man, to dress him to receive his sovereign in dignity. From Leonardo's lips issued a raucous, guttural cry, like a scream.

Melzi and de' Villanis heard it and ran to the bedside. They lifted Leonardo on the cushions, just as he wished, they threw over his shoulders his woolen cloak. Now he was almost sitting on the bed, his eye closed, and he thought the King was standing before him. He would have to find the right words after that long gallop to his bedside.

Leonard was breathing heavily, as if he himself had galloped along the Loire, as far as Saint Germain-en-Laye to tell the King something vitally important, something he no longer remembered.

«Ah, yes», he murmured, «now I remember. I wanted to say that "everything we know begins from feelings"». Then he added tiredly, almost without voice, «Now I feel myself flowing away like the water in the rivers, I feel myself borne by the current towards death. Now I am going to live it, to experience it».

Leonardo's life - Events in history and art

1452 Leonardo is born at Vinci on April 15, the natural son of the notary Piero son of Antonio. In Rome Federico III is crowned Holy Roman Emperor. In Arezzo Piero della Francesca begins the cycle of frescoes called the *Legend of the True Cross* in the church of San Francesco.

1469 Leonardo presumably enters Verrocchio's shop at this time. In Florence, after the death of his father Pietro, Lorenzo the Magnificent comes to power.

1471 Albrecht Dürer is born in Nuremberg. In Florence the first printing works is established.

1472 Leonardo is enrolled in the painter's association, the Compagnia di San Luca. His first works date from this time: staging and costumes for festivals and jousts, a cartoon for a tapestry (destroyed) and various paintings of uncertain date. War between the Medici and Volterra for the possession of alum mines. Death of Leon Battista Alberti.

1473 Drawing of a *Landscape in the 'Val d'Arno'*, now in the Uffizi. Birth of Niccolò Copernicus.

1475 Leonardo begins to work independently as painter and sculptor. Paints the angel in Verrocchio's *Baptism of Christ*; begins the

Uffizi *Annunciation* and the Louvre portrait of *Ginevra Benci,* both completed in 1478. Perhaps participates in Verrocchio's marble portrait bust of the *Lady with the beautiful hands*, probably the portrait of Lucrezia Donati. Michelangelo is born in Caprese.

1476 The artist is accused of sodomy along with other persons, but is acquitted. In Milan Galeazzo Maria Sforza is assassinated in a conspiracy and succeeded by his son Gian Galeazzo. The city is governed by Simonetta.

1478 Leonardo is commissioned to paint an altarpiece for the chapel of San Bernardo in Palazzo della Signoria. In this same year he states that he has completed two paintings of the Virgin, one of which has been identified as the *Benois Madonna* in the Hermitage. He begins to illustrate the sheets of the *Codice Atlantico* and the *Codex Arundel*, containing literacy material and his first technological drawings of hydraulic machines, self-propelled carts, weapons and military bridges, as well as his first projects for flying machines. The Pazzi conspiracy, fomented by Pope Sixtus IV, fails. Giuliano de' Medici dies but the authority of his brother, Lorenzo the Magnificent, is reinforced. Sandro Botticelli paints the *Primavera* and the *Birth of Venus*.

1479 Perugino is in Rome. Verrocchio is commissioned to sculpt the equestrian monument to Colleoni in Venice.

1480 According to the Anonymous Gaddiano, Leonardo works for Lorenzo de' Medici. Ludovico Sforza kills Simonetta, imprisons his nephew and unlawfully becomes the Lord of Milan.

1481 Contract for the unfinished *Adoration of the Kings* now in the Uffizi, stipulated with the monks of San Donato a Scopeto; also begins the *St. Jerome* (Rome, Pinacoteca Vaticana). Botticelli, Ghirlandaio, and Cosimo Rosselli are in Rome to fresco the Sistine Chapel.

1482 Leonardo is sent to Milan by Lorenzo the Magnificent to offer Ludovico il Moro a silver lyre in the form of a horse's head, on

which the artist played superbly. Arrival in Florence of the *Portinari Triptych* by Hugo van der Goes, now in the Uffizi.

1483 On April 25 stipulates with the friars of the Immaculate Conception a contract for the *Virgin of the Rocks* in collaboration with Evangelista and Ambrogio De Predis (Paris, Louvre); studies and model for the equestrian monument to Francesco Sforza. Raphael is born in Urbino.

1485 Completes an unidentified painting, commissioned of him by Ludovico il Moro, to be sent to the King of Hungary Mattia Corvino.

1487 Payments for projects for the lantern on the Milan Duomo. *Codex Trivulziano* (Milan, Castello Sforzesco Library): words and caricatures; Codex B (Paris, Bibliothèque de l'Institut de France): architecture and technology; Codex Forster I (London, Victoria and Albert Museum): hydraulic machines and recipes.

1488 Portrait of Cecilia Gallerani, now at Kracow, identified as the *Lady with an Ermine*; studies and model for the lantern on the Duomo of Milan. Verrocchio dies in Venice, where he was completing the equestrian statue of Colleoni. Bramante is in Pavia, acting as consultant for the project of the Duomo.

1489 Designs temporary settings and decorations to celebrate the wedding of Gian Galeazzo Sforza and Isabella d'Aragon. In this same year preparations begin for a colossal equestrian statue in honor of Francesco Sforza. Paints the *Musician*, a portrait of either Franchino Gaffurio or Josquin Des Prez.

1490 Gathers pupils who operate as members of an ideal Vincian Academy. Codex C (Paris, Bibliothèque de l'Institut de France): theory of shadows; Codex A (Bibliothèque de l'Institut de France): painting, perspective, mechanics.

1491 Gian Giacomo Caprotti da Oreno known as Salaì, ten years old at the time, enters Leonardo's service. The nickname Salaì,

which means devil, derives from the boy's turbulent personality. Ludovico il Moro flees before the French troops, who use Leonardo's model for the equestrian statue of Francesco Sforza for target practice.

1492 On the occasion of the wedding of Ludovico il Moro and Beatrice d'Este, designs the costumes for the procession of Scythians and Tartars. In Florence Lorenzo the Magnificent dies and Savonarola comes to power. The system of alliances sanctioned by the peace of Lodi begins to crumble. Columbus goes ashore at San Salvador.

1493 Codexes H, I, M (Paris, Bibliothèque de l'Institut de France); Codexes Forster II and III (London, Victoria and Albert Museum); Codex 8937 (Madrid, Biblioteca Nacional).

1494 Swamp draining project on a ducal estate near Vigevano. The King of France Charles VIII, allying himself with Ludovico il Moro, invades Italy to claim his right to the Reign of Naples.

1495 Leonardo begins the *Last Supper* and the decoration of rooms in the Castello Sforzesco. The artist is cited as ducal engineer. Brief visit to Florence for the project of the new Hall of the Great Council in Palazzo Vecchio.

1497 The Duke of Milan urges the artist to finish the *Last Supper*, which is probably concluded at the end of the year. Paints *La Belle Ferronière*, probably a portrait of Lucrezia Crivelli.

1498 Finishes decorating the Sala delle Asse in the Castello Sforzesco. Friendship with the mathematician Luca Pacioli, whose *De divina proportione* the artist illustrates. Pollaiolo dies in Rome, where he had completed the tombs of Sixtus IV and Innocent VIII. Michelangelo is commissioned to sculpt the *Pietà* for Saint Peter's. In Florence Savonarola is burned at the stake.

1499 Leaves Milan in the company of Luca Pacioli. Stays at Vaprio in the Melzi home, then goes on to Venice passing through Mantua,

where he draws two portraits of Isabella d'Este. Luca Signorelli begins frescoing the Chapel of San Brizio in the Duomo of Orvieto. Milan is occupied by the King of France Louis XII.

1500 In March Leonardo arrives in Venice, where he draws up a plan of defense against the Turkish invasion. Returns to Florence and lodges in the Monastery of the Servite Brothers at Santissima Annunziata. Designs a grandiose bridge over the Bosphorus for Sultan Baizet III. Sheets in the *Codice Atlantico* and *Codex Arundel*. Cartoon for the portrait of *Isabella d'Este*, perforated to be transposed to a painting but never executed.

1501 First cartoon of *St. Anne* (London, National Gallery).

1502 Enters the service of Cesare Borgia as general engineer and architect, following him on his military campaigns in Romagna. Windsor geographic charts (Royal Library). In Rome Bramante begins the temple of Saint Peter's in Montorio and the courtyard of the Belvedere. Amerigo Vespucci recognizes that America is a new continent.

1503 Returns to Florence, where he devises projects for deviating the Arno during the siege of Pisa. The Signoria commissions him to paint the *Battle of Anghiari*; Codex K (Paris, Bibliothèque de l'Institut de France). The Borgia Pope Alexander VI dies, and Giuliano della Rovere becomes Pope under the name of Julius II. Frances loses the Reign of Sicily and Naples, which comes under the power of Spain.

1504 Continues to work on the *Battle of Anghiari*. Is called to participate in the committee that will decide where to place Michelangelo's *David*; Codex 8936 (Madrid, Biblioteca Nacional). Raphael paints the *Marriage of the Virgin*, then moves to Florence, where he is influenced by Leonardo.

1505 Codex on the flight of birds (Turin, Biblioteca Reale).

1506 At the insistent request of the French governor of Milan, on May 30 the Florence Signoria gives Leonardo a three-months' leave

of absence, later to be renewed several times. Probably begins the *Gioconda,* or *Mona Lisa*, completed between 1513 and 1516; works of architecture and theatrical productions in Milan. *Hammer Codex* on cosmology (Seattle, Bill Gates collection).

1507 In September returns to Florence where he is involved in a lawsuit with his brothers for an inheritance.

1508 Divides his time between Florence, where he assists Rustici in designing the group with *St. John the Baptist* to be placed in the Florence Baptistery, and Milan, where in July he designs a grandiose residence for Charles d'Amboise and an equestrian monument, never to be realized, for Gian Giacomo Trivulzio. Codex D on optics (Paris, Bibliothèque de l'Institut de France). In Rome Michelangelo engages to fresco the ceiling of the Sistine Chapel. In Venice, Giorgione and Titian fresco the Fondaco dei Tedeschi.

1509 Geological studies on the Lombard valleys. Raphael is in Rome, where he begins decorating the *Stanze*.

1510 Debates with Amadeo, Cristoforo Solari and Fusina on the choir-stalls in the Duomo of Milan. Studies anatomy with Marcantonio Torre at the University of Pavia. Project for channeling the Adda from Lecco to Milan. Codex G (Paris, Bibliothèque de l'Institut de France): painting, perspective, technology, mechanics, geometry. Sandro Botticelli dies.

1512 Michelangelo Buonarroti completes the frescoes on the ceiling of the Sistine Chapel.

1513 On September 24 Leonardo leaves for Rome accompanied by his assistants Melzi, Salaì, Lorenzo and Fanfoia. He is lodged in the Vatican, under the protection of Giuliano de' Medici. Codex E (Paris, Bibliothèque de l'Institut de France): painting, perspective, hydraulic engineering, flight of birds, mechanics. Julius II dies, succeeded by Giovanni de' Medici under the name of Leo X. In Florence, Andrea del Sarto begins the cycle of frescoes *Stories of the Virgin*.

1514 Projects for draining the Pontine swamps and for the port of Civitavecchia. Louis XII dies. The new King of France Francis I invades Italy and reconquers Milan and its territory in October. In Rome Bramante dies and Raphael succeeds him as architect of the Fabric of Saint Peter's.

1515 Project for a new Medici palace in Florence; mechanical lion sent from Florence to Lyons. Raphael works on the cartoons for the tapestries in the Sistine Chapel.

1517 Accepts the invitation of Francis I and, accompanied by his pupil Melzi, goes to France, where he lives near the royal residence of Amboise. Receives a visit from Cardinal Louis d'Aragon, who is impressed by the great number of manuscripts shown him. Carries out a project for the Castle of Romorantin and the channeling of the Sologne. Executes drawings of the *Deluge* (Windsor Castle, Royal Library). The Turkish Sultan Suleiman II conquers Egypt. In Rome Raphael and his assistants paint the Vatican Loggias and the Psyche Loggia in the Farnesina.

1518 Participates in festivities for the baptism of the Dauphin and for the wedding of Lorenzo de' Medici to the King's niece.

1519 On April 23 Leonardo writes his will. Named executor is Francesco Melzi, to whom he leaves all of his books and his drawings. Dies on May 2. Charles V of Hapsburg is elected Emperor of the Holy Roman Empire, and conflict breaks out between France and the Empire. In Parma Correggio paints the Abbess' Chamber in the Convent of San Paolo.

Leonardo's works - Topographical index

Hamburg - Drawings
Kunsthalle
Adoration of the shepherds (1478)

Bayonne - Drawings
Musée Bonnat
Adoration of the shepherds (1478)
Madonna with the cat (1478-1480)
The hanged man (portrait of Bernardo di Bandino Baroncelli) (1479)
Study of child with a cat (c. 1480)
Kneeling lady (c. 1483)

Cambridge - Drawings
Fitzwilliam Museum
Study of horses and riders (c. 1480)
Allegory of the ermine (c. 1490)

Chatsworth - Drawings
Duke of Devonshire Collection
Study for a kneeling *Leda* (1503-1504)

Cologne - Drawings
Wallraf-Richartz Museum
Study of crabs (c. 1480)

Krakow - Paintings
Czartoryski Muzeum
The Lady with an Ermine (1485-1490)

Florence - Paintings
Uffizi
Adoration of the Kings (1481-1482)

Florence - Drawings
Uffizi - Gallery of Drawings and Prints
Study of drapery for seated figure (1470-1472)
Landscape of the 'Val d'Arno' (1473)
Study for head of a young girl (1475-1480)
Study of drapery (c. 1478)
Perspective for the Adoration of the Kings (1480)
Madonna with the cat (1480-1483)
Youth and old man (c. 1495)

London - Paintings
National Gallery
Virgin and Child with St. Anne and St. John the Baptist (1508)

London - Drawings
British Museum
Profile of antique warrior (1475-1480)
Young woman with a child in her arms (1478-1480)
Study for a *Virgin with the flowers* (1478-1480)
Madonna of the cat (1478-1480)
Allegories of *Victory* and of *Fortuna* (c. 1480)
Adoration of the Kings (c. 1481)
Codex Arundel (1508)

London - Codexes
Victoria and Albert Museum
Codex Forster I (1487-1505)
Codex Forster II (1495-1497)
Codex Forster III (1493-1496)

Madrid - Codexes
Biblioteca Nacional
Manuscript 8937 (1490-1499)
Manuscript 8936 (1503-1505)

Milan - Paintings
Castello Sforzesco, Sala delle Asse
Painted decoration (c. 1498)

Refectory of the Monastery of Santa Maria delle Grazie
Last Supper (1495-1497)

Pinacoteca Ambrosiana
Portrait of a Musician (c. 1490)

Milan - Codexes
Ambrosian Library
Codice Atlantico (1478-1519)

Castello Sforzesco Library
Codice Trivulziano (1487-1490)

Milan - Drawings
Ambrosian Library
Profile of a young woman (c. 1490)

Munich - Paintings
Alte Pinakothek
Virgin with the Flowers (1478-1481)
Doria Panel (early XVI century)

New York - Drawings
Pierpont Morgan Library
Study from a male model for the Virgin's head in the Uffizi
Annunciation (c. 1475)

Metropolitan Museum
Study for a *Nativity* (c. 1483)

Oxford - Drawings
Christ Church College
Caricature study of a curly-headed man (c. 1515)

Paris - Paintings
Louvre Museum
Annunciation (1478)
Virgin of the Rocks (1483-1486)
La Belle Ferronière (attributed, c. 1497)
Mona Lisa (1506-1510; 1513-1516)
The Virgin, St. Anne, and the Child with a Lamb (1510)
Bacchus (1511-1515)
St. John the Baptist (1513-1516)

Paris - Drawings
Louvre Museum
Study of drapery (c. 1478)
Study for the *Adoration of the Kings* (c. 1480)
Portrait of Isabella d'Este (1500)

Ecole des Beaux-Arts
Study of figures for the *Adoration of the Kings* (c. 1481)

Paris - Manuscripts
Bibliothèque de l'Institut de France
Manuscript B (1487-1489)
Manuscript C (1490-1491)
Manuscript A (1490-1492)
Manuscript H (1493-1494)
Manuscript I (1497-1498)
Manuscript L (1497-1499)
Manuscript M (1499)
Manuscript K (1506-1507)
Manuscript F (c. 1508)
Manuscript D (1508-1509)
Manuscript E (1513-1514)
Manuscript G (c. 1515)

Parma - Drawings
Galleria Nazionale
Portrait of a Young Girl (c. 1508)

Rome - Paintings
Pinacoteca Vaticana
St. Jerome (1480-1482)

Rome - Drawings
National gallery of prints and drawings
Caricature studies of old man (1490-1495)

St. Petersburg - Paintings
Hermitage Museum
Benois Madonna (1475-1478)

Seattle - Codexes
Bill Gates Collection
Codex Hammer (c. 1506-1508)

Turin - Drawings
Biblioteca Reale
Angel's head (1483)
Study for head of a woman (c. 1483)
Study for male head (c. 1500)
Three views of the same head (c. 1500)
Herculean profile of a warrior (1506-1508)
Self-portrait (1512)

Turin - Codexes
Biblioteca Reale
Codex B (c. 1505)

Venice- Drawings
Gallerie dell'Accademia
Vitruvian Man (c. 1490)
Study for the *Battle of Anghiari* (1490-1504)
Study of dancers (c. 1515)

Washington - Paintings
National Gallery
Ginevra Benci (1474-1476)

Windsor Castle - Drawings
Royal Library
Collection of 234 sheets with drawings (c. 1489-1516)

Index

PART THREE

PART FOUR

Printed on july 1999
by Giunti Industrie Grafiche S.p.A.- Prato - Italy